France

A Hedonist Surf Company Production

Editorial

Editorial
Hugh Hutchison, Adam Coxen, Jeremy Goring.

Art
Nick Baron, Arthur Novat, Stéphane Rouget.

Photography
Adrian Myers, Zoom Agence, Skishoot Offshoot, Ian McKenzie, Sarah Winterflood, Andrew Lewis.

Contributors and thank you's
Edgar Grospiron, Christel Pascal, Luc Alphand, Graham Bell, Martin Bell, Jean Baptiste Grange, Alain Baxter, Laure Pequegnot, Pat Sharples, Lesley McKenna, Sean Langmuir, Chemmy Alcott, Charlie Tee, Fabien Bertand, Eric Berthon, Raz Cobbing, Candice Gilg, Becci Malthouse, David Chastan, Patricia Chauvet, Iain Martin, Sarah Bovill, Chris Adams, Simone Clark, Richard Robinson, Jo Oliver, Iain Martin, Carrie Hainge, Pip Goodfellow, Cedric Gacon, Phil Clark, Jon Evans, Mike Beaudet, Kelly Southgate, Ben Patchell, Daniel Loots, Charlotte Murray, Richard Evans, Hamish Farmer, Kirsteen Fox, Jim Izatt, Seb Howell, Phil Allin, Alex Irwin, Andy Evans, Martin Ritchie, Marcus Fox-Kent, Lou Murray, Jacqui Kirkaldy, Snowsports GB, Robin Wallace, A. Rolland, Office de tourisme La Clusaz, service communication.

Published by

Snowsports are dangerous. Respect the mountain.

Snowfinder France is the first in a series of proper guide books for people who love the snow.

The Snowfinder concept is based on the 4 key requirements for any snow-user to enable them to maximise snowtime and après ski enjoyment:

Our guides provide you with all the info you need on all the key resorts in the French Alps. You get:

1. Introductions for each resort from a famous skier or snowboarder who knows the place intimately and wants you to know what it is they love about that resort.

2. The piste-map of that area so you can instantly have it to hand whenever you need it.

3. Our team's comments on the important runs in each ski area - no other resource on the planet can provide you with this, one of the most important things a snow-user needs to know.

4. The good stuff about best places to go drinking, eating, clubbing, dancing or just plain chilling out. Essential.

All of this in a pocket book that fits into your jacket pocket for the price of a couple of glasses of vin chaud!

And a final note:
Just be very careful when skiing on or off-piste.
Observe the simple rules that are there to protect everyone.

Never go off-piste without an experienced guide and all the appropriate safety equipment. You should carry at all times the four essential items of avalanche safety equipment; transceiver, shovel, probe and medical kit. Consider very seriously wearing a helmet on and off-piste.

How to use the Piste-map system

The Snowfinder Piste-map system is designed to make life really easy for you, wherever you are in the French Alps and whatever standard of skier or snowboarder you are.

Simply go to your favourite resort, decide what you want to do for the day and then look at the piste map. Most runs are numbered so you can get a little idea of what to expect if you choose to attempt those runs. So, if you're first on the lifts and determined to bash the mountain for the day, or simply on your way down the mountain after a long lunch, Snowfinder has it all for you.

1. First look at the area map of the ski region.

2. Next, pick out the mountain/resort area you would like to visit today.

3. Finally, decide where you want to go and what level you feel you are up to today.

Make use of the brief descriptions to fine-tune the options eg. maybe it is a mogul day, an off-piste day or you simply fancy a couple of runs prior to a long mountain lunch...!!!

PHIL MEIER
★ SANITAGO Limited Skis

Respect the Mountain

We are committed to supporting the Respect the Mountain Campaign, launched by the Ski Club of Great Britain in March 2005. We urge all of you to log onto the website:

www.respectthemountain.com

Buy a wristband for £2 to show your support for the snow environment we all cherish. All money raised goes straight towards the tree planting scheme and research project that the campaign will fund.

Additionally you can actively show your support for the mountain environment we know and love by following seven steps to preserve the mountains:

Seven steps to preserve the mountains

The aim of the campaign is to remind people to be aware of the delicate environment we live and play in and advises people to try and follow the seven steps:

1. Be aware of your environmental impact as skiers and boarders

Educate yourself about your environmental impact on the mountains, and what you can do to minimise it.

2. Do not leave litter on the slopes

When the snow melts, the litter will still be there. Bin it or take it home. Orange peel takes up to two years to break down, and cigarette ends up to five years. If you find litter on the slopes, do the right thing - pick it up.

3. Respect the natural habitat of mountain animals and plants

If you ski through trees, you can damage them by knocking off branches and killing young shoots under the snow. Take care. Many areas are out of bounds to protect the natural habitat of animals and plants - not just for safety reasons.

La Clusaz

Grand
Flaine
Les Car.
Samoëns

Mégève area 140
Mégève / St Gervais
Les Contamines

Chamonix 140
Chamonix / Argentière/ 148
Les Houches

Trois Vallées area 166
Courchevel / La Tania 174
Méribel 184
Les Ménuires 195
Val Thorens 205

South 368
Risoul / V 371
Pra Loup 386
Isola 2000 394

49 354

4. Choose a resort which uses environmentally friendly practices

Many resorts now use bio-diesel fuel in piste-bashers, solar panels for heating, hydro-electricity/wind energy for power and a host of other initiatives. Some resorts use the International Standards Organisation (ISO) 14001 as a mark of their environmental credentials.

5. Encourage tour operators to adopt green policies

Find out if your tour operator offers train travel as an alternative to flying, if they use. For example, low-wattage light bulbs for their brochures, if they use paper from sustainable forests for their chalets and bio-degradable detergents.

6. Do your bit to reduce global warming on holiday and at home

Re-use your towels each day, re-cycle household waste and switch off electrical appliances when not in use.

7. Reduce CO2 emissions

By flying fewer miles, or switching from air to rail, you can help reduce the volume of greenhouse gases that contribute to climate change. When possible, use your bike instead of your car.

Sarah Winterflood

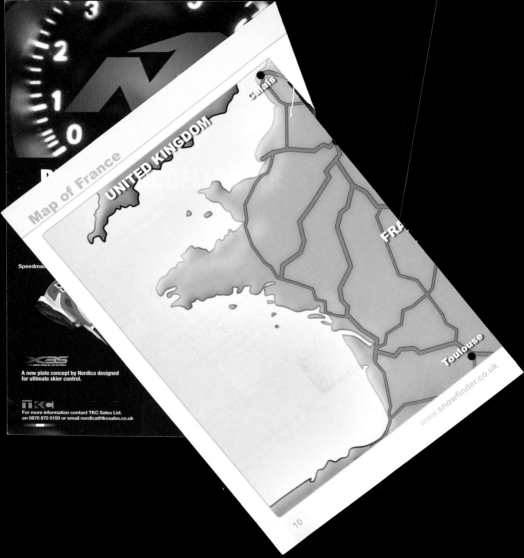

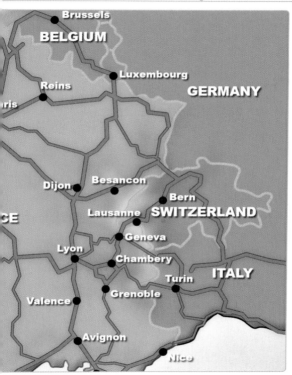

For all you petrol heads.

Be amongst the first to experience the new Saab 9-3 1.9 TiD. Choose from a 150 or 120 bhp engine and relish swift acceleration through a dynamic six-speed gearbox. Plus with low CO_2 emissions, you'll beat a 3% company car tax penalty incurred by less efficient diesel engines. Call us today for a test drive. From just £19,460 on-the-road.

The Saab 9-3 Sport diesel.

www.saab.co.uk Call: 0845 300 93 95

Adrian Myers

Portes du Soleil region

Introduction

The Portes du Soleil was one of those grand ideas born out of a (probably alcohol-induced) conversation in the late 50s between a group of local businessmen and skiers, led by the legendary Olympic Gold medallist skier and now sunglasses manufacturer, **Jean Vuarnet.** The idea was simple: to link the pistes of **Les Crosets** and **Champéry** with neighbouring French areas, particularly **Avoriaz.**

So that's the basic history. **The Porte du Soleil** today is the largest ski area in the world, covering 2 countries, 14 resorts, 208 lifts, 288 pistes and 8 snowparks. All this and only an hour or so away from *Geneva* airport makes this area a total winner for families, weekenders, ski travellers and seasonaires alike. Wow!

Portes du Soleil is a combination of the old and new: **Avoriaz** is the purpose-build super-resort; **Morzine** and **Les Gets** are old towns with all the requisite alpine charm you'd expect. **Chatel** is similar, having a stylish, old but bustling mountain town atmosphere.

We have asked a couple of people who really know the set-up down there - **Becci Malthouse** and **Raz Cobbing** to talk you through the region. **Becci** is one of our most succesful homegrown boarders, who won the *British Snowboarding Championships* at Avoriaz twice. **Raz** is a *World Cup* and *World Championship Freestyle Ski medallist* and *Olympian* (one of those lunatics you see upside down 15 metres in the air!).

The good
- Huge ski area, covering *Switzerland* and *France*.
- Only 75 minutes drive to *Geneva airport*.
- Uncrowded pistes - even in peak times.

The not-so-good
- Only **Avoriaz** is really easily linked into PDS.
- **Avoriaz**'s lack of charm.
- **Morzine Les Gets** potential for lack of snow.

Adrian Myers

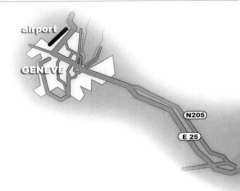

Getting There

Fly: from UK to *Geneva Airport* via BA, Easyjet, flybe or Bmibaby. *Portes du Soleil* is 80km from *Geneva* (approx 1.5 hours).

Drive: take the **E25 A40** Motorway to *Bonneville* and onto *Cluses*. Turn off at **J18 or J19** and climb up the **D902** to *Morzine Les Gets* approx 20km (snow chains are recommended). *Avoriaz* is car-free so you need to park down in *Morzine*. This can be arranged for approx €50 per week.

Coaches: run regularly from *Geneva Airport* - book online at www.altibus.com, as well as taxis.

Train: The nearest rail station is *Thonon Les Bains* (approx 40km away) and *Cluses* (approx 30km).

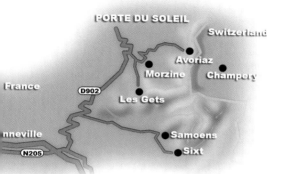

PORTE DU SOLEIL

Switzerland

Avoriaz

Morzine

Champery

France

D902

Les Gets

nneville

Samoens

N205

Sixt

PORTES DU SOLEIL

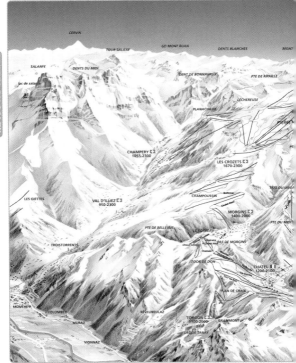

www.snowfinder.co.uk

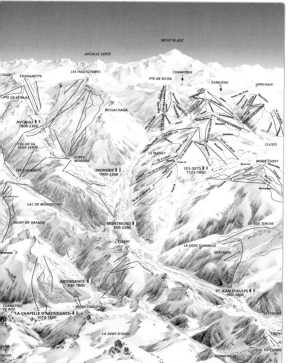

MONT BLANC

AIGUILLE VERTE

COUX CHAVANETTE LES HAUTS FORTS CHAMONIX

PTE DE NYON SAMOËNS VERCHAIX

PTE DE VORLAZ

RESSACHAUX

AVORIAZ
1800-2360

COL DE LA
JOUX VERTE

LE PLENEY CLUSES

SUPER
MORZINE MONT CHERY

LES CRUNNETS MORZINE
1000-2360 LES GETS
1172-1850

LAC DE MONTRIOND

MONT DE GRANGE LA CÔTE TERCHE

MONTRIOND
950-2200

L'ESSERT LA CÔTE D'ARBROZ

GRAYDON

ABONDANCE
930-1800 ST JEAN D'AULPS
500-1800

CORNETTES
DE BISE MONT CHAUFFÉ SEYTROUX

LA CHAPELLE D'ABONDANCE
1010-1600 THON

LA DENT D'OCHE COL DU CORBI

NOVEL BONNEVAUX

Tourist Office

PDS	+ 33 (0)4 50 73 32 54
Morzine	+ 33 (0)4 50 73 22 44
Avoriaz	+ 33 (0)4 50 74 02 11
Chatel	+ 33 (0)4 50 73 22 44

Main office

Portes du Soleil
1401 route de Vonnes
74390 Chatel

General email

info@portesdusoleil.com

Resort websites/email

www.portesdusoleil.com
www.morzine.com
www.lesgets.com
www.avoriaz.com
www.chatel.com

Portes du Soleil lift pass

Discounts available for seniors, under 16, season passes.

Half day	€28
Day	€37
6 Day	€179

Insurance

Carré Neige	€2.50 per day

Morzine & Les Gets

Morzine and Avoriaz come as a bit of a double whammy resort, offering two centres that boast their own distinct characters and skiing to suit everyone. Part of the Portes du Soleil, Morzine and Avoriaz are just two of the 12 resorts in France and Switzerland linked by 650km of pistes. It's location 75 minutes from Geneva airport make this one of the easiest and quickest winter resorts to reach. Morzine is a traditional market town where life continues, albeit at a more relaxed pace outside of the winter season. Traditional wood chalets roofed with local slate create the ambience of friendly mountain village. Avoriaz offers the contrast of high rise purpose built accommodation that has the advantage of being a car free zone.

Designed in the 60s by Olympic winner **Jean Vuarnet** the buildings are clad with wood with the aim of blending into impressive cliffs they are perched on. **Morzine** has its own ski area, linked to **Nyon** and **Les Gets**, a family-friendly area with much varied skiing for all levels. It tends to stay quiet with un-crowded pistes, even in the February holidays it is possible to find yourself on an empty slope.

Morzine lies at about 1000 metres altitude so snow can be unreliable at early or late season. If in doubt, ski in **Avoriaz** where the slopes extend up to 2275 metres altitude and is snow sure from early December to the end of April.

Morzine is home to many independent chalet operators who offer a whole range of personally tailored holidays for all budgets. There are also plenty of hotels to chose from if this is your preferred style of stay. Avoriaz is 90% apartments and be prepared to squeeze in if this is your chosen option. Bunk beds in the hallway and bed settees are the order of the day so you will be short on alpine charm but you get skiing from the doorstep.

Les Gets has sort of decided it should really be in the big time after being relatively overshadowed by neighbouring Morzine for some time!

By Becci Malthouse

First British female snowboarder to compete on the World Cup Circuit. 6th in European Championships, 9th in World Championships. 16 separate British Snowboard titles 1992-7.

Les Gets has invested heavily in 5 new, modern, six seater chairlifts over the last two seasons. Maybe due to the fact that the town is only 1170 metres above sea level, but nonetheless very welcome is a seemingly endless number of new snow-making facilities.

However, don't be fooled. From the top of *Mont Chery* (1800 metres) you'll find a stunner of a view of the *Mont Blanc* range and some quite serious skiing and boarding too. All this and empty pistes? Not so bad these lower level resorts eh?

Over on the *Chavannes* side of the village the lifts take you up past the beginner slopes to **Le Ranfolly**, **Le Rosta**, **Chamossière**, **La Turche** and then over to **Morzine** via **Nyon**.

Other Activities:

Between the 2 resorts there is plenty for everyone to do, including ice-skating, ice-hockey matches, gym, squash, night-skiing, ice-diving, sleigh rides, as well as a range of activities organised weekly by the tourist office. Both resorts are served by a free bus service, which is useful given the distance you can get in a day.

My favourite runs

Best off-piste
Easy off piste skiing without a guide is possible in the **Crozat Snocross** run. *Avoriaz* has pioneered development of Snocross runs which are un-pisted but are avalanche controlled and within the ski patrol area.

Best black run
Chammossière where the north facing aspect keeps the snow in top condition. The long run forms good bumps as well as offering challenging off piste from the same chair.

Best red run
Chery Nord, on the back of the *Mont Chery area*. This red run has a good variety of pitches and the added bonus of there never being anyone there!

Best blue/green
the tree lined **Procolou** in *Avoriaz* is wide and gentle from start to finish. From here, novice skiers can also access the *Super Morzine area*, ideal for snowplough turners.

Best snowpark
There are many parks in the area but the best is by the **Arare** piste in *Avoriaz*. The best snowboarders in the world come to work their talents here but fear not, there is now an easier park up on the beginner plateau which has jumps and a boarder-cross for all levels of rider.

Best eats
For traditional fare try **Chez Nannon** on the *Nyon Plateau*. It's tiny so book if you want to be sure of a table inside. The main restaurant on the *Nyon Plateau* is being renovated ready for winter 2005-06 so will be well worth a visit.

Morzine

Head to the **Dixie** for a friendly Irish pub if it's a glass of Guinness you are after.

The Buddha Bar has a particularly chilled atmosphere with lots of comfortable corners to relax in and the **Cavern Bar** will let you get on it and dance into the small hours. Typical evenings here will result in very shabby starts to your next day on the snow! Well worth it though.

The **Tavaillon** and the **Choucas Pub** are lively apres ski bars in the centre of *Avoriaz* - you'll undoubtedly end up in one or both of these boozers at some stage. Plenty of Brits, shooters, resort workers, music etc etc.

PORTES DU SOLEIL

Les Gets

It has to be **Bar Bush** and the **Boomerang Bar** for the party people.

Look for **Chez Nannon, Les Mouilles,** the **Perdrix Blanche** at *Pré-de-Joux*, and **Restaurant Lotty** over towards *Chamossière*.

In *Morzine* itself, check out **Chalet Philbert** or **La Chamade** for proper eating nights out (if you are not too worried about the dent in your credit card), **L'Etale** for the real-deal Savoyarde experience, and a host of others faster food options.

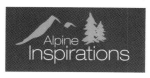

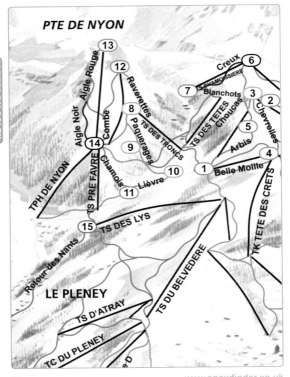

PORTES DU SOLEIL

1. **Belle Moille** : Quick link run to Nyon/Chamossière.

2. **Tétras** : Short steepish section from Le Ranfoilly onto Choucas. run. If you're nervous, follow Gentiane instead to top of Choucas.

3. **Choucas** : Really pretty, scenic, very easy run through the trees. Links Les Gets with Nyon/Chamossière sectors.

4. **Chevrelles** : Nice sweeping red through the trees. Wide and flat at the bottom. Can lose snow from the top.

5. **Arbis** : Great long red from the top of Chamossière chair. Some steeper sections. Good off-piste on both sides.

6. **Creux** : Steep narrow black. Rarely gets the sun, usually has some good moguls. Can be hard and icy. Good off-piste on a powder day.

7. **Blanchots** : Link run back from Chamossière sector to either Les Gets or Morzine. Drag lift is very steep. Not for the timid!

8. **Raverettes** : Short beginners area. Nice and gentle. Wide and plenty of room.

9. **Paquerages** : Short blue through the trees linking onto Lièvre.

10. **Lièvre** : Easier alternative to Chamois to get from Nyon Plateau back to Morzine. Can be icy/hard at the bottom.

11. **Chamois** : Nice fast red. Go over the bridge at the bottom to take the Fys lift, or follow Lièvre to the Nyon cable car. (Short walk at the bottom).

12. **Combe** : Bottom of Aigle rouge. Bit more open for faster speeds.

13. **Aigle Rouge** : Longish red. Basically just follows a winding track down. Boring. Plenty off-piste opportunity here.

14. **Aigle Noir** : Short section at the bottom of Aigle Rouge from La Pointe chair. Not pisted. Fun in the bumps and trees.

15. **Retour des Nants** : Flattish run back to Morzine from Nyon sector. Some poling needed. Ski home if your chalet is that end of town.

PORTES DU SOLEIL

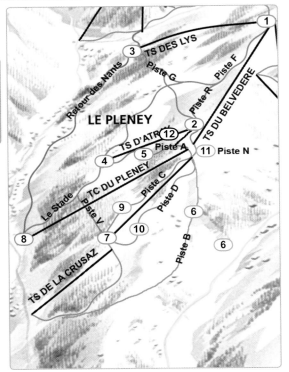

1. Piste F : Another great red run from top of Fys chair to bottom of Atray chair. Alternatively link up with Piste G back to Fys chair.

2. Piste R : Another option from Pleney down to Atray or Fys. Through trees at top then nice and wide and open. Good for fast wide carving.

3. Piste G : Easy run winding through the trees. Links Pleney and Nyon sectors.

4. Piste A : Great fast open red. Can really get some good wide carving down here. Often quiet. Good restaurant near bottom.

5. Piste H : Alternative to Piste A. Steepish at the top. Can link into Le Stade and back to Morzine. Fast and open.

6. Piste B : Great beginners run. All the way from top of Pleney back to Morzine. Winds through the trees. No surprises.

7. Piste V : Alternative to Pistes B and D back to Morzine . Not difficult. Holds snow better than B and D.

8. Le Stade : Short sharp red. Floodlit and used for slalom racing. Can get hard-packed and icy. Not the best run back to Morzine if you're timid.

9. Piste C : Great beginners run. Wide and in the trees. Can link into Pistes D and B all the way back to Morzine.

10. Piste D : Variation of Piste B. Can either get back up to Pleney on Mouilles chair or follow track back to Morzine. Snow can get thin at the bottom.

11. Piste N : Short blue from top of Nabor chair. Links into Piste B. Can also take unmarked trail through the forest back to Les Gets.

12. Piste J : Decent wide Black run. Good for fast carving. Steepish section at the top. Easy to take it by mistake!

Les Gets - Mont Chery

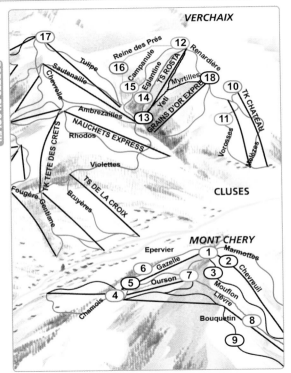

VERCHAIX

PORTES DU SOLEIL

Reine des Prés

17

Tulipe

16

Campanule

12

Renardière

TS ROSTA

Sautenaille

Chevrelle

15

Eglantine

Myrtilles

18

10

TK CHATEAU

14

Yeti

Ambrezailles

13

GRAINS D'OR EXPRE

11

Vorosse

NAUCHETS EXPRESS

Mélèze

Rhodos

Violettes

TK TETE DES CRETS

CLUSES

TS DE LA CROIX

Bruyères

Fougère

Gentiane

MONT CHERY

Epervier

1

Marmottes

6

Gazelle

2

Chevreuil

5

7

3

Ourson

Mouflon

4

Lièvre

Chamois

Bouquetin

8

9

1. Marmottes : Good longish red run. Can sometimes be icy in places. Good restaurant at the bottom just up from the lift.

2. Chevreuil : Nice, even pitched black run. Can get some good moguls here. Get in the trees for a bit of fun on a powder day.

3. Mouflon : Variation on the above. Flatter at the bottom.

4. Chamois : Very fast smooth red from the top of Chery all the way to the village. Watch the road crossings near the bottom.

5. Gazelle : Several variations down to the village. Can lose snow quickly due to south facing slope.

6. Epervier : Gentle, smooth, even red run. Great views of Mont Blanc from the top.

7. Ourson : Nice easy blue. Watch out for the stunts in the snowpark at the top. Grande Ourse lift is very slow.

8. Lièvre : Another one for speed. Jump into the skier-cross area near the top for a bit of fun.

9. Bouquetin : Steep top section, often mogulled. Narrow, steep section at the bottom. Good skiers only.

10. Mélèzes : Good fast run through the trees down to La Turche. Often quiet. Several variations through the trees.

11. Vorosses : Nice, long, gentle blue back to La Turche and Perrières car park. Take the chair rather than the drag lift though.

12. Renardière : Good gentle run for those finding their ski legs again.

13. Yeti : Short steepish pitched run. Not normally pisted, so usually get some nice bumps! Good for posing under the chair (if you're good).

14. Eglantine : Good thigh-burner red or carbing turns.

15. Campanule : Take Rosta chair for the option of a black, red, blue and green all meeting at the bottom. Great for mixed parties.

16. Reine des Prés : Standard green.

17. Tulipe : Lovely long red from the top of Ranfoilly (Great views to Mont Blanc and the Aiguilles). Stop at the café half way down.

18. Myrtilles : Usually left unpisted, so can get some good bumps here.

Adrian Myers

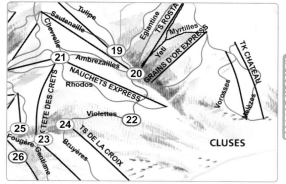

19. Sautenailles : Short and not too steep. Get into the trees on a powder day for a bit of fun.

20. Ambrezailles : Ditto. Watch out for the "locals" in the moguls under the Nauchets chairlift!

21. Rhodos : Quite a gentle red, not too steep and well pisted.

22. Violettes : Easy access to the Les Gets bowl from the top of the Chavannes Express chair. Nice and gentle.

23. Gentiane : Home run from Chavannes to the village, so can get busy at the end of the day. A slightly steeper section just below the top of the "red egg".

24. Bruyères : Alternative way from the Chavannes or Les Folliets back to the village. Flat section over the golf course means a bit of "poling".

25. Fougère Piste : Great beginners run, short and not steep. Only downside is the draglift.

26. Piste 64 : Great beginners run, short and not steep. Only downside is the draglist.

Skishoot offshoot

Avoriaz *By Becci Malthouse*

Avoriaz is a totally different proposition to the charming towns of Morzine and Les Gets down the mountain - in fact Avoriaz is the highest resort in the whole Portes du Soleil area at 1800 metres plus. I love it because it's so boarder-friendly.

This is yet another example of the great ideas that came out of the 60s being executed in a functional post-revolutionary manner! I guess what we mean is, a cluster of 'modernistic' wooden apartments that could never be described as pleasing on the eye, but hey, it has its benefits.

Not least: the most reliable snow in the area; instant access to quality skiing of all standards, but especially some challenging stuff up high in *Les Hauts Forts area*; top quality snowboarding facilities, including an awesome snowboard park - some would say the most boarder-friendly resort in the French Alps; some great off-piste and the resort is car-free. Oh, and don't forget the rocking apres-ski! Sounds pretty good, eh?

Avoriaz has 3 main cable car access points from *Morzine* but for those living there, ski in ski out is the winning bonus of all the accommodation. The resort does get very busy in high season but explore away from the main town to get quieter areas. The nice thing about it is that you can expect snow cover to be good in early April - which cannot be said for many of the lower resorts.

There is also very easy access to the Swiss side of PDS, including *Champery, Les Crosets and Champoussin* so **Avoriaz** really can be seen as a gateway to miles and miles of piste and off-piste to suit all standards.

There's all the usual non-snow activities, including horse-drawn sleigh action, which can be quite a winner given tired legs and the lack of cars.

Après

Plenty of options, as you would imagine. If it's serious quality you want, look no further than **Les Dromonts**. For traditional food and charm, head to **Les Trappeurs** just above the **Résidence Le Sépia**, or the very old and very well known **Chalet d'Avoriaz** - booking strongly suggested.

It is expensive and busy up the mountains, but you should get what you want if you are patient. Try **La Cabushe** at *Ranfoilly*, any of the restaurants around **Les Lindarets** or **Coquoz** in *Planachaux* for a bit of hearty Swiss fare.

Other good eats in the reasonably priced range include **La Chanterelle** at *Chery Nord*, **Les Fountaines Blanches,** and for something a bit more eclectic and chill-friendly, try **Le Crepy.**

Après ski and partying will depend on which tribe you belong to: boarders and the cool dudes of all nationalities currently hang in **Le Fest** or **Le Choucas**, the biggest, sweatiest and fullest club in *Avoriaz.*

Globe Trotters is all about taking it easy after a hard day on the slopes - a great place to hit if the sun is shining. Also has the benefit of making it the shortest trip possible to head next door to **Shooters** in your ski gear for those intent on serious partying into the small hours.

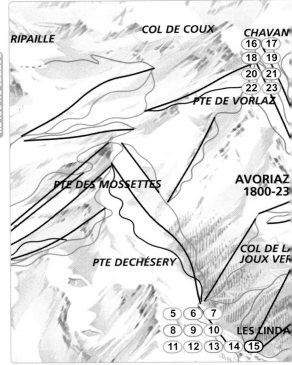

RIPAILLE

COL DE COUX

CHAVAN

16 17
18 19
20 21
22 23

PTE DE VORLAZ

PTE DES MOSSETTES

AVORIAZ
1800-23

PTE DECHÉSERY

COL DE L
JOUX VER

5 6 7
8 9 10
11 12 13 14 15

LES LINDA

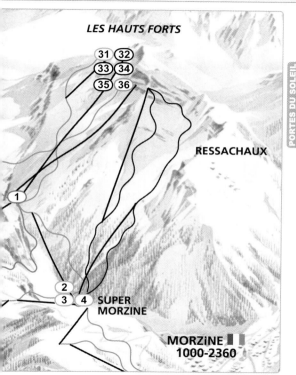

LES HAUTS FORTS

31 32
33 34
35 36

RESSACHAUX

PORTES DU SOLEIL

1

2
3 4 SUPER
MORZINE

MORZINE ▮▮
1000-2360

Avoriaz Station

1. **Greens** : Loads of options here for the complete beginner. Not far from refreshments either when you're tired.

Super Morzine

2. **Tétras** : Very flat. Better to take Qu'mont piste to Baron drag (can be busy at end of day).

3. **Zore, Gernes** : Great area for beginners. Gentle, wide blue runs with paths through the trees. Can't ski back to Morzine though.

4. **Qu'mont, Seraussaix, Proclou** : Good view of the ski/board park.

Lindarets

5. **Grand Plan** : Nice gentle run back to Les Lindarets after the Portes du Soleil circuit. Can get busy at end of day and worn out at end of season.

6. **Chaux Fleurie** : Return run from Chatel. Good off-piste potential. Chaux Fleurie lift is very slow.

7. **Abricotine** : Great long cruisy run from Swiss border all the way back to Lindarets. Fun jumps and rollers just off the piste.

8. **Les Cases** : Steeper, short section, usually bumped up from top of the Mossettes lift back to Abricotine Piste and to Lindarets

9. **Mur de Cubore** : Links the Mossettes with Chavanette area. Steep and bumpy at the top. Good off-piste to the left. Links into

10. **Brocheaux** : Couple of small snow-parks in this area.

11. **Abricotine, Mossettes, Stade de Slalom** : Three similar runs from the top of Prolays chair. Some good off piste here, particularly under the chair.

12. **Prolays, Combe a Floret** : Wiggly windy run through the trees on and off forest paths. Great for intermediates.

13. **Les Tannes** : Nice fast red through the trees. Can get quite busy.

14. Parchets : Home run to Ardent. Do it in the morning when its just been pisted and there's no-one on it. Busy in afternoon.

15. La Frontalière : One of the best in the area. Can be bumpy all the way down. Great off-piste on skiers right, but does tend to slide easily. Take care.

Chavanette

16. Cubore, Patenaille : Really just a link run back to Chavanette from Mossettes area. Good off-piste potential on skiers right.

17. Chavanette : Sweet run from top of Chavanette chair straight back down. Great views of Dents Blanche and Dents du Midi from the top.

18. Alpages and Blanchots : Short, steeper reds from the top of Choucas chair. Link into Fornet or the natural snowpark of the Canyon.

19. Fornet : Intermediate paradise. Stick to the piste or pop off into the Canyon for a bit of fun. Nothing too difficult here.

20. Marmotte : Very similar to the Canyon, good for all standards wanting a bit more than groomed piste.

21. Canyon du Pschott : Loads of natural features bumps, rollers, jumps, drops. A natural park.

22. Aller Chavanette : Gets you to Chavanette from to of the Arare area. Go through the tunnel at the bottom or you miss the lifts.

23. Retour Chavanette : Does what it says on the tin and gets you back to Avoriaz from the Chavanette area. Long and flat and slow. Boarders beware!

Adrian Myers

Arare

24. Bleue de lac : Good long run for intermediates. Stop at the **snowpark** near the top and watch the tricks. Huge jumps.

25. Stade d'Arare : Great blue run. Sometimes closed at top due to racing. Can be very exposed and windy at the top.

26. Stade de Slalom : Slalom race piste. Often closed. Massive half pipe at the bottom...if you dare.

27. Vaineuve : Wee short link piste, you probably won't notice you were on it.

28. Combette : Short sweet black run. Doesn't go anywhere, just go up and down. Can get bumpy.

29. Bleue d'Arare : Good alternative to the Stade decent long run either back to Avoriaz or link into Le Crot all the way down to Prodains Cable car.

30. Snowpark : Serious snowpark.....how do they do that stuff...?

Hauts Forts

31. Le Crot : Home run from bottom of Haut Forts back to Prodains car park. Gets busy late in day and can get hard and icy.

32. Combe de Machon : Steep at top, usually moguls in the middle. Can get back up the Machon Chair or continue down to Prodains or Verare chair.

33. Arête des Intrets : The spot to be on a powder day. So many options, so little time.

34. Crozats : Great black run. The off-piste on both sides of the Machon chair is great, but can be thin and rocky on skiers left. Take care.

35. Coupe du Monde : Another sweet black run. Definitely the most challenging pisted area in Avoriaz.

36. Gouilles Rouges : Nice short red through the trees. Really only links Verare and Crot chairs.

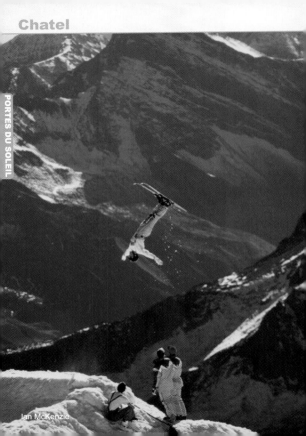

Chatel

Ian McKenzie

by Raz Cobbing

Freestyle World Championship Silver medallist 1993. World Cup medallist & Double Olympian Tignes 1992 and Lillehammer 1994. Five times British Champion

As a professional freestyle skier I was lucky enough to visit all the major French ski areas over the years and of these Chatel has provided me with some of my fondest memories. I performed here as a member of the Red Ski Team and also competed on the slopes of Chatel for the British Championships. I've returned to this beautiful spot many times since and have never failed to have a good time both on and off snow.

The village of **Chatel** has existed as a farming community and local market town since long before skiing was ever thought and there's still a lot of farming going on here today. The traditional charm of its wooden chalets and its situation in the beautiful light-filled Abondance valley are a large part of what make this area a favourite.

You can head straight up the mountain to **Super Chatel** from town and play around there, or using *Chalet Neuf* chairlift, head onwards to the Swiss resort of *Morgins* and *Champoussin*, via *Porte du Culet*.

A short bus ride down the valley takes you to *Petit Chalet* with access to the small Swiss resort of *Torgon*, and up the valley to *Villopeyron* opens up *Linga mountain area*. Further on to *Pré-la-Joux* gives you access to more skiing on both sides of the valley - and a portal to *Avoriaz*.

Chatel has fantastic family facilities and is probably not the spot for the extreme couloir boarder or the all-day charger amongst us. However, it is a great place if you have a car becasue it is so close to so much varied skiing in PDS region and being so close to *Geneva*, one of the better potential weekender resorts.

Chatel

Of course, you're here to ski and ride, and **Chatel** certainly doesn't come up short on opportunity in this department. Being part of the *Portes du Soleil region*, **Chatel** is linked to 13 other resorts with access to some 400 miles of pistes, one of the largest interlinked areas in the world. The old cliché of 'never having to ski the same run twice' is actually well applied to Chatel and a trip here is the perfect opportunity to rack up the mileage exploring valley after valley of classic Alpine terrain.

For those with a lot of skiing under their belts and looking for a bit of adventure I would suggest a foray into the backcountry of Chatel. A day trip to the summit of either of the two highest peaks in the area *Mont de Grange* (alt. 2,432m) or *Cornettes du Bise* (alt 2432m) is an awesome introduction to ski touring.

Amazing views of *Lake Geneva* to the north and the *Mont Blanc* range to the southwest, plus fields of untracked snow on the long decent make the effort well worthwhile. Of course you'll need a guide and the right equipment, including avalanche safety gear but these can be found via the **Office du Tourisme.**

If hucking air is more your bag then **Chatel** boasts a nice terrain park featuring a range of big and small hits marked out in colour grades to indicate difficulty. There's also a nice halfpipe coming up at about 120m in length and a recent addition is the 800m long boardercross course which is well worth spending a bit of time on.

I've always found the locals in this valley to be friendly and full of alpine charm. You can't leave without sampling some of the local fare particularly the Abondance cheese and the Crepy white wine which make a fine combination.

Why not head down to Chatel's smaller neighbour *Chappelle D'Abondance* (via Torgon on the Swiss side of the border) and drop into to any of the cracking little traditional eateries for that one lazy afternoon soaking in the beauty of the Alps that every ski trip should have.

Après

There are not exactly stack of choices to eat in town. If it is traditional you're after, try the pretty chalet restaurants of **Le Fiacre** or **Le Pierrier**. The former is good value, the latter has a bit more haute cuisine about it.

There's always the chalet **Le Tremplin** on the way to *Linga* or for the real deal, go to the very old, classically chocolate-box style **Vieux Four.**

If you're just after a quick snack, the creperie **Rendez vous le Gourmands** does the job, or grab a reasonably-priced pizza or bowl of pasta at the pizzeria **La Flambée.**

The centre of the action for the cool apres crowd is either the **Isba, The Pélican** (conveniently located at the base of the *Super Chatel Gondola*) or **The Tunnel Bar** in the middle of town - you can't miss them!

For later evening pubbing/clubbing carnage, the main spot is the **Avalanche Bar** for all the usual activities.

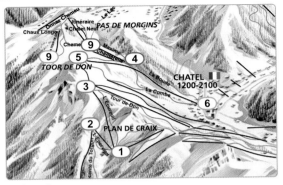

PORTES DU SOLEIL

Barbossine

1. **L'Epervier, l'Ecureuil :** Uncrowded and if there's snow, unbeatable runs through trees. Nice, wide and steep - perfect intermediate. Unreliable snow (and also no artificial snow-making).

2. **Descente du Torgon :** This run leads you to the Swiss resort of Torgon where a good day can be had skiing (if the snow conditions allow - by March this area is not worth visiting).

3. **Tour de Don :** Principally a link run between Super Chatel and Barbossine but decent nonetheless.

Super-Chatel

4. **Maxine, Chanterelle :** Most challenging green in Chatel. Little to separate it from the neighbouring Chanterelle blue run. Both runs are good to learn on.

5. **La Combe :** Good intermediates red. Wide pistes with show-off factor below Conche chairlift! Beware top of Le Crêt chairlift as it is narrow and often icy.

6. Le Boude : This winding blue through the trees is an easier alternative to La Combe. It is easy to miss the start of the run as it is obscured by a restaurant.

7. Chalet Neuf, Bellevue : Excellent slopes for beginners/early intermediates to feel at ease on skis/boards. Long, wide and gentle with good snow.

8. Le Corbeau : This is the shortest black known to man! Good views of the Abondance Valley from the top as long as you can hold on to the rather violent drag lift!

9. Chemeu, Itinéraire Chalet Neuf : Two interesting, short runs that twist and turn through the trees reaching Chalet Neuf. No snow cannons so pretty red in poor snow conditions.

10. Chermillon: From the top of Morclan you can ski reds all the way into Chatel itself, Chermillion is often quiet and opens up towards during the lower half. Not the highest piste-basher priority so can be one of the more challenging reds in Super Chatel.

13. Chermillon Piste Mauve : Known as the 'Milka' piste, its gentle incline makes it a good run for those with small children and if you're lucky you may receive some free chocolate from the Milka cow!

14. Onnaz : This run is an ok challenge for intermediates although it is too short to really enjoy.

15. Ombrieux : Like Omnaz it is an ok run for more experienced skiers but it finishes before you really get going.

16. Le Lac : Link between Chalet Neuf and the rest of Chalet Neuf, expect to do some poling by the lake as it is as flat as a pancake.

17. Barbossine : Surprisingly challenging (even the expert skier) given the rest of the skiing in Super Chatel, the first part is very steep. Forget it in bad conditions. Note it is a long lift ride away from town.

18. Onnaz-Chermeu : One of the best early intermediate runs in Torgon/Barbossine although piste marking can be erratic!

19. Panoramique, Chaux Longe : Links connecting Torgon/ Barbossine with Super Chatel. When the cloud descends navigation can be a real problem.

PORTES DU SOLEIL

Chatel - Secteur Linga

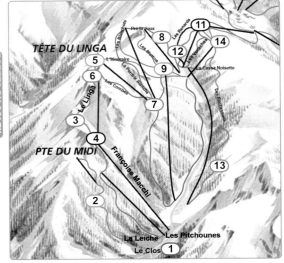

TÊTE DU LINGA

Les Blanchots

Pré la Joux

Les Renards

8

11

12

14

Les Biollaz

Les Vonnes

La Casse Noisette

Des Rochassons

L'Itinéraire

La Perdrix Blanche

5

6

9

7

Les Combes

Le Linga

3

PTE DU MIDI

4

Françoise Macchi

13

2

La Leiche

Les Pitchounes

Le Clos

1

1. Le Clos : A run in isolation to the rest of the mountain - handy for parents with small children.

2. La Leiche : These runs provide an easier alternative to Le Linga from mid-station, these are pleasant runs that pass through wooded sections of Linga, there is now a new piste that connects Linga with Lake Vonnes

3. Le Linga : Awesome views of Chatel from the top where there is often the best snow in the area for good intermediates. Very long and a vertical descent of approx 1km. Exhilarating for you and your thighs!

4. Francoise Macchi : This black is one of the easier in Chatel, ideal for those intermediates wishing to gain the kudos of skiing a black. Often deserted but the full length is rarely open.

5. **L'Itinéraire :** Good early intermediate run - only one to connect Linga with Plain Dranse without having to get a lift. Needs a lot of snow before skiable. A lovely old twisting and turning run.

6. **Les Combes :** Beware a couple of narrow 'pinch points' though. Gets rocky so if snow cover is poor try elsewhere if you value your skis.

7. **La Perdrix Blanche :** The definitive intermediate run. A real 'gem' within the Linga ski area. Isolated, undulating and uncrowded. Needs a lot of snow to make it skiable and so it often doesn't open until late January.

8. **Pré la Joux :** Alternative route back to the car park through the trees but only skiable in good snow conditions when it becomes a mogul field as the piste bashers rarely venture onto it. Good in bad light.

9. **Les Blanchots, Les Blattins :** For beginners who have progressed from the greens by the car park these two runs represent the logical next step.

Turn right at the the top of Les Blanchots for the popular off-piste area **Donkeys** *- gentle, full of small gullies and jumps which make it a perfect place for your first off-piste attempt.*

10. **Les Rennes :** This run, in the shade of Pointe de Chesey, has two (luckily avoidable) steeper sections that can get icy.

Turn right as soon as you leave the Chaux des Rosses chairlift and go under the rope you stumble upon an off-piste area known as the **Keyhole***. Take a guide.*

11. Les Renards : Long mogul field for the expert with it being on a par with the infamous 'Swiss Wall'. As you ride the Chaux-des-Roses lift over the top you'll see why we say for experts!

12. **Les Voraches :** An alternative to the busy La Casse-Noisette although like Rhododendrums the top part is particularly steep.

13. **Les Rochassons :** This 'motorway' run is a fantastic moral booster at the end of the day back into the car park.

14. **La Casse-Noisette :** The easiest and most accessible red when returning from Avoriaz. Watch out for the narrow top section.

PORTES DU SOLEIL

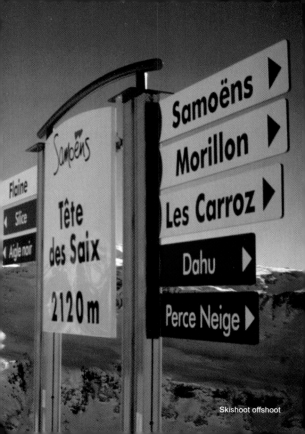

Skishoot offshoot

Introduction

The **Grand Massif** is a mixture of old and new; traditional French and definitely-not-so-traditional French style; Little old ski villages such as Sixt, and big (soon to get bigger) purpose-built resorts ie. **Flaine**. All in all though, this region has an awful lot to offer.

The area has received negative publicity in the past, as it starts at only 700-720m above sea level at **Morillon** and **Samoëns** respectively, and is often seen as a 'low' resort. There is also a lot of chat about the uncoolness of **Flaine**: perched on the cliff-tops, looking like *Peckham-les-Alpes*; the only time it looks good up there is in a white-out; you've heard them all before!

However, to the smart snow traveller, think about this as a seller: closer to *Geneva* airport than *Portes du Soleil*; lots of very low-cost airlines; weekends easy - all of a sudden we get a new picture. Leave UK at 4pm on Friday; arrive *Flaine* just after 7pm local time. Too easy! And **Grand Massif** is not all **Flaine**. Check out the lovely **Sixt, Samoëns** and **Les Carroz**, the sharpest contrast to Flaine you can imagine.

Just ask **Martin Bell**, *4 times Olympian* between 1984-94, 5 times *World Championship* competitor and the highest-placed British downhiller in history. He's got a thing or two to say about this area...

The good
- 60 mins drive to *Geneva airport.*
- **Cascades** : 14km of blue run.
- Great value and lots of good skiing.

The not-so-good
- The wind can force lifts to shut too often.
- Not exactly the *Alps* party capital.
- Potential for lack of snow.

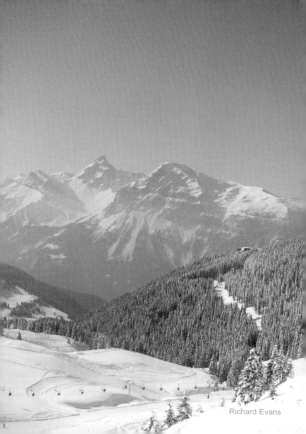
Richard Evans

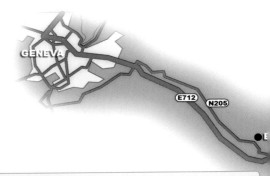

GRAND MASSIF

Getting There

Fly: from UK to *Geneva Airport* via BA, Easyjet, flybe or Bmibaby. **Grand Massif** is 70km from *Geneva* (approx 1-1.25 hours).

Drive: take the **E25 A40** Motorway to *Bonneville* and onto *Cluses*. Turn off at **J19** onto the **N205**, then take the **D106** for approx 25km up to *Flaine* (snow chains are recommended). *Flaine* is car-free so you need to park down in *Les Carroz*. This can be arranged for approx €50 per week. For *Samoens*, *Sixt* and *Morrillon*, take **N25** north to *Taninges* then onto **D907**.

Coaches: run regularly from *Geneva Airport* - book online at www.altibus.com, as well as taxis.

Train: The nearest rail station is *Cluses* (approx 30km). Easy transfer by coach or taxi to *Flaine*.

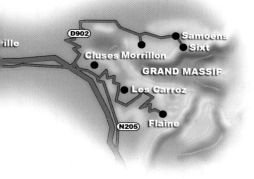

ille

D902

Samoens

Sixt

Cluses Morrillon

GRAND MASSIF

Les Carroz

N205 Flaine

Overview

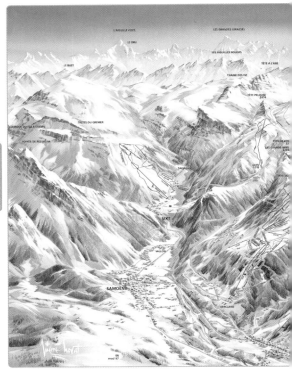

L'AIGUILLE VERTE
LES GRANDES JURASSES
LE DRU
LES AIGUILLES ROUGES
TÊTE A L'ÂNE
LE BUET
CHAINE DES FIZ
TÊTE PELOUSE
2474
CROIX DU FER A CHEVAL
CRÊTES DU GRENIER
TÊTE DE MER
POINTE DE PESSALLNA
LES GRANDS VANS
2104
SAGINAY
SIXT
VALLON
SAMOËNS
VERCLAND

www.snowfinder.co.uk

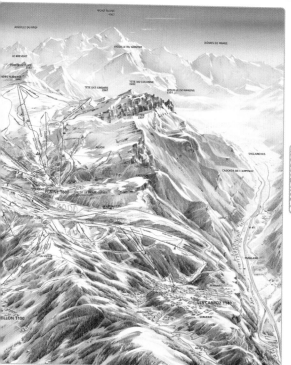

MONT BLANC 4807

AIGUILLE DU MIDI

DÔMES DE MIAGE

LE BRÉVENT

AIGUILLE DU GOÛTER

POINTE DE PLATÉ

IDES FLAINES

TÊTE DES LINDARS 2561

TÊTE DU COLONNEY 2692

AIGUILLE DE VARENS 2551

LE CROIX DE FER 2337

AEDON

SALLANCHES

CASCADE DE L'ARPENAZ

FLAINE 1600

CDE DE LA VEILLE CARNE

LA VEILLE

MAGLAND

A 40

PENNART

LES CARROZ 1140

ILLON 1100

ARACHE

SERVERE

ARU

Tourist Office

Flaine	+ 33 (0)4 50 90 80 01
Les Carroz	+ 33 (0)4 50 90 00 42
Samoëns	+ 33 (0)4 50 34 40 28
Morillon	+ 33 (0)4 50 90 15 76

Main office

Galerie Marchande Forum
74300 Flaine
France

General email

welcome@flaine.com

Resort websites/email

www.flaine.com
www.lescarroz.com
www.samoens.com
www.ot-morillon.fr

Grand Massif lift pass

Discounts available for seniors, under 16, season passes.

Half day	€29.50
Day	€33.50
6 Day	€168

Insurance

Carré Neige	€2.50 per day

GRAND MASSIF

Martin Bell

Flaine

Of course, everyone has an extremist opinion on Flaine. The uncompromisingly rectangular high-rise architecture, the antithesis of a quaint Alpine village, means that a lot of people rule it off their lists, but I would definitely consider it for a family holiday. It is close, both to Geneva Airport and the cross-channel ports, the "village" is compact and car-free, i.e. relatively safe for kids, and the slopes leading back home at the end of the day are not too scary. The nightlife is not the wildest you'll find, but there's usually something going on at the White Grouse. This genuine pub is owned by a traditional British brewing family, one of whom represented Britain in ski-racing alongside myself. I found that the standard of food, beers and music there was always top-notch – except on karaoke night, when the music is a bit more hit-and-miss!

If you absolutely have to stay in a cute "chocolate box" chalet, then you have the option of **Le Hameau de Flaine**, a collection of pretty Norwegian-designed houses about a mile from the "village" centre. In my racing days, I was fortunate enough to be accommodated in one of these chalets by my sponsor, *Bladon Lines*. The stay was very pleasant but I must warn you that the walls tend to be fairly thin, so choose your fellow guests carefully if you're planning on getting any sleep!

Flaine is linked to two other bases, **Les Carroz** and **Samoëns**, both of which are traditional Alpine villages. If you really can't abide concrete, you could stay in either of those, but beware: both are substantially lower than Flaine itself, and the snow

quality on the connections could be unreliable in early or late season. **Flaine** itself is at 1600m, and the three times that I skied there, in early April, it was always possible to ski down to the base. Mind you, that was in the early 90s, and in these days of global warming, 1600m no longer guarantees you snow all season. But the upper slopes are high enough, although there is no glacier.

By Martin Bell

Best British Olympic Downhill result:
8th Calgary 1988.
Eight top 10 results on World Cup Downhill circuit.

The whole linked-up area is called **Le Grand Massif**, and is pretty big, nearly as extensive as *Val d'Isère / Tignes*, but unlike those resorts it doesn't have the reputation of an *off-piste Mecca*. Often, however, it is precisely this kind of low-key resort where you can find the best powder, because there aren't hundreds of powder-hound ski bums tracking it all out in two hours after each storm.

Flaine's concrete buildings were supposedly designed to blend in with the nearby limestone cliffs, and from a distance they do. Up close, the "village" simply feels like a stark concrete jungle. But if you can turn a blind eye to the aesthetics, and focus on the skiing, **Flaine** is not a bad choice for a convenient and hassle-free family ski trip.

GRAND MASSIF

Adrian Myers

Best off-piste
Gers bowl accessed from *Styx* is fantastic playground offering endless off piste skiing especially when just opens after a fresh snow fall. Often closed and when it is it is for a reason – don't go! Warning: watch out for off piste skiing in the Flaine bowl – it is made up of chalk and therefore has lots of holes that can be covered by snow – always consult an expert or guide.

Best black run
Corbalanches - access from top of *Gentians* lift an old and slow 2 man chair! A black that seems to be in either great or crap condition! When it's great it's fabulous - powder or bumps when its bad it's a nightmare, icy and chopped moguls!

Best red run
Belle Place at *Tête de Balme in Le Tour*. Fantastic red I never get bored of, leading onto the wonderful blue run, *Les Esserts*, for powder tree-skiing extraordinaire!

Best blue
The super long **Index** run in *Flégère* that has enough challenge to keep the good skiers happy and is exciting for the not-so experienced too. A couple of stetches you have to walk/pole but worth it for the scenery and ends up in Sixt a stunning little village where you get the bus back to Samoens or Morillon.

Best green
The Marvel has to be the best green run ever! Gently twists through the woods down to *Morillon*. Look out for the signs of local animals, birds and plants – great for kids of all ages!

Flaine

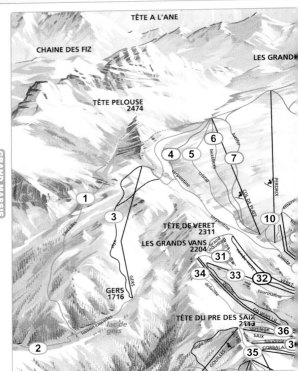

TÊTE A L'ANE

CHAINE DES FIZ

LES GRAND

TÊTE PELOUSE
2474

LES GRAND

4 5 6 7

1

3

COL DE PLATÉ

PERDRIX

10

TÊTE DE VERET
2311

LES GRANDS VANS
2204

31

34 33 32

VERET

GERS
1716

liaison Cascades

lac de
gers

TÊTE DU PRE DES SAIX
2113

36

2

35

74 www.snowfinder.co.uk

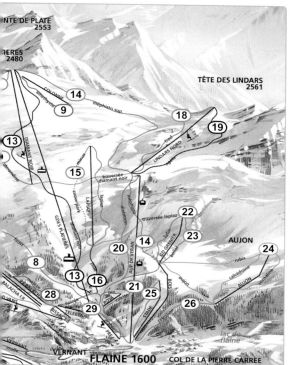

PTE DE PLATE
2553

IÈRES
2480

TÊTE DES LINDARS
2561

COLONNEY

amethyste

mephisto sup

14

9

DIAMANT NOIR

13

amandine

15

traversée
diamant noir

lapiaz

snow park

LAPIAZ

diamant noir

GDES PLATIÈRES

18

19

fred

LINDARS NORD

gentiane

mephisto

traversée lapiaz

lucior

DES GRENIERS

aster

22

23

AUJON

rubis

24

cornaline

AUJON

calcédoine

8

20

14

13

16

21

25

26

BOIS

STADE

lupin

ALP DE VÉRAN

BALACHA I.II

28

O VANOE

BESSA

29

TÉLÉBENNE

DESSA

SERPE

AZALEE

ROSEE

BOIS GRENIER

PRO

VERNANT

orolle

VERNANT

FLAINE 1600

COL DE LA PIERRE CARRÉE

lac de
flaine

Flaine

1. Cascades : 14km run! Stunning scenery with frozen waterfalls. Take a picnic & take your time. Only way back is a bus to Samoëns or Morillon so don't leave it too late. Only downside is a bit of poling. Wow!

2. Zeolite : Long flatish track to access Gers bowl.

3. Styx : Fabulous black run for expert skiers/boarders, giving access to a load of off-piste, cutting through the wonderful Gers bowl. Often unpisted. Only way back is a long, steep drag.

4. Serpentine : Easy, wide and sweeping red run.

5. Crystal : Wide cruisey blue - a great confidence builder for those beginners trying blues.

6. Belzébuth : An easy sweeping blue run. Changes into a red half way down so keep an eye out for that and keep right if you don't want a red run.

7. Lucifer : Good wide, sweeping intermediate red run great for long wide GS turns.

8. Faust : Long run all the way from the top of Flaine back to the bottom. Watch out for the increase in steepness at the bottom as near the trees.

9. Almandine : Short red to get to the Diamant Noir lift from Faust.

10. Emeraude : Open blue to cut back across to Col de Plate and Perdrix chairs.

11. Topaze : Intermediate red run to the trickier bottom section of Faust.

12. Axinite : Very easy blue through the trees to return to the village.

13. Diamant Noir : Challenging black run with a steep and narrow section near the top that often gets bumped up, If in doubt, check it from Diamant Noir chair. Easier section at the bottom.

14. Mephisto : There is a flatish section near the top just after it swings to the right, so keep your speed up. It gets a bit narrow there so beware.

15. Minos, Lapiaz : Fast open reds for intermediate posing!

16. Jade : Short linking run.

17. Tête de Lindars : Straightforward blue.

18. Fred : Highest point in Flaine - often not open until later in the season. An easy red, great for getting your confidence up if you are used to blues.

19. Agate : Fun black run. Steep in parts. Keep to the piste unless you know where you are going or have a guide - a few small cliffs etc.

20. Diablotin : Narrower twisty red heading down through the trees back into Flaine. Good in bad light.

21. Calcite : Tight red back into the village.

22. Lutin : This is the jampark - Flaine's skier and boarder park - plenty of jumps to play on and high-level pose potential.

23. Bélial : If you don't fancy the jumps take a right at the top and ski down with the drag on your right and watch those like to take to the air!

24. Rubis, Calcedoine, Cornaline, Aujon : As far as you can get on this side of Flaine - easy open blue run playground.

25. Stade : The race run, often closed with local races.

26. Célestine : A fun and fast but narrow red run between the trees - watch for a couple of hair pins.

27. Olivine : Wide open blue - take this to keep to the right if you are heading back out of Flaine to Carroz or the other villages.

28. Mélèze : Beginners run accessed by a short drag.

29. Azurite : Narrow red with couple of sharp bends back into the bottom.

30. Baudroit : Link from bottom of drags to Grand Vans chair.

31. Grand Chaudron : At the top (great views) turn left and traverse across the top of the black run to access the red.

32. Combe de Veret : Often closed - this is a great run when open and has off-piste bits on the side to play in. Acessed by a steep drag that has a very hard jerky pull at the start! Great views from the top.

33. Tourmaline : Very busy as it is the main link from into Flaine.

34. Dolomie : Has a steeper section is at the very bottom otherwise easy run - often bumps just off to the left of the piste at the top.

35. Silice : Path to avoid the challenging Sortilege and easy way to access Vernant and onto Flaine for intermediates.

36. Sortilège : Steepish red that has constant gradient. Often has bumps but is pretty inconsistent since it often loses snow quickly and can get icy.

Les Carroz, Sixt & Samoëns

These resorts have to be the yang to Flaine's yin. There could not be a more bi-polar region in the Alps. Sorry to harp on about Flaine, but it's too easy to make jokes about architects, tetrahydracanabanol usage, Doctor Who re-runs, blah blah blah. Even the more attractive Hameau is like Heidi designed by Japanese toy manufacturers.

In reality it is fun to have a knock at **Flaine**, but it is not really that unattractive and we don't really mind too much anyway, do we?

Anyway, **Les Carroz** is the real deal. Authentic, attractive, stylish and cool. Miniscule lift queues (not always but very often), easy access to *Flaine* and *Samoëns* in particular.

Samoëns is equally charming. In fact so charming that **Samoëns** is the only ski resort to be classified as an historic monument by the *Caisse des Monuments Historiques*. It is a very popular resort with French families but is good for all sorts - there's a SnowPark and access to the rest of *Grand Massif* via the spanking *Grand Massif Express*. There's also a free bus up the valley (or back down the valley) to *Sixt* to boot....

Sixt is a tiny, hidden gem of a Savoyarde hamlet. No trip to this area would be worth thinking about without a trip to **Sixt** for two reasons. First, it's a very nice place to sip vin chaud, coffee etc. Second, however, is that it is at the bottom of the *Cacades* run - a full 14km worth of blue run from the top of *Les Grandes Platières* all the way down. This is one of the few genuinely epic blue runs you'll find!

Finally, **Morrillon** is believe it or not, more of the same. Tiny, the lowest of the resorts at 1100 metres (40 metres lower than *Les Carroz*!), but with 7 lifts to get you into the action, **Morrillon** is definitely not to be discounted. Oh, and just like *Samoëns*, incredibly close to the *Portes du Soleil* if you fancy a change!

Après

Within *Flaine* itself, the 2 main party bars are the **White Grouse** and **Flying Dutchman** - this is definitely where you'll find the Brits who like a bit of home-from-home!

Several good quality places serving usual fondues, pizzas etc personal favourites are **L'Agora** for pizzas, **Crêperie Bretonne** for…. er…. crêpes!! **Le Poirer** for pizzas and not to be missed for carnivores a local speciality dish *"La Potence"*, **La Fringale** for late night snacks (chips, kebabs pizzas etc).

Good old Savoyarde food favourites are served up at **Perdrix Noire** in *Flaine Foret* (the bar of choice for saisoniers) or **Chez Daniel** in *Flaine Forum*, and the **Neve** gets a great recommendation.

Up the mountain, options are slightly more limited. Try **Le Bissac** just near the *Balacha lift* if you fancy a vin chaud - gets pretty busy though.

Alternatively, **Les Chalets du Michet** comes well recommended for good food with small queues, and for the panoramic view of *Mont Blanc* across to *Les Grandes Jorasses* range. Try **Le Desert Blanc** right up the top of the main gondola.

If you're after bars, in *Les Carroz* it is centred round the main square in **Le Marlow, Le Pointe Noir** and **Carpe Diem** – although there are other smaller bars around. When busy they tend to stay open 'til about 2am but can get quiet in the off season.

One nightclub **Club 74** (after the post code 74300!) stays open 'til the early hours, it tends to be only open on Thursday, Friday & Saturdays and girls get in free! It has a cage to dance in and there is a big fish tank on the side of the dance floor – bizarre! Locals will come up from the valley as it's apparently the best club in the area so is often busy with locals as well as holiday makers.

GRAND MASSIF

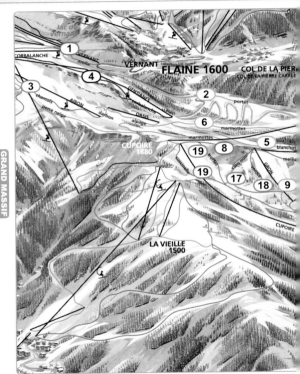

GRAND MASSIF

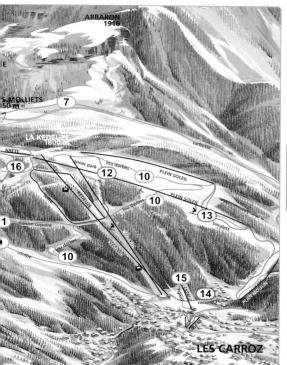

ARBARON
1916

S.MOLLIETS
50 m

7

LA KÉDEUZE
1800 m

ARÊTE

16

snow park

lou darbes

PLEIN SOLEIL

12

10

10

PLEIN SOLEIL

13

1

liaison cupoire

10

10

15

14

LES CARROZ

Les Carroz

Les Carroz - Vernant

1. Arolle : Just a green track to access the car park at the bottom of Vernant lift.

2. Portet : The first bit is quite flat so keep your speed up to get you to a steeper winding section through the trees to the bottom of the Molliets lift. Cruisey & pretty.

Les Carroz - Les Molliets

3. Chamois : Accessed from the Airon chairlift, this is a steepish red that can get a bit bare at times. Watch out for the rocks.

4. Corbalanches : Accessed via the ancient 2 man chair from Gentians chairlift - a black that seems to be in either great or terrible condition! When its great it is fabulous - powder or bumps. When its bad it's a nightmare of icy and chopped moguls!

5. Blanchot : Top is a flatish track from bottom of Oasis drag. It is a cruisey blue through the trees down to Molliets chair with a steeper section right at the bottom which nervous intemediates won't like.

6. Marmottes : Just a track through the trees to access Airon, Gentians and Molliets.

7. Sarbotte : Long blue to get from the bottom of Molliets chair if it is closed or has a massive queue. Loads of poling on the flat so not recommended (definitely not on a board). Very pretty though!

8. Molliachets : Flat track back to the top on the way back to Carroz. Tuck from top of Molliets lift to avoid having to walk more than you have to! After that an easy green serviced by the Crètes drag - more often than not full of kids ski schools.

9. Combe : A gentle pretty blue through the trees back into the village.

10. Lou Darbes : The top of this is a fabulous wide open blue run suitable for all levels - turns into a track when turning right under the Plein Soleil chair at the top of the Timalets.

11. Raccord Cupoire : Track to link to bottom of Gron.

12. Pimprenelle : Short red that is often unpisted and pops out on to a track - steepish for intermediates but not long.

13. Timalets : The main run back into Les Carroz - holds the snow really well as is in the shade for most of the day - can get a little icy and not good for beginners.

14. Raccord : A track to take you back to the village from the bottom of the Timalet.

15. Figaro : Maybe a blue but a bit steeper than you'd expect - not suitable for beginners though there is a "track" across it to get down from the télécabine.

Les Carroz - Gron

This is a great play area - good reds, lots of trees in poor visibility and endless off-piste runs just off the sides.

16. Rhodos, Zorta : good quality intermediate reds.

17. Cupoire : Nice, easy red piste through trees, often quiet. Great for carving big GS turns.

18. Véroce : Turn right of the top of Gron and then right again down a track to access this - drops off to the left under the Gron chair - a great red often not pisted so superb when there is powder if you are learning and often has bumps on it at other times - can get quite big & chopped moguls at the bottom.

19. Coccinelle, Truffe : Top part is in a largish bowl and can be tricky but then moves into wide piste through the trees.

GRAND MASSIF

Richard Evans

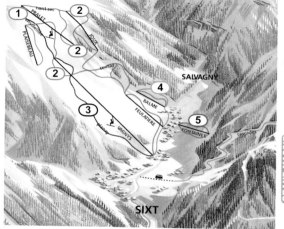

1. Ensoleillée : Pretty straightforward black. A good option for people making the step up from reds.

2. Joux, Nant Sec, Coutaz : Set of basic red runs for those moving up from blues.

3. Planay : Good pisted black run. Alot of the run is more red than black it seems.

4. Salvagny, Balme, Feulatière : Open, cruisy blue runs for those taking it easy - good option to warm down after Cascades.

5. Fontaine, La Combe : Easy greens to take you back to where the bus leaves for Samoens and Morillon.

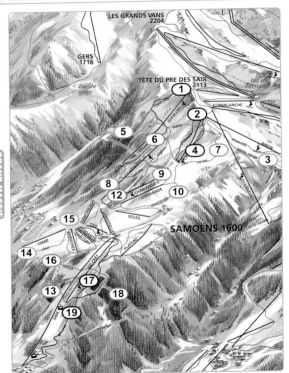

LES GRANDS VANS
2204

GERS
1716

lac de
gers

TÊTE DU PRE DES SAIX
2113

lac de
vernant

CORBALANCHE

SAMOËNS 1600

Samoëns - Têtes des Saix

1. Aigle Noir : Challenging black that often has bumps on it.

2. Chamois : Like above but probably not as bad as it looks from the top!

3. Perce Neige : The way back to Carroz and Morillon - it is long with two flat sections. Usually busy especially at the end of the day, so get your speed up, get in a tuck and see how far you can get - otherwise, you're walking!

4. Marmottes : The top is often bumped up - sometimes not as good as you think they will be as you can't see them from the top of the run. The bottom section after crossing the Dahu is steeper.

5. Dahu : Blue path to avoid the trickier and more challenging slopes here.

6. Aiglon : Easy linking blue to avoid the blacks around it.

7. Corne : Excellent fun at the top. Turns into a path at the bottom.

8. Retour Chariande : An extension of Dahu.

9. Gouilles : Narrow path that goes from the top of Chariande chairs past the **Snowpark** to the bottom of Gouille chair.

10. Chariande : Fast good red. It is a bit steeper and a bit more challenging than neighbouring Combe.

11. Combe : Fast and great for those of you who secretly yearn after a GS title.

12. Vérosse : The top is fun and wide the bottom is just a path to link round to Samoëns plateau and lifts.

13. Stade : The race track. Probably no need to say more than that.

14. Char : Open beginners type slope accessed by drag lift giving access to car parks.

15. Damoiseaux, Babuches : Short uninspiring blues!

16. Aouia : The top section of Vélarge (see below).

17. Inter : Often quiet, this black can get icy but with good snow is well worth it for good advanced and expert skiers and boarders.

18. Forry, Vélarge : Really good intermediate fun runs - Vélarge is the easy way down to Vercland.

18. Grand Crêt : Getting lower and again sometimes patchy snow but in good snow often empty since the new Samoëns télécabine opened.

GRAND MASSIF

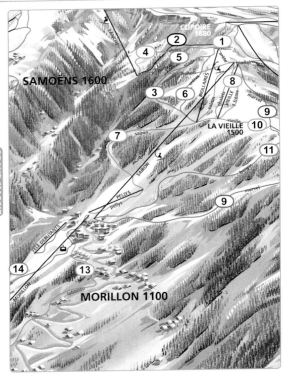

www.snowfinder.co.uk

1. **L'Arête** : A narrowish path that runs along the top of a ridge to access Morillon from Carroz.

1. Lanche : This black seems to have the best snow anywhere but is prone to slide - why do you think its called what it is!! Often closed, has great powder!! Makes sure the Lanche chair is running before you do this otherwise it's a long walk out!

3. **Stade** : Often closed with local races but when it's not it runs down through the trees and is often quiet and in good condition ready for the next race!

4. **Chars** : An easy blue to access the Lanche lift and then over to Samoëns and onto Flaine.

5. **Paccoty** : Open red to the bottom of Lanche chair - better skiers can take this run and meet their friends who go round the Chars.

6. **Crète** : An easy wide red, good for the step-up from blues.

7. **Sairon** : Wide open confidence builder.

8. **Chalets, 7 Frères** : 2 short easy blue runs for everyone.

9. **Marvel** : Probably the world's best green run!! Beautiful winding run through the trees suitable for beginners and even experts will love it. Watch out for the signs on the trees of local wildlife and plants - especially the mysterious Dachu!

10. **Vielle** : Standard short blue.

11. **Bergrin** : Standard short red!

12. **Charnia** : Can often be quiet and empty - standard blue run down through trees running into...

13. **Laberieu** : This lovely easy blue through the trees all the way to Morillon village - its not often open as it goes down to 700m but when it is worth it - stunning views over the valley.

14. **Doina** : Yet another nice, easy red through the trees all the way to Morillon village (if open, great views down as Laberieu).

GRAND MASSIF

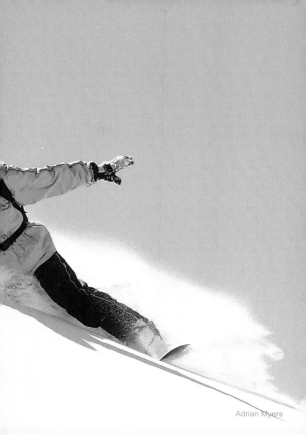

Adrian Myers

La Clusaz

Introduction

La Clusaz is probably not the first resort on the tips of the tongues of the average Brit skier or snowboarder on their annual powder crusade to the French Alps (or indeed for that matter, the beginners, weekenders, seasonaires and ski bums). That said, this is never necessarily a bad thing, and in **La Clusaz**'s case, is definitely never necessarily a bad thing! It is a surprisingly big region stretching from *Massif de Beuregard* nearest to the town on the *Annecy* side at 1690 metres, all the way due East to the *Massif de Balme* at 2600 metres, part of the *Chaine des Aravis* that separate **La Clusaz** from its near neighbour, *Megève*.

The resort is very family oriented with a wealth of restaurants, bars and facilities and all the usual trimmings you'd expect such as free buses throughout the resort and very good childcare facilities.

The resort is actually only 50km from *Geneva airport* make this a really quite interesting option for those of you who would previously not had **La Clusaz** on the tips of your tongues. And finally, a good little lead-in to the skier who helped us with his insight into La Clusaz, it is the home resort of the legendary **Edgar Grospiron**, *Olympic gold medalist mogul skier at Albertville* who when asked if he followed a special diet while training, answered, "Yes: one week red wine and the next week white wine." Nuff said!

The good
- 50 kms / 1 hour drive to *Geneva airport*.
- **Edgar Grospiron**'s home town.
- Very family oriented.

The not-so-good
- Not exactly the extreme capital of the universe.
- Potential for lack of snow.
- Very family oriented.

Skishoot offshoot

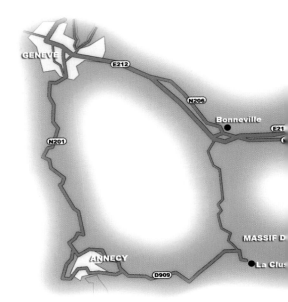

GENEVE

E212

N206

Bonneville

E21

N201

MASSIF D

ANNECY

D909

La Clus

www.snowfinder.co.uk

Getting There

Fly: from UK to *Geneva Airport* via BA, Easyjet, flybe or Bmibaby.
La Clusaz is 50km from *Geneva* (approx 1 hour).

Drive: 2 options to get to **Annecy**: take the **E25** then the **E712**
Motorway just after **J15** to *Annecy* (or **N201** South from *Geneva* and
join **E712** at **J18**). At **J17** take **D16** then **D909** to *La Clusaz*. Or turn
off **E25** at **J16**, take **D12** direct (can be bad in the snow).

Coaches: run regularly from *Geneva Airport* - book online at
www.altibus.com, as well as taxis.

Train: The nearest rail station is *Annecy* (approx 20km). Easy
transfer by coach or taxi to *La Clusaz*.

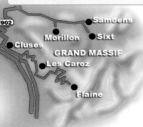

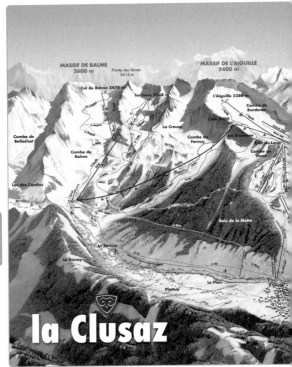

MASSIF DE BALME
2600 m

Pointe des Verres
2616 m

MASSIF DE L'AIGUILLE
2400 m

Col de Balme 2470 m

Torchère 2548 m

L'Aiguille 2380 m

Combe de Borderan

Côte 2000

Combe de
Bellachat

La Creuse

Combe du
Fernuy

Les Etaceres

Combe de
Balme

Crêt du Loup

Combe du
Vorat

Lac des Confins

Bois de la Motte

Le Fernuy

Le Danay

Le Plan

Plattuy

la Clusaz

LA CLUSAZ

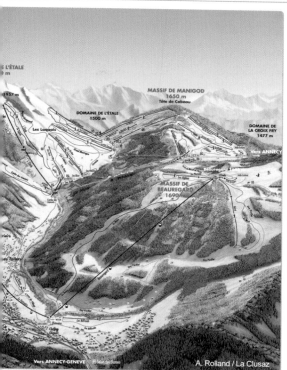

L'ÉTALE
0 m

1957 m

DOMAINE DE L'ÉTALE
1500 m

MASSIF DE MANIGOD
1650 m
Tête de Cabeau

DOMAINE DE
LA CROIX FRY
1477 m

Les Laquais

Vers ANNECY

Beauregard

MASSIF DE
BEAUREGARD
1690 m

riers

Les Tollers

Vers ANNECY-GENÈVE

A. Rolland / La Clusaz

LA CLUSAZ

Tourist Office

La Clusaz + 33 (0)4 50 32 65 00

Main office

161 Place de l'église
74220 La Clusaz
France

General email

infos@laclusaz.com

Resort websites/email

www.laclusaz.com

La Clusaz lift pass

Discounts available for seniors, children under 16, season passes. Also Aravis area pass entitles access to all the Annecy region areas for an extra €10-15 per week. Book online at www.skipasslaclusaz.com

Half day	€21.50
Day	€27
6 Day	€140.50

Insurance

Aravis Securite €2.70 per day

LA CLUSAZ

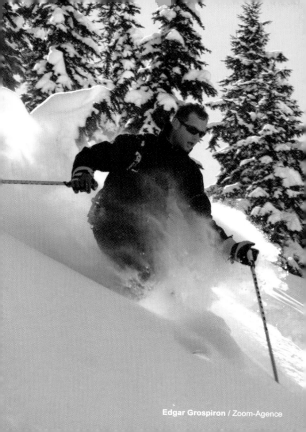
Edgar Grospiron / Zoom-Agence

La Clusaz *By Edgar Grospiron*

La Clusaz is a classic French resort known for its fantastic skiing and its legendary partying afterwards!

There are many options, all easily accessible from the town. For me, my favourite skiing days start with a relaxed, gentle warm up run on *Beauregard* with its stunning views of *Mont Blanc* in the background. The pistes are normally very well-groomed and the gradients of the slopes are gentle enough to get you into the swing of things without too much effort.

Then, I'll glide over onto l'*Etale mountain* which is a wide area with many different piste options for long and perfect parabolic turns. The tree skiing is nice there because it keeps the snow fresher and lighter...

Onto le *Massif de l'Aiguille* and there is a very nice run into the magical *Combe de Borderan* with its two surrounding cliffs on each side of the track. Stop off, take a seat and relax in front of the magnificent panorama of *La Chaîne des Aravis* at the highly-recommended fast food restaurant **Relais de l'Aiguille**. Then relax for half an hour and get going on the serious work - your Alpine tan! I often shoot across to the *Balme secteur* in the afternoon through *La Combe du Fernuy*. *Balme* is the place for freestylers. There are many of them around - jumping off everything possible whenever they can. This area is the freeride playground of **La Clusaz**.

At the end of the day's skiing or snowboarding it is time to hit Après Ski-land in the village. You will find a solid party atmosphere at the **Cave du Paccaly** - a really nice old chalet-style bar where locals and tourist enjoy sharing the day's exploits, and many more spots besides. Then dive home for a quick shower because the nights are long in **La Clusaz**... there are many restaurants in the village or in *Les Confins valley* and then to finish off, the legendary night club **L'Eccluse** to party till dawn!... Yes this is life in **La Clusaz**... Come visit us soon!

Après

Olympic Champion Albertville 1992.
Olympic bronze Lillehammer 1994.
World Champion 3 times; 1989 Oberjoch, 1991
Lake Placid, 1995 La Clusaz.
Four World Cup Series titles in 1990-1994.

Up the mountain, there's a little gem of a spot - traditional, roaring log-fires, open till late with obligatory pissed sledge-ride home - the Alps at their best at **Le Bercail** on the *Massif de L'Aiguille* (definitely book). Otherwise it's relatively limited. Over *La Balme* side, a good option is **La Bergerie** which is functional and family-oriented (like most of the restaurants in La Clusaz, luckily).

In town, try **Le Grenier** for raclette, the traditional **L'Ecuelle** or **La Calèche** or any of the very good hotel restaurants. Faster food can be good and cheap at **La Scierie** and **La Braise.**

La Clusaz will never be the winner of the inaugural *Most Rocking Party Venue* on Snow in France 2005-6. However, you knew that anyway. That's not to say it is offically dead though.

The partying options are: **Panama Café,** for the clubby techno crowd (you almost certainly look good, ride good and behave bad!); **Les Caves du Pacally** for a more chilled set-up, and **Bar Roc Café** for fromage-y 80s sounds.

On the dance side, the trendy crowd head to the pumping, sweaty **Club 18** and **l'Ecluse** - the local institution which actually has a glass dance-floor built over the river flowing beneath. Weird but very cool.

Finally, if you are a 30-40 something, have kids and have persuaded some complete nutter to babysit them for the evening, the places to head for are **Le Saltu** or **Le Pressoir.**

LA CLUSAZ

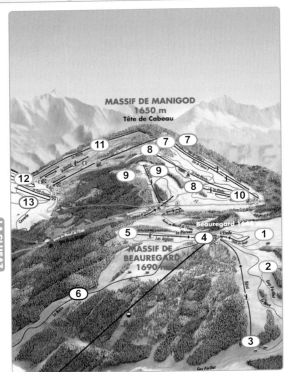

LA CLUSAZ

www.snowfinder.co.uk

Beauregard - Manigod

Beauregrard

1. Etoile des Neiges : From the top of Beauregard gondola take in the breathtaking views, then shoot down this very gentle blue run across to L'Etale or Manigod. Flat at the bottom.

2. Guy Perillat : Really nice long blue run winding down through tree-lined pistes back down to Beauregard. Lots of snow-making facilities at the bottom.

3. Le Nève : A red run sharing a start with Guy Perillat - just a steeper pitch down the fall-line to the Nève drag lift. Look near the trees for freshest snow.

4. Le Plateau : Simple green.

5. Les Aiglons : Aiglons is a straightforward medium-length blue with lovely views out across La Clusaz.

6. La Noire : A difficult black to find! Heads through trees all the way from the top of Beauregard down to town.

Manigod

7. Tête de Cabeau, Tête de Cabeau : Choice of two versions of this piste. Well-groomed open pistes that get busy. Often in the sunshine up here.

8. Crête Blanche, Crête Blanche : Similar set-up to Tête de Cabeau, only more bends to test your short swings. The red has a few bumps too. Also sunny.

9. Grand Crêt, Grand Crêt : Lovely narrow blue run through the trees and more open red that has some good intermediate/advanced moguls.

10. Les Rhodos : Nice easy learner blue with a green beginner slope adjacent.

11. Le Merle, Le Chevreuil, Le Blanchot : Three similar blues facing towards Etale mountain. Improver level playground to get the snow miles up. Blanchot has a **snowpark** for the freeriders.

12. Petit Choucas : Short basic blue at the base of the Etale side of the valley.

13. Coverie : Long shallow green run from Petit Choucas down to Laquais drag lifts.

Edgar Grospiron / Zoom-Agence

L'Etale

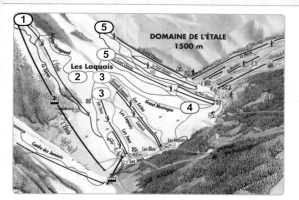

1. Tétras : A hidden gem - fantastic roller-coaster ride through the trees. Loads of jumps and never the same twice.

2. Régine Cavagnoud : The very top of Etale has stunning panoramic views and takes you down the nearest thing La Clusaz has to a downhill course - now renamed after *Regine Cavagnoud*, La Clusaz's top female racer killed in action.

3. Joux, Laquais, Ecrins : Not particularly steep but plenty of dips and jumps - popular with telemarkers possibly due to the great Telemark café.

4. Grand Montagne : Good schuss down this long green to take you back towards Manigod.

5. Grand Choucas, Grand Chamois, Petit Chamois : Somehow these three red and one black runs just aren't much fun. Being south-facing they are the first slopes to deteriorate. However there is some kite-ski potential here.

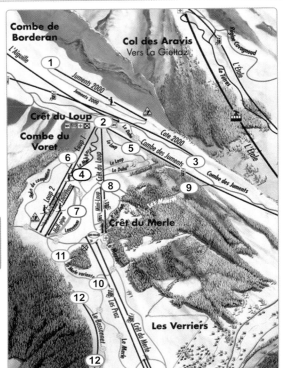

Combe de Borderan

Col des Aravis
Vers La Giettaz

Combe de Borderan

L'Aiguille

Juments 2000

Crêt du Loup

Combe du Voret

Le Dahu

Le Loup

Cote 2000

Combe des Juments

Combe des Juments

L'Étale

Le Loup

Le Dahu

Crêt du Loup

Vallée de Champée

Loup 2

Mini-Loup

Lombardes

Maxi-Loup

Crêt du Merle

Les Mélèzes

Mini-Loup

Maxi-Loup

L'École variante

Le Merle

Les Fraz

Crêt du Merle

Le Bossonnet

Le Merle

Les Verriers

LA CLUSAZ

Crêt du Loup - Crêt du Merle

1. Juments 2000 : Out of the way blue run at the top of the dodgy Juments drag lift. Lots of gullies, ridges and a good place to find powder.

2. Le Dahu : Linking blue from Crêt du Loup opening up the various options on Crêt du Merle.

3. Combes des Juments : Tricky skiing, lots of potential off-piste, fun in the trees, though watch out for rocks near end of season. Useful link up with L'Etale at bottom.

4. Mur d'Edgar : Experts only on this black mogul run named after La Clusaz's Olympic champion *Edgar Grospiron*.

5. Le Loup : Good red mogul run at top leading into fun run through the trees and ends up at Chez Harry monster cafe. Shorter chairlift ideal for beginners and munchkins. Excellent snowpark with serious jumps leading on to the half-pipe which is served by the shortest of the 3 button-lifts.

6. Stade de Compétition : 3 button-lifts serving race training piste for the local club and also the excellent half-pipe served by the shortest button.

7. Louveleau : The green with arguably the best **snowpark** in La Clusaz attached. Give the half pipe a go if you dare!

8. Petit Loup : Simple green learner slope - a ski school favourite.

9. Les Mélèzes : A red narrow path that cuts straight through the forest to join up with Combe des Juments back to the Cable Car. Fun in powder!

10. Le Merle, Merle Variante : Great to do first thing in the morning on the rat tracks, passing 3 great alpine restaurants - gets busy and carved up by the end of the day as it is the main motorway back down into the village.

11. La Ruade : Very long, slightly steeper alternative to Le Merle. Nice simple off piste off to the left to ski home to the chalets.

12. Bosonnet, Mur du Bosonnet : Really the same piste, but avoid the red if you are not fully confident on ice and in the shade. flat light.

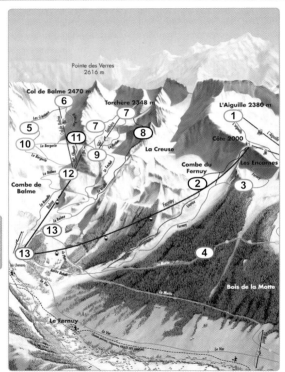

Pointe des Verres
2616 m

Col de Balme 2470 m

Torchère 2348 m

L'Aiguille 2380 m

6

5

10

11

7

7

8

9

12

La Creuse

Côte 2000

Les Encarnes

Combe du
Fernuy

2

3

Combe de
Balme

13

4

13

Bois de la Motte

Le Fernuy

LA CLUSAZ

1. L'Aiguille : High, open, steep and extreme. Great powder slopes with fresh snow and top mogul field fields when packed.

2. Lapiaz : Massive monster of a black run reached via a narrow and steep drop-off top section down into a big powder bowl, followed by some bumps and a tree-lined, sometimes icy finish. Watch out for avalanches.

3. Furney : Not for the feint hearted, this side of the mountain is totally wild. No lifts or punters here, just acres of wide open extreme space. On or off-piste your legs will be burning by the bottom.

4. La Motte : Easy but stunning run through the forest - tuck down and schuss over to La Balme area.

5. Les Crintiaux : The highest point in the resort at 2470 metres and panoramic vistas to match. Starts with a long traverse but worthwhile as you will always find steep powder or virgin crud at the end.

6. Blanchot : Steep fast and cold. The view from the top is one of the best in the Alps, looks over Mont Blanc and Megève.

7. Le Botion, La Torchère : The two high-altitude red runs off the difficult Torchère drag lift. Great views from the top. Bumpy, undulating terrain: great for freeriders and boarders to do tricks.

8. Le Vraille : Experienced skiers only - this black run is never pisted but offers great variety of terrain taking you all the way to the bottom of La Balme.

9. Le Lachat : Effectively an extension of Blanchot - combine the two for a long exhilarating thigh-burner down the mountain.

10. La Bergerie, La Balme : Easy, winding blue that links with La Balme to form a long cruisey run back down to the station. Good piste for introducing yourself to freeride.

11. Les Choucas : Short steep black mogul run.

12. La Roualle : Weaves in and out of trees - race to the bottom without stopping and you deserve a cold beer!

13. Le Plan, Le Var, Access Balme : Three motorway runs link the Balme secteur and Le Fernuy with the rest of La Clusaz.

LA CLUSAZ

Introduction

Megève itself is extremely well-known to the french and many other Europeans as a car-free centre of sophistication, understated style and great skiing. To the British, it is often thought of as being very close to Geneva, very low and not the world's most challenging of mountains'.

Whichever way you look at it, the incredibly pretty, stylish savoyarde village is centre of an area of surprising variations and options for all snow users. Just east of *La Clusaz*, west of *Chamonix* and south of the *Grand Massif,* the area consists of:

Megève, split into the three main areas of **Mont Joly, Rochebrune** and **Jaillet**. The valley on the north east side of *Mont d'Arbois*, dominated by the resort of *St Gervais*, consists of **Le Bettex** *and* **St Nicholas**, and east of *Mont Joly* is **Les Contamines** in the shadow of *Mont Blanc*. There's a good variety of skiing and boardriding options to keep you on your toes and for the travelling snow-hound, many good day-trips within an hour of the main village.

Hugh Hutchison will help you decide whether it's for you or not. He knows a thing or two about challenging skiing, bumps, freestyle, and schlepping through the extensive après ski in the **Megève** area!

The good
- 70km drive to *Geneva* airport.
- Cool, sophisticated and French.
- Surprisingly big and varied ski area.

The not-so-good
- Potential for lack of snow.
- A parking nightmare unless you own a chalet.
- Could be a little bit the wrong side of intermediate!

Skishoot offshoot

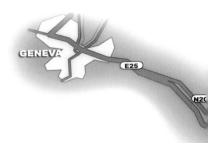

Getting There

Fly: from UK to *Geneva Airport* via BA, Easyjet, flybe or Bmibaby. **Megève** is 70km from *Geneva* (approx 1 hour).

Drive: from *Geneva* get onto the **A40 E25** Motorway through *Bonneville* and *Cluses* to *Sallanches*. Turn off at **J20** on **N205** and turn left onto **N212** through *Combloux to Megève*. For **St Gervais** stay on **E25** till **J22** then follow **D909** for 4 km. From *St Gervais*, take **D902** for approx 10km to **Les Contamines.**

Coaches: run regularly from *Geneva Airport* - book online at www.altibus.com, as well as taxis. The SAT bus from *Geneva* to *Sallanches* takes 70mins then onto **Megève** approx 30mins.

Train: The nearest rail station is *Sallanches* (approx 15km). Easy transfer by coach or taxi to *Megève*.

MEGÈVE

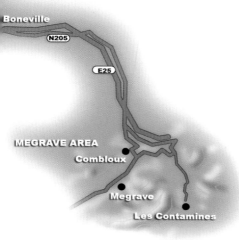

Boneville

N205

E25

MEGRAVE AREA

Combloux

Megrave

Les Contamines

MEGEVE

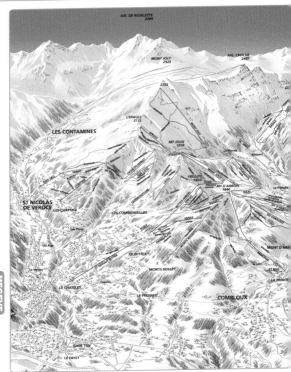

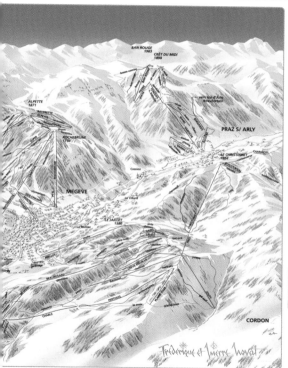

MEGEVE

Tourist Office

Megève + 33 (0)4 50 21 27 28

Main office

BP 24
74120 Megève
France

General email

megeve@megeve.com

Resort websites

www.megeve.com.com

Evasion Mont Blanc passes

Covering Megève Combloux plus St Gervais, Les Contamines &
Praz-sur-Arly. Discounts for seniors, under 16, season passes.

Half day	€25
Day	€33
6 Day	€179

Forfait Mont Blanc passes

As Evasion Mont Blanc but also Chamonix region, including Aiguille
du Midi €216 for 6 days.

Insurance

Carré Neige €2.50 per day

Recommended Ski Instructor

Mike Beudet, ESF, Megève.

MEGEVE

Megève *by Hugh Hutchison*

The French St Moritz! One of my favourite resorts although at 1100m it is fairly low. But if the snow is OK you have a chic old village with fantastic scenery and extensive skiing (79 lifts and many runs are tree lined). If you are looking for a traditional old French village with good skiing, easy access from Geneva, plenty of chic and lots of options for long lunches then Megeve is for you.

There are two main ski areas; **Mont d'Arbois** and **Rochebrune** are independent of each other although a cable car connects the two areas. The Rochebrune area has mostly green, blue and red runs, including an excellent blue run L'Olympique.

Megève has invested in snow-making equipment in recent years and has 185 snow making machines. Also many of the pistes are alpine meadows and so less snow cover is needed for good skiing. The most spectacular runs are on Cote 2000 which has a fantastic wall of mountain all along one side.

On the **Mont d'Arbois/Bettex/Mont Joly** sector some of the prettiest runs are those that run down to the hamlet of St Nicolas de Veroce. But for better skiers Mont Joux and the red and black runs of Mont Joly are the place to be.

Le Jaillet, on the opposite side of the valley from the rest of the skiing, is Megeve's third and smallest and quietest ski area but worth a visit

Megève is not a hot spot for snowboarders but there is a Fun Park with a half-pipe on Mont Joux and the are is good for beginners and intermediates. There is also a boarder-cross course at Rochebrune.

Megève is a good choice for skiers non skier alike as it has a good sports centre, an ice rink, loads of designer shops, horse drawn carriages, restaurants and bars…

Après

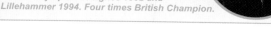

Adrian Myers

Britain's most successful mogul skier. Double Olympian at Tignes 1992 and Lillehammer 1994. Four times British Champion.

As far as mountain restaurants are concerned, Megève is the place to be. The resort has a massive selection of high quality (and expensive) options considering the size.

The Rochebrune area has **L'Alpette** which has a comprehensive menu (including a large selection of champagnes), a large fireplace and a terrace area.

Super Megève at the top of the *Rochebrune* lift also has a large terrace area. There are both service and self-service restaurants and there is an outdoor barbecue.

Le Radaz is a farm converted into a restaurant, which has a local savoyarde menu and atmosphere as well as great views up towards *Cote 2000* from its sunny terrace. **L'Auberge du Côte 2000** is also a converted farm restaurant which you can ski or drive to. Again it has a terrace.

The Mont d'Arbois area has several gourmet, fur coat options: **Chalet Ideal Sport** at the top of the *Princesse* gondola does superb grilled meats, while **L'Igloo** has a sun terrace with good views of *Mont Blanc*. **Les Mandarines**, below the *Mont d'Arbois* summit has a good reputation. **The Club House du Mont d'Arbois** at the foot of the slopes is a good choice for non-skiers and those with young children.

Megèves après ski and nightlife is pretty good but can be expensive. After skiing in the later afternoon popular café-bars in town include **Le Chamois** and the **Cascade**. **Harry's** is the Brit bar with satellite TV, karaoke and a good choice of beers. The cool young crowd tend to hang out in the **Village**

MEGEVE

My favourites

Advanced and experts
There are some great off piste runs off **Mont Joly**. Hook up with a good local guide such as my friend **Mike Beudet** to get the very best out of the off-piste in *Mégève*.

Black run
If you want a serious challenge, try the famous **Emile Allais** black run on *Rochebrune* - once one of the most famous race runs in France. Steep and bumpy at the top, followed by a narrow, sometimes icy track through the trees. A genuine must for good advanced and expert skiers and boarders.

Red run
Either go for **Etudiants** which takes you down through the pine forests on the *Mont Joux* (an area with some great red runs) or try **Lanchettes** on *Rochebrune* - a very long wide and undulating run ideal for building confidence if you are new to red runs.

Blue run
Good choice of runs on *Rochebrune* or try skiing from the top of *Mont d'Arbois* down under the *Princesse Gondola* to *St Gervais*.

Green run
One not to miss is the classic **Sept Nains** (Seven Dwarfs) over on *Jaillet* mountain. Fantastic scenery and views as well as a long gentle run down which is ideal for families and beginners.

Rock Café while the **Puck** is more local. **Palo Alto**, by the ice rink has a piano bar with live music on the ground floor while downstairs there is a night club. **Pallas** is a newly refurbished bar/restaurant just above the ice rink worth checking out. **Le Club de Jazz Les Cinques Rues** has more than just live jazz! It's pretty cool and has a fireplace but it is not cheap. If you are looking for night clubs check out **Les Caves de Mégève** or **Cargo Club**, which is a fairly new and popular.

St Gervais

Adrian Myers

Another option for skiing the Mont d'Arbois area, Megeve area or indeed the whole Mont Blanc area is St Gervais-St Nicholas.

St Gervais is a pretty 19th century spa town on the east side of *Mont d'Arbois* towards *Chamonix*. It is a small town but is full of shops, bars and has some good restaurants. There are thermal baths and the Olympic ice rink as well as a sports centre. As a resort it is much less expensive than *Mégève* and yet it is linked to *Mégève* by the *Princesse Gondola*.

If you head up the **Prarion** on the other side of town, the rack and pinion railway links you to the slopes of **Les Houches** (to the west of *Chamonix*) and its newly updated mens World Cup Downhill course!

On the down side, there is often heavy traffic bottlenecking in the village centre, and it being a low resort, you don't tend to get the postcard snowy village vista too often. But hey, this is more than made up for by the stack of boardriding and skiing options nearby and the lack of crowds.

It is very much a small French resort with none of the brit-approved nightlife of other nearby resorts - most people head into *Mégève* for bar life and food.

On the mountain, ski down **Venaz** and head for **la Flêche d'Or** for a little sharpener on the way back to town. There's a good steakhouse in town, **La Galetta** and brilliantly, there's an Irish chalet bar restaurant serving truly international food called the **Star of County Down** in the *Chalet Etoile*. How?

Le Duplex is the main nightclub in town - classically French, smokey, busy with good DJs spinning the tunes, and there's the **Nuits des Temps.**

MEGEVE

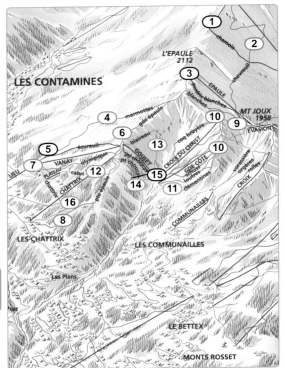

LES CONTAMINES

LES CHATTRIX

LES COMMUNAILLES

LE BETTEX

MONTS ROSSET

Les Plans

L'EPAULE
2112

MT JOUX
1958

EVASION

EPAULE

CROIX

CROIX DU CHRIST

GDE CÔTE

COMMUNAILLES

chamois

chevreuil

barbu-blanches

blanchet

marmottes

gde épaule

coq boyels

écureuil

blaireau

olympique

cabris

VANAY

PLATEAU

CHATTRIX

chantres

pte épaule

pt christ

GOUET

voressière

ordères

rolles

déménines

loutes

LIEU

MEGÈVE

1. Chamois : Great black at top of Mont Joly lift. Amazing views into either valley with two steep sections for advanced skiers/boarders upwards.

2. Chevreuil : Long, winding and undulating red from the top of Mont Joly lift. Awesome views out across the valley to Côte 2000.

3. Perdrix Blanche : Short steep and challenging black straight down from the top of Epaule.

4. Marmottes : Brilliant long red on this west-facing slope, looking out over Les Contamines & St Nicholas. Provides access to off-piste if you take a guide.

5. Ecureuil : Short bumpy black from the top of Vanay chair.

6. Grande Epaule : Turn left off Marmottes at the fork and head along the shoulder (hence the name!) to join Olympique and Petite Epaule.

7. Olympique : Excellent racer red, often closed with local St Nicholas races, down through the trees into town.

8. Petite Epaule : Nice intermediate extension of Grande Epaule. Finishes down through the trees in town.

9. Blanchots : Fantastic linking red that opens up a wealth of red run skiing and boarding in the bowl below from the top of L'Epaule.

10. Coq Bruyères, Schuss, Loutres : 3 similar reds in this intermediate playground bowl. Quite steep at the top but often uncrowded.

11. Clémentines : A nice easy blue down from Blanchots red for those of you who have tired legs from skiing all those reds here.

12. Cabri : Really nice laid-back blue that stats with wide-open pistes and finishes through the trees at Vanay.

13. Blaireau : Good winding and open blue - part of the intermediate bowl playground.

14. Petit Choucas : Regular little blue for beginners and improvers.

15. Grand Choucas : Steep black going straight down through the forest from the top of Goulet. Can sometimes be short of snow and rocky.

16. Chattrix : The extension of Cabri - a good cruisey blue run taking you down into Le Chattrix. You can turn off onto Retour Village blue to access St Nicholas.

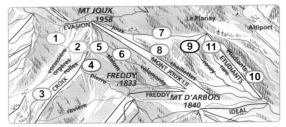

1. **Vorassières** : Relatively shallow gradient, long winding blue from the bottom of Evasion lift through the valley. Takes you all the way down to Les Comunalles if you want.

2. **Orgères** : Straightforward blue run - one of three or four for beginners and improvers to get hours on the snow in one small area.

3. **Rolles** : A good run for improvers to step up to their first red run. Reasonably steep start section but nice from there onwards.

4. **Pierre** : Easy flat and long option to get across from Mont Joux to Mont d'Arbois.

5. **Slalom** : Short bumpy red from the summit of Mont Joux. A good warm-up for Valamonts.

6. **Valamonts** : Good intermediate-testing red, especially for those of you who fancy your GS carving turns.

7. **Joux** : A linking wide-open red taking intermediates over to a good area to hammer down pistes and improve technique - Etudiants.

8. **Chaillettes** : Lovely red run down through the forest, either side of the piste. Classic Megève skiing.

9. **Rosay** : Excellent short, bumpy and narrow black through the pine forest. Good advanced standard.

10. **Etudiants** : Really good red known for its good snow quality taking you down through the pine forests. Try Rare for wider pistes.

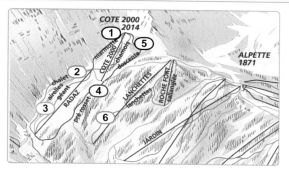

1. Marmotte : Beautiful bumps down from the summit of Côte 2000. Often a good place to get up early if there's been a powder dump - which is not unusual since this is Megève's most reliable and some say, best quality snow zone.

2. Chalet, Chamois : Take either from the top or join Chalet from **Marmotte**. Both cruisey red runs with quality snow to take you close to the mountain down to Côte de Mille plateau.

3. Airelles : Take this cruisey well-groomed GS run from Radaz chair down to Côte de Mille plateau. Beginner or Improver. Easier version is Géant.

4. Pré Rosset : Long tree-lined blue from Lanchettes down to Radaz. Not often crowded and perfect to build confidence for the less-experienced.

5. Descente : Super G at its best. Fast racey black run for good advanced standards upwards. Well-groomed pistes and a nice place if there's powder.

6. Lanchettes : Very long intermediate-level red - not massively steep, open and undulating.

Megéve - Mont d'Arbois & Bettex

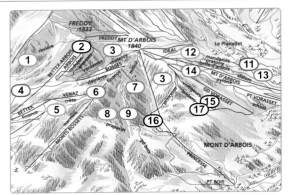

1. **Ravière :** Good back-country style blue reached from Bettex or via the Freddy lift from Mont Joux side.

2. M Dujon : One of two good steep blacks from the top of Arbois lift. Short with bumpy terrain for good skiers and boarders.

3. **Vardasses :** A fun, linking red from the summit of Mont d'Arbois across to the base of Arbois, giving access to Mont Joux.

4. **Chateluy :** Very nice long green through trees down into the valley. After Bosses lift the pistes open up and bring you to Ecole lift. Very popular with beginners and ski schools.

5. **Finance :** Very long blue that opens up the Mont Rosset area for improvers.Links with Chénas to take you all the way down to the bottom. Excellent.

6. **Crètes, Marmires :** Two nice Bettex reds with wide-open GS-style pistes, accessed from Finance blue or via Venaz chair. Good step-up slopes for improvers.

7. Clairières : Pretty, short red through the trees. Interesting little spot if the powder is about!

8. Prapacot : Wonderful blue run off the Finance blue. Lovely tree-lined pistes with great views over Mont d'Arbois. Links with Encraty and Le Plan to take you to the base of **Princesse**.

9. Milloz - Grand Bois : One of Megéve's classic reds. Long, undulating and tree-lined pistes. The bottom can be patchy and rocky if not much snow about.

10. St Gervais : A stunning tree-lined descent into the beautiful old resort of St Gervais, although you need plenty of snow to avoid much frustration, when it can be magical.

11. Mandarines : A gentle start to this wide-piste green run. There's a good long flat section at the end, perfect for families with children.

12. Oratoire : Nice blue, often crowded as it is a link run from Mont Joux and Mont d'Arbois to Rochebrune, linking up with **Mandarines**.

13. Belle d'Arbois : A bit of an undiscovered gem for many people who might normally ski/board the other three below. This is a real quality red known for its good snow quality.

14. Slalom, Pylones, Schuss : The three main reds on Mont d'Arbois. Not too steep with good quality snow although sometimes patchy down the bottom. Busy.

15. Voltigeurs : This is one of the best in Megéve. Early morning powder heaven at it's best. Nice steep bumps at the top, a steep section through trees then flattens out at the bottom.

16. Princesse : Standard black run, but good for intermediates stepping up to their first black, as there's a steep start but it becomes flatter and more red the second half. Very pretty run.

17. Bridans : Similar stuff to the other two neighbouring blacks. Links up with **Voltigeurs** and opens out at the bottom, where it is sometimes patchy and rocky at start and end of season.

MEGÉVE

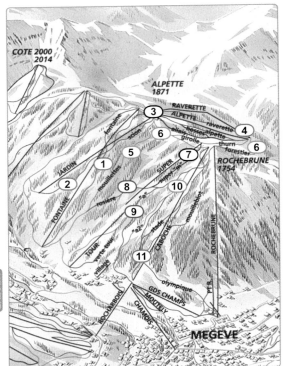

1. Fontaine : Long challenging red through the trees with stunning views from the top.

2. Scion : Similar option to Fontaine, which it joins, only reached via Jardin lift.

3.Emile Allais : Most famous race piste in Megève. Steep narrow bumpy section at the top, leading to narrow shady icy section through trees. You need to be good to do this properly!

4. Ravarette, Alpette : Two charming reds through trees with amazing views out towards Praz. These are winners in the sunshine. Take **Bosses** black off Alpette to find out what **Emile Allais** is like.

5. Mouillettes : Beautiful wide open pistes up the top then narrowing through trees towards the end.

6. Girolle, Thurn, Forestier : Quality batch of blues reached via **Ra** blue run from the Jardin lift. Lovely views up the valley to Praz sur Arly.

7. Super Megève : Not very long but technically challenging. Steepest on the right side. Shady and sometimes icy in afternoon.

8. Rosière : Straightforward long green perfect for beginners to gain confidence before joining the blue at the bottom. Ski school favourite.

9. Piste A : Turn left off Rosière to take you on a 3km long beauty of a run across through the trees to the cable car at Rocharbois and beyond into town.

10. Piste A2 : Slightly more challenging version of **Piste A**.

11. Stade, Mouilletbiot, Olympique : 3 excellent red runs - often used for racer training so watch out for piste closure. **Olympique** is a classic!

MEGÈVE

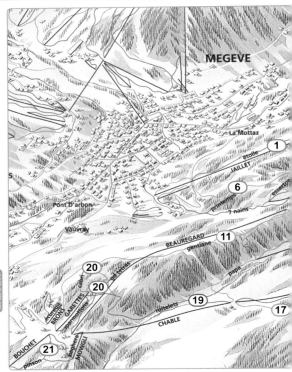

MEGEVE

La Mottaz

1

étoile

JAILLET

essenu

6

pinsons

7 nains

Pont D'arbon

Vauvray

BEAUREGARD

11

gentiane

papi

20

od blute

20

calori

roitelets

19

17

astrou

BRONS

CHABLE

GARETTES

pipermoisine

BOUCHET

21

laughena

MOWGLI

pinson

MEGEVE

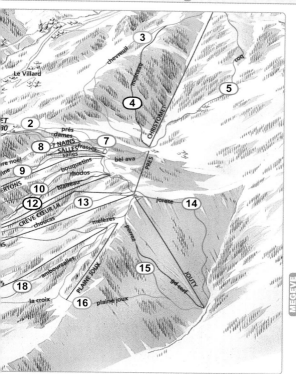

Megève - Jaillet

1. Etoile : Exciting, rolling red with a steep start tailing off to a more gentle end section. Good slope to advance from blue to red runs.

2. Prés : Very nice, tranquil back-country blue run acting as the link to the ski areas of Le Christomet, Praz and Giettaz.

3. Chevreuil : Brilliant blue with amazing views out over Megève.

4. Molneau : Challenging black cutting down through the trees into the valley to join Christomet lift.

5. Coq : Lovely undulating red. Get here early for amazing views of the Mont Blanc massif.

6. Père Noël, Essertons, Printemps : Père Noël is a fantastic long blue from the summit of Jaillet all the way back down to base. Take Essertons to go back up quickly, or Printemps through the trees (awesome if powder), to join **7 Nains.**

7. Frasses : Fairly short, basic but uncrowded red.

8. 7 Nains : Very long gentle green for all the family.

9. Ravine : As the name suggests, a long red run down through the tree-lined valley. Good warm-up red.

10. Bouquetins, Rhodos : Good reds down through the valley - linking with the lifts to more reds further on along the mountain.

11. Gentiane : Very long cruisey blue over to the Combloux secteur.

12. Blaireau : Quality, challenging black down through the forest. Shallower at the bottom where it becomes Rhodos red.

13. Choucas : Similar proposition to Rhodos - this area is an intermediate playground. Melezes is similar.

14. Jorace : Very isolated, tranquil winding and undulating back-country red. Access to off-piste options with a guide.

15. Porrez : Reached via Mélèzes. Never busy. Go left halfway down for challenging black option. Access to off-piste options with a guide.

16. Plaine Joux : A long way from the action. Quiet blue for improvers to feel what back-country skiing is really like. Amazing in powder.

17. La Croix : About as far as it goes for improvers and intermediates.

18. Ambourzalles : A red version of La Croix. Lovely tree-lined top section then open pistes to the bottom of Perthuis.

19. Riotelets : Gets you back to Beauregard and onwards if you want to ski back to town. Make sure you give yourself plenty of time.

20. Grand Tetras, Cabri : Two short bumpy reds through the trees. Snow quality can be sketchy, particularly early/late season.

21. Pinson : Isolated, short but open-piste red. Never crowded.

Adrian Myers

MEGEVE

Best off-piste
Since you are in one of the best off-piste areas on the planet, the options are endless. As always, get a guide and do it properly!

Best black run
From *Signal*, get across to *Aiguille du Croche* and ski down the steep red *Aiguille* onto the challenging black called **Grevettaz**. You can take Liaison and nip back up *Veleray* to come down the amazing *Rebans* black as an extra thigh-burner!

Best red run
There are 3 reds on the top of *Col du Joly*, reached via the *Nant* Rouge chairlift. Head onwards up **Monument** to come down **Nant** Rouge or take **Bartavelle** down to join *Besoens or Col*.

Best blue/green
Montjoie itself, down from *Signal cable car* to *Etape 1470* is great - very long and great views of town in the valley.

On the mountain, try the functional **L'Etape** at 1470 or **La Ferme de la Ruelle** at *Ruelle 1600* on the *Hauteluce* side. **Signal** station has a big family-friendly cafe snack-bar restaurant.

The bars are very French and you'll always find live music on most nights of the week.

There's a lovely little traditional bar restaurant called **Savoisienne** right by the river. Also recommended are the **Husky** and **La Cressoua** restaurants - both with terraces to soak up the sun.

The main late night club/disco in town is **L'Igloo**.

MEGEVE

Les Contamines *by F. Bertrand*

With Mont Blanc as it's back-drop, situated at 1164 metres, Les Contamines is part of the Evasion Mont Blanc area, with direct access to over 425km of pistes throughout the 5 main Mont Blanc resorts. Although it is part of this cosmopolitan area, Les Contamines maintains a very French laid-back atmosphere.

It is a traditional resort built around a traditional old village square, situated due east of *Megève*, south of *St Gervais* and west of *Mont Blanc*, and is only an hour or so drive from *Geneva* - so a real hit with weekenders, ski travellers etc.

Les Contamines has always had a reputation for reliability of snow and snow conditions, which is unusual for such a low resort. Many theories abound as to why this is, but the smart money is on proximity to *Mont Blanc* itself in some way, shape or form!? Virtually all the skiing is over the 1600-1700 metres mark.

You can access all the (mainly intermediate) skiing and boarding from right in the centre of town via the *Signal* and *Montjoie Gondolas*. This is not the largest ski area in its own right, but there's plenty to do both on and off the slopes and it is especially recommended for families, given airport proximity, ease of access to slopes, lack of a major party scene and facilities.

Accomodation is mainly apartments and chalets. There are not too many restaurants and bars in town, but with *Megève* round the corner, this is not really a problem. There are regular (if very busy) Navette shuttle buses to get you into the centre and lift stations.

If it's non-snow activities you are after, **Les Contamines** has it all (and the really great thing is that if by any chance it doesn't, you know there a resort within 10 minutes that does).

MEGEVE

Richard Evans

Chamonix region

Introduction

More has been written about this resort than pretty much any other in the French Alps...steeped in the history of extreme winter sports, particularly climbing and skiing, this town is really somthing else. Very often the subject of differing view points, one tends to be from one of two schools: the 'there is no other resort worth going to' school and the 'what on earth is all the fuss about, I have to get a bus everywhere' school!

As you can imagine, it's really not quite so simple as all that - not least because the region consists of: **Chamonix** town with the areas of **Flégère** and **Brevent**; **Argentière**, leading to the off-piste heaven of **Grand Montets**; **Le Tour**, and the **Balme** area; **Vallée Blanche** and down the valley, **Les Houches**.

in fact one of it's best know ski areas, the glacier at *Les Grands Montets* was even the setting for one of the great movie stunt scenes - the ski chase in *James Bond 'The World Is Not Enough'*...which is why it is a rare privilege to have the area introduced by the great **Candice Gilg**, who just so happens to have been one of the stunt doubles for *Sophie Marceau's character Elektra* in the movie. Well, that wasn't actually her day job, just a little hobby - by day **Candice** was *double World Champion Mogul Skier* and *triple World Cup Champion!*

The good
- 90km drive to *Geneva airport.*
- Off-piste and extreme heaven.
- Massive ski and party options.

The not-so-good
- No ski in ski out.
- Not great for the less experienced.
- Families without cars will struggle!

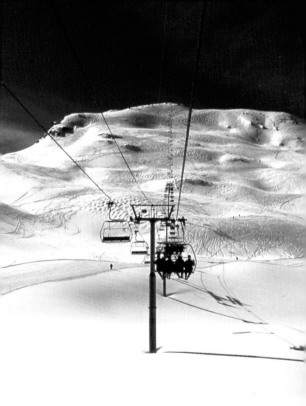

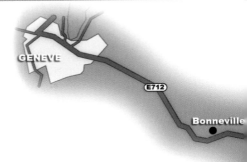

GENEVE

E712

Bonneville

Getting There

Fly: from UK to *Geneva Airport* via BA, Easyjet, flybe or Bmibaby. **Chamonix** is 90km from *Geneva* (approx 1.5 hour).

Drive: from *Geneva* get onto the **A40 E25** Motorway through *Bonneville*, *Cluses* and *Sallanches*. Turn off at **J22** on **N205** and follow the road for approx 20km to *Les Houches* and then *Chamonix*. Continue out of *Chamonix* on **N506** for 10km for **Argentière.**

Coaches: run regularly from *Geneva Airport* - book online at www.altibus.com. The bus from *Geneva* to *Sallanches* takes approx 70mins then onto *Chamonix* approx 50mins.

Train: There are train stations in *Chamonix*, *Argentière* & *Les Houches*.

CHAMONIX

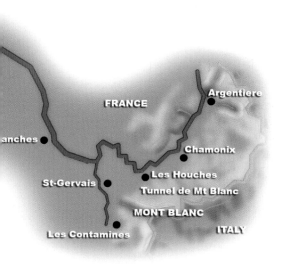

FRANCE

Argentiere

...anches

Chamonix

St-Gervais

Les Houches

Tunnel de Mt Blanc

MONT BLANC

Les Contamines

ITALY

CHAMONIX

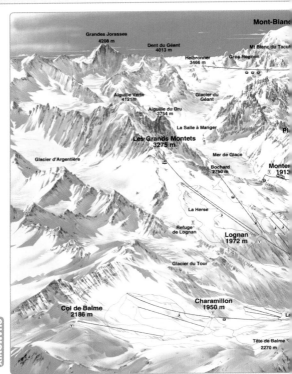

Mont-Blanc

Grandes Jorasses
4208 m

Dent du Géant
4013 m

Mt Blanc du Tacul

Gros Rognon

Helbronner
3466 m

Aiguille Verte
4121m

Glacier du
Géant

Aiguille du Dru
3754 m

La Salle à Manger

Les Grands Montets
3275 m.

Glacier d'Argentière

Mer de Glace

Bochard
2750 m

Monter

1913

La Herse

Refuge
de Lognan

Lognan
1972 m

Glacier du Tour

Col de Balme
2186 m

Charamillon
1950 m

Tête de Balme
2270 m

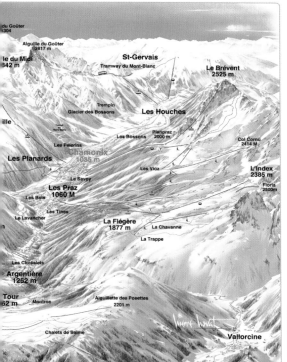

du Goûter
304

Aiguille du Goûter
3817 m

le du Midi
342 m

St-Gervais

Tramway du Mont-Blanc

Le Brévent
2525 m

Tremplin

Glacier des Bossons

Les Houches

ille

Les Pélerins

Les Bossons

Planpraz
2000 m

Col Cornu
2414 M

Chamonix
1035 m

Les Planards

Les Vioz

L'Index
2385 m

Le Savoy

Floria
2500m

Les Praz
1060 M

Les Bois

La Flégère
1877 m

La Chavanne

Les Tines

Le Lavancher

La Trappe

Les Chosalets

Argentière
1252 m

Tour
62 m

Montroc

Aiguillette des Posettes
2201 m

Chalets de Baime

Vallorcine

Need to know

Tourist Office

Chamonix + 33 (0)4 50 53 23 33
Argentière + 33 (0)4 50 54 02 14
Les Houches + 33 (0)4 50 55 50 62

Main office

85 place du triangle de l'Amitié
BP 25
74400 Chamonix
France

General email

info@chamonix.com

Resort websites

www.montagne.chamonix.com

Cham Ski passes

All lifts in Chamonix valley (except Les Houches) + Aiguille du Midi cable car. Discounts for seniors, under 16, season passes.

Day €44
6 Day €186 (+ 1 day at Courmayeur)

Ski Pass Mont Blanc passes

All Chamonix valley including Courmayeur. €216 for 6 days.

Insurance

Carré Neige €2.50 per day

CHAMONIX

Candice Gilg / Martin Cuchet

Chamonix Argentière - Les Houches

Chamonix Argentière is really the adventure capital of the French alps (in fact, probably the whole alps). It is famed for it's proximity and views of the great Mont Blanc, a climbers haven, the incredible Aiguille du Midi and probably the most famous ski run of them all, the Vallée Blanche.

Chamonix is always referred to as if it is one resort. It is actually a number of resorts, served by 4 main base stations:

Aiguille du Midi, the gateway to the *Vallée Blanche* and *Mont Blanc* (the famed cable car is found just out of the middle of Chamonix town).

Grand Montets via *Argentière* and *Lognan* (the home from home for every psycho, screw-loose couloir-eating extreme snow-user).

La Flégère and **Le Brevent**, a short bus trip out of *Chamonix*, which is two areas linked, and the main ski area of *Chamonix* town.

You can then chose to drive up the valley to *Le Tour*, giving access to *Tête de Balme* and *Col de Balme* and onwards to the Swiss resort of *Vallorcine*, or down the valley to *Les Houches* and it's lovely tree-skiing in the right conditions.

Since we talk in detail about the runs later on, I won't say another word about the unbelievable variety of skiing and boarding available in this incredible area, nor will I mention the thrill of stepping out of the top station and onto the knife-edge steps designed to scare everyone stupid, to the wonders of the 22km glacial wilderness that is the *Vallée Blanche* run down to *Montenvers*...

By Candice Gilg

Two times World Champion mogul skier.
Won the 1996 and 1997 World Cup series title.

Les Houches

Definitely deserving a mention, Les Houches often suffers the
ignomy of being labelled down-the-valley-from-Chamonix! How-
ever, this is a great little spot to warm up for the more serious stuff
up the hill, for beginners and families to play, or for a change...
and don't think it's just easy blues and reds, although there
are plenty...

Just get your arses over to the **La Verte Olympic Mens Downhill Run** if
you think the only way to scare yourself is by jumping over crevices
over on *Grand Montets*! This is definitely not for the slow!

At its best, a great place for powder and treeline skiing - particularly
if the weather has closed in up the valley and visibility is suspect. It
is well worth a day trip, given that it is free with your *Ski Pass Mont
Blanc* and there's a free bus to take you there.

And you can always nip into **Servoz** and try the acclaimed tartiflette
at **Les Gorges de la Diosaz** - never something to brag about
doing in the bars of *Rue des Moulins* but a refreshing change to
the extremes of the playground up the valley!

CHAMONIX

My favourite runs

Best off-piste
Not a very easy question to answer, I'm afraid. There is just soooo much to do. Definitely take a guide and try Grand Montets if there's any hope of powder. You will not be disappointed.

Best black run
Charles Bozon at *Brevent Flégère*. Stunning views, accessed by a cable car only so not often crowded...especially when you see the off-piste just past the sharp right hander on the left.

Best red run
Belle Place at *Tête de Balme in Le Tour*. Fantastic red I never get bored of, leading onto the wonderful blue run, **Les Esserts**, for powder tree-skiing extraordinaire!

Best blue/green
The super long **Index** run in Flégère that has enough challenge to keep the good skiers happy and is exciting for the not-so experienced too. A lovely run.

Best eats
All the chat about the **Albert premier** is true. It's very expensive but the food is real gourmet stuff. I'm just as happy in **Midnight Express** having a sarnie on the way up the mountain to be honest.

The best eats (non wallet-burning) in town are to be found at **Le Caveau** - next to *Midnight Express*, the entrance leads down to an old wine cellar that has been converted into a restaurant. The garlic bread for starters has to be tasted to be believed, it could be a meal in itself. On top of this the staff are friendly and the prices are very reasonable.

There is an apparently awesome *Michelin Star* restaurant - **Albert Premier** but no-one we know has been there! Alternatively, if you're one of the influx of City boys who now owns a chalet out here, try **Atmosphère** with its stunning *Mont Blanc* view.

Other places of note include **Casa Valerio**, a very cool little Italiano, just close by the conveniently or not-so-conveniently situated **Casino**! Also **Le Matafan** in *Hotel Mont Blanc* is a special occasions option.

Two others of note are **L'Impossible,** in a beautiful ancient barn in *Chamonix Sud* for traditional fondue grills and **Rusticana** in *Argentière*. **Chaudron** is similar ambience and quite reasonably priced. Try the new and sensibly-priced **Boccalatte** or **L'M** for a cheaper, faster brasserie meal in the middle of town.

At the budget end definitely impossible-to-miss **Midnight Express Sandwich Bar** - the eatery of choice for anyone after a big days skiing.

As the evening beckons, *Chamonix* becomes a whole new world of diehard partying. You'd expect it from the extreme capital, I guess. Pretty much any bar in town is going to be full of various sub-demographics of mountain user. If you're a first timer, just head down the *Rue des Moulins* and dive in wherever you fancy - quite literally! Try **Chamouny, Rond Point, La Cabolée** (if you're coming down from *Brevent*), or **Office Bar** in *Argentière*.

Obvious spots include **Dicks** and the **Garage** in *Chamonix Sud*. In town, **Arbat, Wild Wallabies, Blue, Driver, Ice Rock Café** or **Jekyll & Hyde.**

CHAMONIX

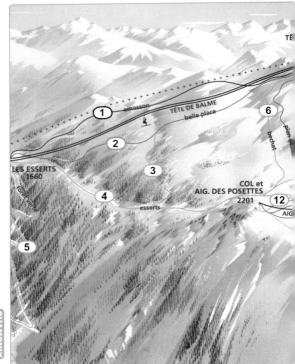

TÊ

emosson

TÊTE DE BALME

belle place

① ⑥

② plan d

③ bechat

LES ESSERTS
1660

④ COL et
AIG. DES POSETTES
2201 ⑫

esserts AIG

forêt verte

⑤

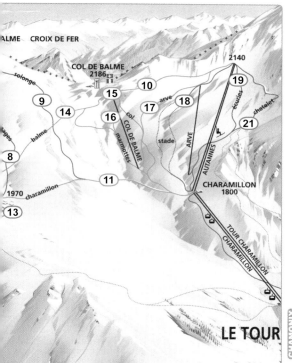

BALME CROIX DE FER

COL DE BALME
2186

2140

solonge

9

14

10

15

19

17 18

16 arve

col

21

chatelet

aiguilles

8

balme

stade

ARVE

AUTANNES

11

CHARAMILLON
1800

1970 charamillon

13

TOUR CHARAMILLON
CHARAMILLON

LE TOUR

Chamonix - Le Tour

1. Emosson: Great black down the right side of Tête de Balme chair. In powder this is one long bowl all the way down to the trees and then down to the chair, a long descent and a real test of endurance. Often un-marked. If in doubt take a guide.

2. Belle Place: Brilliant red from the top of Le Tête de Balme down through the trees to Les Esserts. Has it all! From the top you keep your speed up and head down and then up under the chair to a brow in the hill. As the run approaches a tree band you can continue down the run to the right, take a left turn to the blue Belle Place Esserts or else head straight through the trees for some of the best tree skiing in the valley.

3. Les Esserts : Super-wide cruising blue through the trees to the Tête de Balme chair. Great for beginners who want to practise bigger faster turns and on bad viz days.

4. Liaison Esserts: A variation of the above with the same qualities, worth a look when it is busy.

5. La Forêt Verte : Fantastic blue run winding down through the trees with views over Vallorcine. Normally quiet with good snow as is protected from the sun. No artificial snow so sometimes shut.

6. Le Bechat : Good, steady cruising blue run that runs parallel to the drag lift and links with the Esserts run for an even longer journey.

7. La Variante du Bechat : Blue parallel to Alpages except not so steep. A few rollers for jumps too. South facing so gets the sun and looks right down the valley.

8. Les Alpages : Same as the Solonge, a well kept piste that has a nice pitch. Not always bashed so great on powder days. Also try Plan des Reines.

9. Solonge: Fast red groomer that is usually well pisted for those Super G turns. Finishes near the Autannes chair.

10.Liaison Balme : Long flat blue from Autannes chairlift right across the mountain to the Chalets de Balme. Offers access to some awesome off-piste and jumps on the front side for experts only.

11. Tour Charamillon : Flat and easy red that leads back to the mid-station, ideal at dinner time for getting back to the restaurant.

12. Les Posettes : Excellent long blue run with view both to Chamonix and over the back of Aguillette des Possettes down to Vallorcine.

13. L'Aguilette : Good cruising red that mirrors the path of Les Posettes down from the Aguillette.

14. Balme : Lovely long blue all the way from the top of Autanes down to Posettes. Beautiful views and an out-of-the-way feel make this a special run for all standards.

15. Le Col : Short blue run for beginners. Offers stunning views over into Switzerland for those prepared for a 5 min walk.

16. Les Marmottes : Nice long, wide blue giving views the entire length of the Chamonix valley on the way down. Normally quiet.

17. L'Arve : Easy cruising blue for beginners to find their feet on. Finishes at the Autannes chair so beginners can meet more advanced friends who have been on the Ecuries red.

18. Stade : Race piste where the young racers practise the curious sport of gate-bashing. Often closed.

19. Les Ecuries : Similar run to Le Chatelet but with the added bonus of a natural half pipe. Good start-of-day thigh-warmer.

20. Les Caisets : Excellent, fast red run back to base. Can get busy at the end of the day. For those who enjoy speed it allows you to carve some big fast turns with a long schuss at the end.

21. Le Chatelet : Nice long red leading down from the Les Autannes chair. Good views up towards the Le Tour glacier but the chair can be bitterly cold on windy days. Watch out for the bumps!

CHAMONIX

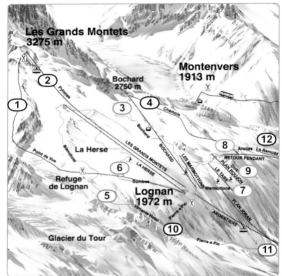

1. Pointe de Vue: Long black takes you from the top of Les Grands Montets back to the Lognan area with stunning up close views of the Argentiere Glacier. The top half is never pisted so stay within the markers or you are in 'Crevasse City' - You have been warned!

2. Pylones : Another black and great unpisted run from the top of Les Grand Montets. Again plenty of dangers so stick within the piste markers (or hire a guide to make the most of it)! Big moguls!

3. Bochard : Popular red with a number of variants on the way down. Unless fresh snow has fallen recently, it can be very hard and icy in patches.

4. Chamoix : Long black that's quiet even in busy periods. Stunning views into the Lavancher Bowl and also gives you access to some of the best off-piste in the Chamonix valley. Warning: Make sure the Retour Pendant lift is open before you commit (it will tell you at the top of the bochard gondola).

5. La Variante Hotel : An unpisted red which joins up with the Pierre a Ric piste (the home run), normally one big mogul field, but in busy periods it's always an alternative.

6. Les Combes : Steep and fairly narrow at the top but opens up into a rolling run. Plenty of opportunities to play in the powder by cutting off this piste where ever you feel like it.

7. Les Marmottons : A wide and relatively easy blue run which gives you the opportunity to check out some of the runs leading down to it if you are unsure. The edge of the piste is the stage for the *'Boss de Bosses'* a fantastic bumps competition in March.

8. Arolles : A meandering blue taking you into the Lavacher bowl and offering some spectacular views. Again ensure the Retour Pendant lift is open before you commit.

9. Les Coqs : Short but challenging blue. Leads to Plan Joran where there is a restaurant, cafeteria and indoor picnic area, perfect for that well earned spot of lunch and a vin chaud!

10. Pierre a Ric : The home run from Les Grand Montets ski area and a real leg burner! Always busy towards the end of the day and can get quite cut-up. That said, definitely worth a run down after the morning rush as you don't have to queue too long to get back up.

11. Les Chosalets : A small area consisting of 3 beginner slopes near Argentière. Great for those making their first turns on snow!

12. La Remuaz : A steep black mogul field. The skills and stamina will have been really tested by the time you reach bottom. Again, just make sure Retour Pendant chair is open.

CHAMONIX

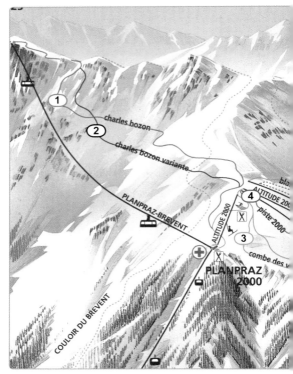

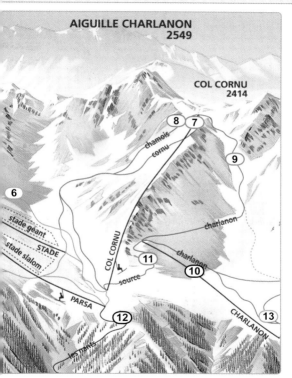

AIGUILLE CHARLANON
2549

COL CORNU
2414

chamois cornu

charlanon

COL CORNU

STADE

stade géant

stade slalom

source

PARSA

les lanz

CHARLANON

charlanon

Chamonix - Brevent

1. **Charles Bozon** : Excellent black/red run from the highest lift at Brevent. Allows easy access to some awesome off piste for the experts. Famous run. Famous views.

2. **Variante Bozon** : As above, but takes a more meandering path down the mountain.

3. **Combe des Vioz** : Fun, nice length blue run that has wide-open pistes and lots of natural bumps to keep even advanced skiers happy.

4. **Piste 2000** : Small beginners run that runs alongside the draglift. Ideal for young children and complete beginners.

5. **Stade** : The race piste where you can look on in envy at the 5yr old stars of the future.

6. **Blanchot** : Fabulous long blue run that skirts around the race piste and ends beside the Col Cornu chair for the brave or Parsa chair.

7. **Chamois** : Another stunning red run that links up with the **Col Cornu** half way down. Some nice off-piste in between the 2 runs.

8. **Col Cornu** : Great red run that offers stunning views across the other side of the valley from the top of the Col.

9. **Combe de la Charlanon** : Fantastic long red run that joins **Variante de la Charlanon** for the brave halfway down or take...

10. **Variante de la Charlanon** : A relatively mellow black run that is accessed from the Charlanon piste and takes you to the Charlanon chair or the link cable car over to Flégère.

11. **Source** : A gentle blue at the base of the Col Cornu rock formation.

12. **Les Nants** : A narrow winding black that leads back down to the Savoy nursery slopes and offers wonderfull views through the tress. It's not steep after the top bit, but does need good snow cover and is best done first thing in the morning. If left until late in the day it can get busy.

13. **Les Tretas:** Medium lengthed blue run from the Charlanon chair that will keep beginners happy. Just watch out for the skiiers joining halfway from the red **Charlanon** run or the black **Variante**.

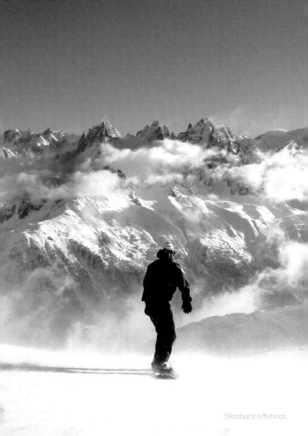

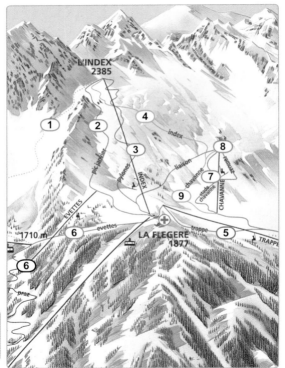

www.snowfinder.co.uk

1. **Combe Lachenal** : You can be completely alone on this excellent run, which gives you an idea of the solitude that big mountain skiing brings. Lots of off-piste options available as this is the only piste in a huge bowl - just beware of those cliff drops!

2. **Pic Janvier** : Another challenging long red, again offering stunning views across the valley, and with plenty of off-piste opportunities.

3. **Pylones** : A good long red offering excellent views across the valley towards the Mer de Glace. Plenty of opportunities to take short off-piste lines.

4. **Index Chavanne** : Very wide blue with a steepish top section. Relatively quiet most of the time so another good practice area particularly for those long carving turns.

5. **Trappe** : An excellent green beginner run. Nice and wide and most importantly no steep sections to catch you out.

6. **Praz, Evettes** : Brilliant long winding black (starts off from the base of the red Evettes) all the way back into Flégère. The only skiable option back down so if in doubt take the cable car.

7. **Stade** : Area reserved for the local kids to demonstrate just how good and fast they are!!!

8. **Remuaz** : A relative short red but with plenty of opportunities to explore the many off piste gullies.

9. **Liaison Chavanne/Flégère** : Starts near the bottom of the Index run and will take you back to base of the L'Index lift.

10. **Crochues** : A long, challenging and quiet red. Taking the short drag lift takes you to the highest lift point in the Flégère ski area. Access to some fantastic off-piste terrain - just don't stray too far to your right!

11. **Floria** : A long black ending back on the Crochues piste. Again a quiet run allowing you to explore some off-piste (particularly on the lower section as you can spot your exit points back onto the piste)!

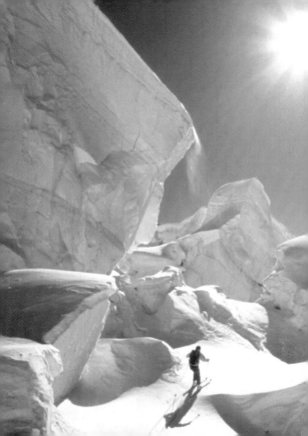

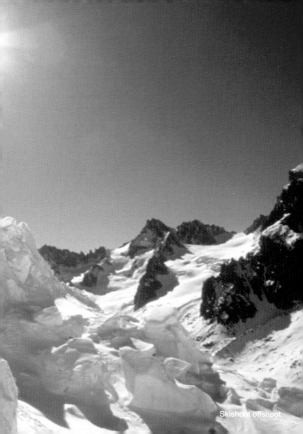
Skishoot offshoot

Trois Vallées region

Introduction

The Trois Vallées is such an unbelievably mammoth ski area that it's hard to put words to paper that can express how good it is - the answer is obviously to just go there. There are 4 major resorts: **Courchevel, Méribel, Les Ménures, Val Thorens**, each with their own unique atmosphere, style, image and stereotypical Brit visitor. All this, however, has changed massively over the last few years with the massive increase in different types of snow-user and the radical change in the way visitors can get to the resorts.

Courchevel has always been seen as the big boss - rich, full-to-the-brim of eurotrash (and more recently eastern eurotrash!). **Méribel** - the pretty alpine capital for young gap-year Sloanes in the 90s and sometimes criticised for being too low down at 1450 metres (to 1740 for *Méribel-Mottaret*). **Les Ménures** with it's distinct lack of prettiness and emphasis on budget travel, right up to the 2300 metres highest of all Europe's resorts, **Val Thorens**, with its 3000 metres plus testing glacial red runs and incredible views.

We have asked some equally eclectic powderhounds to help us out: **Alain Baxter,** first ever Briton to win an *Olympic ski medal*; **Pat Sharples**, International pro freeskier; **Sean Langmuir** - British No 1 Slalom skier in the 90s and Olympian at Albertville; and **Eric Berthon**, *Moguls World Champion and coach of the French Olympic Gold Medal winning freestyle team at Salt Lake City*. That probably says enough...

The good
- Incredible range of linked skiing in a huge area.
- Resorts to suit all types and budgets .
- Snow guarantee at **Val Thorens**.

The not-so-good
- Can get pretty expensive, especially **Courchevel**.
- No ski in ski out, crowds and Brits in **Méribel**.
- The heavy trek to get up to **Val Thorens**.

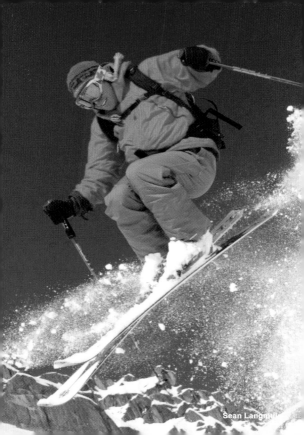
Sean Langmu[...]

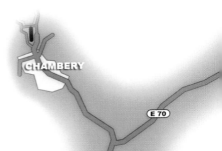

Getting There

Fly: from UK to *Geneva Airport* (120km), *Lyon* (125km) or *Chambery* (75km) via Easyjet, flybe or Bmibaby. *Chambery* can be reached from *Southampton & Birmingham* via flybe.

Drive: from *Geneva* get onto the **A41 E712** Motorway through *Annecy* to *Chambery*. Turn onto **A43 E70** to *Albertville* then **RN90** to *Moutiers*. From *Lyon* take **A43 E70** to *Chambery* then the same route.

Coaches: run regularly from *Geneva Airport* - book online at www.altibus.com. There are regular taxis.

Train: The nearest rail station is *Moutiers* (25km from *Trois Vallées*). Excellent bus service from the station to resorts.

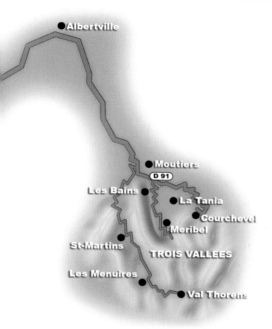

Albertville

Moutiers

D 91

Les Bains

La Tania

Courchevel

Meribel

St-Martins

TROIS VALLEES

Les Menuires

Val Thorens

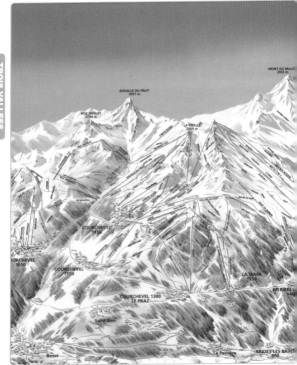

MONT DU VALLON
2952 m

AIGUILLE DU FRUIT
3051 m

ROC MERLET
2734 m

LA VIZELLE
2659 m

COURCHEVEL
1850

COURCHEVEL
1650

COURCHEVEL
1550

LA TANIA
1350

MERIBEL

COURCHEVEL 1300
LE PRAZ

Saint Bon

Bozel

La Perrière

BRIDES LES BAINS
600

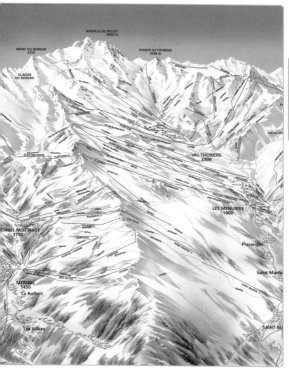

Tourist Office

Courchevel + 33 (0)4 79 08 00 29
Méribel + 33 (0)4 79 08 60 01
Les Ménuires + 33 (0)4 79 08 73 00
Val Thorens + 33 (0)4 79 00 08 08

Main office

La Croisette, BP 37
73122 Courchevel
France

General website/email

www.les3vallees.com
info@les3vallees.com

Resort websites

www.courchevel.com
www.meribel.net
www.lesmenuires.com
www.valthorens.com

3 Vallees Ski passes

Discounts available for seniors, under 16, season passes, early season, spring skiing.

Half day €34
Day €42
6 Day €210

Insurance
Carré Neige €2.50 per day

COURCHEVEL
1850 m

MOTTARET
MERIBEL

Combe de la Saulire

SANGLIER

Méribel Mottaret
MARCASSIN

Sarah Winterflood

Courchevel & La Tania

I have spent a pretty good chunk of my life in Courchevel ever since I started with the British Ski Team. My mum, Sue and stepdad, Kenny run the Supreme Ski School in Courchevel 1850. In my early team days I spent a good bit of time there training on the awesome race piste, Stade, alongside many of the French racers.

Courchevel is such a top set-up, like many resorts, built just after the war above the *Bozel* valley on government dosh to encourage tourism. It is situated in the *Trois Vallées*, with cheap flights into *Geneva*, 2 hours by car and 3 hours by bus to and from the resort. There are also flights into *Lyon* and *Grenoble* - both around same transfer times. And *Courchevel* being what it is ie. full of the jetset, you can even fly direct to the Altiport. Might need to buy a lot of lottery tickets before this becomes a regular thing though! Trains run into *Moutiers* and it is half an hour on from there to *Courchevel*.

Courchevel connects into the *Trois Vallées* - the largest ski area in *Europe* and this makes it quite unique, in that it is pretty massive on its own with plenty of all level type skiing, but when you realise how much skiing and boarding there is to be had, it's quite awesome. It was the venue for *Ski jumping* and *Nordic* combined at the *Albertville Olympics in 92*.

The variety of skiers visiting range from your films stars and royalty to your *average joe* on a package holliday - and everyone seems to love the place. The resort breaks down into 4 very different sub-resorts: **Le Praz** at 1300 is the original pretty French village, from where you can visit the very nice, car-free, purpose-built little village of **La Tania**.

La Tania is a really good little spot to visit whilst you're here - not least because you can ski down through the trees, grab a beer in the village, and then you're still only 2 lifts away from either *Méribel* or back into *Courchevel*. It is almost an **Alps** rarity in that it has an awful lot of charm but is pretty new - built in the 1990s.

By Alain Baxter

Current British Olympic medal hopeful.
First British Olympic medallist ever Salt Lake 2002.

1550 is custom built and not the most attractive; **1650** ditto but a little more pleasing on the eye; and **1850** is a proper job done properly: attractive; jam-packed full of designer stores; considerably higher up than the others; only chalets; ski in ski out...you know the drills... that's what makes it such a pull for the *euro jet-set*.

In terms of the slopes, there is a great variety of action to be had - particularly for intermediates. When you hit **1850**, it seems all you can see are slopes you want to get into! There's also plenty of extreme stuff up here too - couloirs galore. Snow quality is normally good and consistent with most slopes facing North. The pistes are always well-looked-after although sometimes in early season, there may not be a great deal of depth. Of course, they thought of this ages back though, and there is always stacks of man-made where needed. From mid January onwards, the consitions are usually brilliant. The resort is pretty safety conscious and they do not open any avalanche prone slopes. Slush in spring is usual. Lift queues - the lift system is modern and fast so they are minimal apart from usual school hols.

Chalet holidays are the best value as hotels tend to be hellishly expensive (4 star hotel = big credit card bill!) and luxury apartments compact and bijou (also = big credit card bill!). For non-ski days, there's a good ice rink, hotel swimming pools only, bowling, climbing wall indoors, great gym, arcades and shopping, and of course, the apres ski is second to none.

It is always good to go back because there are loads of Scots working in **Courchevel**!

My favourite runs

Best off-piste
Grand Couloir. There's a narrow, tricky path to get there, but this is an awesome chute. It's not as bad as it looks! If in doubt, take a guide with you.

Right at the top of the mountain is the steep part and north facing slopes have good powder. **Swiss** is the bumps run - they get pretty massive and can be icy - lovely!

Best black run
Get up to **Loze**, then follow **Bouc Blanc** and turn off on **Jockeys** - great challenging and scenic black run with a good long finish through the trees down to **Le Praz**.

Best red run
Combe de Pylon - fab red run from top of mountain - get all the way up to *Vizelle* and charge down all the way into *1850*. Great views and a great run.

Best blue/green
Get **Pralong**, **Biollay** or **Super Pralong** up to **Biollay** - magic easy blue with interesting terrain straight back into 1850.

Best eats
The best mountain restaurant for me is **Bel Air** at the top of the *gondola at 1650* - it's better value than alot and very popular so you have to book. Great food, good service. Wins every time.

Après

There are plenty of restaurants in *1850 area*, although they are normally on the heavily expensive and up-market side. Prepare yourselves for a bit of a shock to the sytem!

On the mountain - **Chalet de Pierres** and **Le Cap Horn** - isn't it funny how the higher up you go, the more expensive it gets? I always think over a tenner for a drink is a tiny bit silly! **Jacques Bar** and **Le Saulire**, both in t*he Square* are quality and you can get away with an OK bill!

Nightclubbing at heart-stopping prices takes palce at the old favourites - **Les Caves** and **La Grange**. The **Jump** at *1850* is the place for the euro-cool. Nightlife is normally pretty hazy later on but the **Kalico** at *1850* is the most popular haunt.

Try **Le Bubble** at *1650* for Brit-style boozy lunch or evening beers a convenient short walk from the lift station. Also **Rockies** and the revamped **Signal** bar are worth it. *1650* restaurants of note are **L'Eterlou** and **Le Petit Savoyard**, and for a bit better value - **La Montagne**.

Further down the valley, try **Chanrossa** in *1550* which gets good later on too and apres-ski central, **Glacier Bar** and **La Taverne**. **Le Darbeilo** in *Le Praz* is fun, or to eat, the famous **Bistro du Praz.**

La Tania is not the most blessed apres ski and eating venue in *Trois Valées* but that's not really why you go there. A couple of good (primarily because they are reasonably priced!) restaurants - **Le Bouc Blanc, Chenus** and **Roc Tania.**

Ski down through the trees to the stylish chalet bistro and bar, **The Hotel Télémark** is a great stop-off pub and hub of drinking and good value eating in *La Tania*. Head for the **Pub le Ski Lodge** for beers and bar food in particular, or the very cool, modern **La Taiga Restaurant & Bar.**

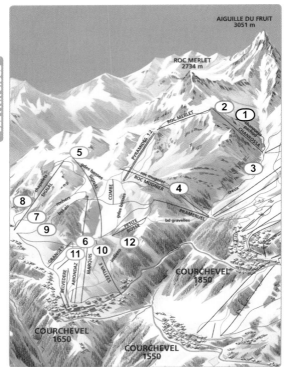

AIGUILLE DU FRUIT
3051 m

ROC MERLET
2734 m

1. Chanrossa : RHS (skiers right) is good for moguls after a dump - LHS is good morning off piste. A must do whether on the bumps at the side or the piste. Plus of course the link to 1650.

2. **J Pachod :** The red that runs down from **Chanrossa** parallel with the better-known black. Challenging and quite steep.

3. **Creux :** Gets heavy & green late in the season as is low & the main way back to 1650. A good alternative in the sun and an option vis a vis the steeper bit at the top of the Saulire Bowl.

4. **Combe roc Mugnier :** If conditions are good, a nice red with second section in the trees. However, can be patchy and rocky. Good connector back to 1850.

5. **Grandes Bosses :** Short simple blue - useful as a link-up to get you down to the blues heading into 1650.

6. **Ariondaz :** The only way back to 1650 - turns into a bit of road & then joins all the gentler slopes.

7. **Rochers :** Look at the name to take a stab at what may be a bit of a problem for this red!

8. **Chapelets :** One of the best runs in 1650. An excellent piste, especially after a big dump & great fun through the trees. Lots of places to build your own jumps to learn on, if that's your thing!

9. **Bel Air :** Best restaurant on 1650 piste. A bit of the beaten track but that is the point. Trainy enough at the top with possibly a few bumps at the bottom. An outlook that makes you feel that you have reached the extremes off the lift system.

10. **Marquis :** Often crowded with beginners, which it is fine for. Lots of artificial 'machine made' snow.

11. **Piste Bleue :** Solid beginners slope down below **Ariondaz** and so, the main route back to 1650. Expect the obvious.

12. **Indiens :** Great place to learn to board on. Tree-lined, therefore in shadow most of the day & almost flat!

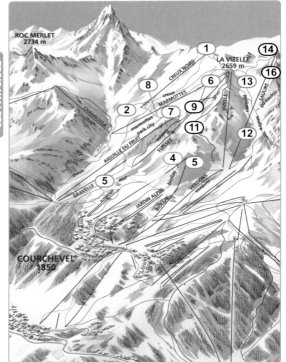

Courchevel 1850 - Saulire

1. **Roches Grises :** Very high, sunny red just off Creux Noirs lift which is fantastic if there's been afresh powder dump. Links up with Creux.

2. **Creux :** Long straightforward red, steep at the top and some bumps. Useful to make your way back to 1850 without going to the top of Vizelle.

3. **Bd Lac Creux, Cave des Creux :** Creux splits at the bottom section. Go left to take these two options down to Prameruel.

4. **Pralong, Biollay, Petit Lac :** Nice easy beginner/improver runs close to the nursery slopes, to play on before trying Mur & Marquetty.

5. **Marquetty, Mur, Biollay Verdons :** Well groomed wide-piste reds. Good option for beginners and improvers making the step up.

6. **Marmottes :** Good moguls/bumps when open - gets a lot of sun & so goes patchy quickly.

7. **Park City :** Gets icy but is often a better alternative down to Suisses. Good intermediate level.

8. **Rama :** Short linking red to get you from Fruit chair to Marmottes.

9. **Suisses :** Great moguls - very steep. Be careful late in the season around the edges as it often gets crevasses & avalanches. Famous for the bumps. Often very quiet!

10. **Piste E :** Exposed steep and fast black run, heading straight down the Vizelle ridge. Often uncrowded and sunny.

11. **Epaule Vizelle :** The challenging and steep black alternative to get you from Vizelle down and back up to Saulire.

12. **Combe Pylones :** This is a quality winding run from the top of Vizelle all the way down to Verdons.

13. **Belges, Combe Saulière :** Like Pylones but with crowded and ice. Best once the pistes have shut & first thing in the morning.

14. **Sous Le Télé :** Short steep, exposed black down from the summit of Saulire under the cable car for (expert) posers.

15. **E Allais :** Take the same route from the cable car for **Grand Couloir** and turn right for steep expert couloir action in the second of the 3 Couloirs.

16. **Grand Couloir :** The most famous and they reckon the steepest route down Saulire. Challenging couloir set-up for the extreme only.

Courchevel - Chenus & Loze

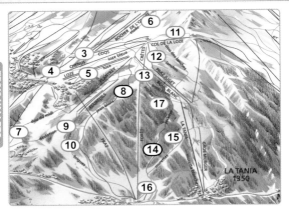

Chenus

1. **Lac Bleu** : Chenus is an intermediate playground and this red epitomises the area: well-groomed, not too steep and sometimes crowded. Fun slope after lunch.

2. **Lac Bleu** : Good undemanding beginner slope.

3. **Chenus, Coqs** : Good after lunch workout blue runs if you happen to have been looking at the (stunning) view from either of the two restaurants at the top – a popular stopping off point.

Loze

4. **Loze Bleu** - Very nice winding but easy run - often basking in sunshine too. Provides a good long run down into 1850.

5. **Loze Rouge** - A motorway red for those going back into 1850. Always busy after lunch and at the end of the day.

6. Stade, Slalom - The town race pistes, regularly shut for local race competitions. Sense of inadequacy easy to get here when you see the tiny racers going much faster than you ever could!

7. Dou du Midi - A really good long red that is the home run for many of the slope-side chalets and anyone going down to 1550. At the top of Dou du Midi lift many turn off to Le Praz to on Brigues.

8. Jean Blanc - awesome, well-known black all the way down through the trees to Le Praz. There is the option to turn off on...

9. Déviation 1550 - To take you back to 1550. Much of the same stuff and sometimes a little busy azt the end of the day.

10. Brigues - Red run through the trees to take you back down to 1300. Very low so sometimes suffers from patchy snow and ice.

La Tania

11. Dou des Lanches : You get to this great uncrowded red by taking the green Col de la Loze from the top of Col de la Loze (with its amazing views) and turn off left to link up with the La Tania pistes.

12. Lanches : Straightforward, undulating and isolated red offering great views and a bit of relief from the crowded 1850 side of the mountain.

13. Jean Blanc : One of those runs where the resturant here is one of the mian reasons to do it! Great spot, always busy though so need to book.

14. Jockeys : Off-piste through the trees for good advanced and experts. This run is fantastic. The piste itself is also good, goes low near the end so snow isn't always good, but a great run.

15. Stade de Slalom : Really good for intermediates who feels that they want to start to get some speed up on skis and boards. They can certainly do that here.

16. Murettes : Excellent long red run to practice turns on the undulating rollers. Also links up with Jockeys near the bottom if you have a bit of bravado going on (it's not steep that low on Jockeys anyway!).

17. Bd Arolles : Good long blue through the trees from Crêtes down to Bouc Blanc and then onwards into La Tania.

Skishoot Offshoot

Méribel *By Pat Sharples*

Top British freeskier.
Head coach of the British freeski camps.
Former England freestyle captain.

Adrian Myers

Méribel has always been very special to me as it is been right on my door step for the last 12 years. My favorite spot for freeriding is playing on the couloirs from the top of Saulire which joins Courchevel and Méribel.

There are two main areas to the resort: **Méribel Village** (1450 metres) up the valley from *Brides-les-Bains*. This is a traditional town centre for the many chalets and the place to go for apres ski and nightlife; and **Méribel Mottaret** up the mountain (1750 metres), sandwiched between the *Saulire* mountain adjoining *Courchevel 1850* to the north east and the long ridgeline of *Tougnete* adjoining *Les Ménuires* and *Val Thorens* to the south. **Méribel-Mottaret** is a stylish ski in ski out collection of chalet complexes, with all the snow access but is a little lacking on the late night party action front!

Méribel has traditionally been seen as an upmarket chalet resort for most of South West London to debus to for winter holidays. It has always had so much more to offer than this little stereotype suggests.

For example: it is the nearest to the *Trois Vallées* hub of *Moutiers*; it is the best situated resort in the *Trois Vallées* to access all of the extensive options; it is very easy to get up to the off-piste heavy zones of *Saulire* and *Val Thorens*; and, **Méribel** and **Mottaret** also have the best freestyle parks in the region! They are well maintained and have a great selection of jumps halfpipes and rail slides. If playing in the park is your thing, then you should check it out!

Best off-piste
The Death Couloir is the Holy Grail of couloirs for me - totally amazing when the snow conditions are right. There is also a great couloir, easy enough, from the top of the *Becca* chairlift. Hike 30 metres up to your right then drop over the back to *Mottaret*. Take a guide with you to get the best out of it.

Best black run
La Masse, a whole mountain of good skiing with the Lac de Lou itinerary off the back or take itinerary down to *Bettex*. Otherwise if you like your bumps, try **Bartavelle** on *Mont de la Challe*.

Best red run
Allamands, very popular but good pitch. If not, go up *Mont du Vallon* and shoot down the *Combe Vallon* or *Campagnol* down. Both are steep at the top and get mogully, and both are normally pretty quiet.

Best blue/green
Grand Lac, blue run from *3 Marches* down to the new *Les Granges* chair then continue all the way to *San Martin de Belleville*. **The Blanchot** green coming down through the trees near the *Altiport* is one of the best beginner runs you'll find.

The only regular negative criticism you'll often hear is that **Méribel** is low down so it's prone to a lack of snow, particularly early season and in spring. True but think about how easy it is to get on a lift and get anywhere in the *Trois Vallées* where there definitely will be snow!

So cast aside the stereotypical crap you've heard spouted about **Méribel** and come and see it for yourself. Rarely is anyone dissatisfied with the decision to visit!

Après

Starting up the mountains, *Méribel* is just as good as its neighbour *Courchevel* at charging stupid prices for average food. However, there are one or two spots which are bearable and even good!

The most famous of them all, and a great party spot is **Le Rond Point**, where you'll find large-scale partying from lunchtime onwards. Try the well-known **Les Castors** at the bottom of the green *Truite* run on *Mont de la Challe*. For traditional Savoyarde mountain food, ambience on the balcony go to **Le Chardonnet** at *Pas du Lac* cable car, **Chalet Tougniat** at *Combe* chairlift. For real budget, go to **Fast Food** in *Mottaret*.

In town, if it's pizza you like then head to **Pizzeria du Mottaret** or for pizza with a 'covered-in-lager, vodka-shot, chalet-girl' type of ambience, **Pizza Express** above the old favourite party venue of choice, **Dicks Tea Bar,** and even more of the same at **Le Plantin**. **La Chrismamara** in *Mottaret* is good for light lunch, sarnies etc. Also **Zig Zag** for a good value lunch with nice staff to boot. There's a nice little tapas bar on the way to *Chaudane* called **Bar Le S** and many of the locals swear by the bar at the **Lodge du Village.**

Les Enfants Terribles is a good wine bar, and the locally-known **The Tav (La Taverna)** is another good apres ski spot. **Rastro's** at *Plattières* lift station is excellent.

For beers/clubbing, try the big one - **The Pub, Le Loft** for a cool smokey club scene and **The Ice Café**. Many of the trendies head for **Jack's Bar** straight off the piste at *Chaudane* for early evening shots and happy hour, or if you want something a bit more chilled, **Scott's Bar** or **Chez Kiki.**

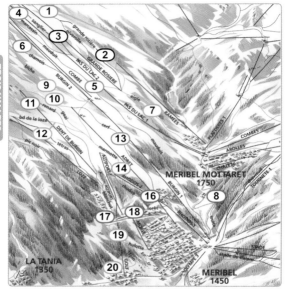

Saulire & Altiport

1. **Nivorolle** : The beginning of this run is quite flat but don't be deceived as it soon steepens into a pretty exciting quality red run.

2. **Grande Rosière** : A run to test your ability - steep fast and sometimes icy. Good advanced standard plus.

3. **Sanglier** : A very steep and challenging run, good for getting the adrenaline pumping. One of the best in Méribel in our book.

4. Marcassin : Very nice cruisey red for intermediates.

5. Mauduit : Long well-groomed red from the top of La Saulire to La Chaudanne. Perfect for intermediates.

6. Chamois : Slightly mogully at the top but nevertheless an easy red - recommended for improvers just taking the step up from blue.

7. Aigle : Great run back from the Pas du Lac 2 although gets busy.

8. Chardonneret : A very flat and easy piste for beginners linking Mottaret to Meribel. Also crowded especially at the end of the day.

9. Biche : Great run for intermediates with fantastic views over the valley. Beautiful scenery and nice cruisey run. Excellent.

10. Geai : Sweet and easy for beginners. Joins up to Belette.

11. Renard : Difficult red - quite steep. A challenge for any intermediate and it's one of those reds that advanced skiers/boarders will love.

12. La Loze : Good long run for intermediates when the snow is good - get your GS head on and tank it down!

13. Cerf : A wide-pisted red, great for practising those carving turns.

14. Marmotte : Good run for beginners/intermediates taking you right back into Méribel to the Côtes lift. Gets you off Cerf if you're tired!

15. Belette : Short linking run to **Rhodos** green.

16. Rhodos : Easy green for beginners to practice turns although it can be surprisingly steep for a green in places. Just what you need!

17. Blanchot : The best place in Méribel for beginners. A long, wide and easy piste to beat first time nerves! Top place to take the kids too.

18. Forêt : A nice green going away from the Altiport although pretty flat and narrow in places so be prepared to schuss or pole!

19. Hulotte : The only run to lead directly back to Morel down past the altiport. Doesn't often get too busy though.

20. Lapin : The only run to lead directly back to Méribel Village.

21. Doron : The only run back to La Chaudanne on the Saulire side for very confident beginners. Can be narrow and busy in places.

TROIS VALLEES

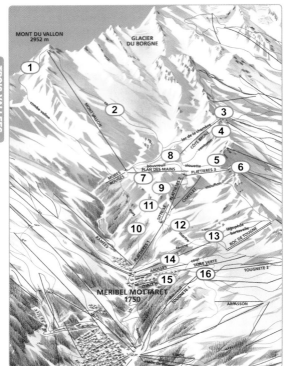

Mont du Vallon

1. Combe Vallon : Long runs which are relatively quiet except during high season. Be wary of the steep and sometimes icy top section.

2. Campagnol : Long, steep and challenging red with some real quality moguls. Amazing views from the top and possibility of off-piste.

Mont de la Chambre & 3 Marches

3. Lac de la Chambre : A long easy red after a steepish start from the top of Côte Brune chair (and amazing views) in this red run playground area.

4. Venturon : Difficult red but a great opportunity for off-piste in powder. Surprisingly steep and bumpy in places. Good intermediate run.

5. Alouette : Nice challenging intermediate run. As per **Venturon**, often great in the powder.

6. Mouflon : Relatively easy intermediate run with some good off piste beside - off the other side of Plattières chair to Alouette, but can be reached from Mont de la Challe too.

7. Bouvreuil : Good run coming off of Plan des Mains chairlift. Burn your legs by doing it straight after **Venturon** or **Alouette**!

8. Bouvreuil : Quite flat and thus a really straightforward run. Good blue to purge the hangover before you go back up the mountains.

9. Rossignol : Wide and easy well-groomed blue piste.

10. Ours : Blue run linking bottom of Mt Vallon to Mottaret. Gets busy with the traffic coming down into town.

11. Sizorin : Joins **Martre**, almost all flat. That's about it!

12. Martre : Flat traverse across the mountian.

13. Coqs : A short red but not too difficult - really a linking run to get you back and forth to Tougnète.

14. Hermine : Lovely little run from the top of Arolles back into Mottaret but can be icy at times.

15. Perdrix : A little steep to start but once mastered is easy the rest of the way. Good confidence builder for beginners close to the facilities of Mottaret.

16. Furet : Flat beginners run, but I guess you expect that don't you!

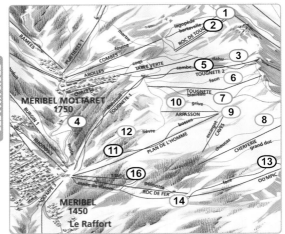

Mont de la Challe

1. Lagopède : A really good confidence-generator for those beginners making the step up to intermediate level. Not too steep.

2. Bartavelle : Great mogul field (at the top of a drag) to get those legs working! This is a real favourite run in Méribel.

3. Dahu : Link between Méribel and Mottaret. Not much more to say than that, other than the obvious propensity for crowds.

4. Truite : The only direct piste linking Mottaret and Méribel. A nice cruise through the trees.

Tougnète & Roc de Fer

5. Combe Tougnète : A fantastic black, steep at the top but then eases off to become a great run for those intermediates who wish to try a black.

6. Faon : An easy intermediate run to gain confidence - nice and long and really good fun in the powder.

7. Blaireau : Wide and long intermediate run often with good snow.

8. Choucas : A run for confident beginners/intermediates to improve their carving turns or short swings in relative peace and quiet.

9. Escargot : Best in the morning when the snow is good - links up with the long Gélinotte for a full mountain-ride feel!

10. Grives : Nice and easy blue to traverse over towards the Tougnète bubble.

11. Bosses : A mogully back recommended only for the experienced. Snow conditions are not always the best so it can be real demanding stuff.

12. Lièvre : A nice blue bringing you back to La Chaudanne down through the trees.

13. Face : Crowdless black which isn't too daunting for the reasonably competent intermediate/basic advanced skier/boarder.

14. Gélinotte : A good blue leading back to La Chaudanne. Can get icy later in the day.

15. Villages : The only run down to Le Raffort and Les Allues. Only open when snow conditions are good.

16. Stade de Slalom : Often closed for competitions where you can see big names race under floodlights.

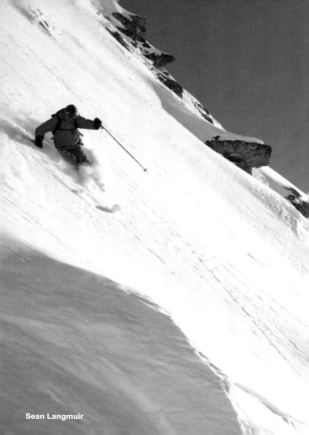
Sean Langmuir

Les Ménuires *By S. Langmuir*

Britain's No 1 slalom skier in the early 1990's.
29th at the 1992 Albertville Olympics .

Les Ménuires has always had a not-inconsiderably sized chip on its shoulder about where it sits in the Trois Vallées pecking order. Over the last five to ten years, the powers that be have fired the PR people (if there ever were any), got their arses in gear and decided to develop Les Menuires ot what it really could be.

As a result all new buildings are built in chocolate box Savoyard chalet-style and several luxury developments have been built to attract a slightly different clientele to normal (ie. those with plenty of dosh and their rich friends!). This is all about shaking off the *'about-as-pretty-as-a-logging-factory'* image - one of the negatives, and you only have to nip into the **Les Bruyères** or **Preyerand** to see it done properly.

In our opinion, one of three best things about the place are that it has to be the cheapest place in the sometimes jaw-droppingly expensive *Trois Vallées*, although this is definitely changing.

The other two are that **Les Menuires** is at 1800 just down the valley from *Val Thorens*, giving it easy access to incredible skiing up the valley or over the mountain to *Méribel* (and actually, plenty of which is on its own slopes). Add to that alot of slope-side apartments with ski in ski out and we're beginning to get a rather different picture.

It does suffer a bit from the fact that many of the slopes being over-exposed to the sun (great for tans, not so great for snow conditions). It does get cold up here though, even though often sunny. It is easy

Best off-piste

I normally head to the north face of **La Masse** which is the best off-piste black area. There's a number of very good options down from *Lac du Lou* on the *Val Thorens* border, best ridden with a guide.

Best black run

Hard to beat the steep black that runs down from the **Pointe de La Masse** itself. Has plenty of moguls and a good spot for a bit of freestyling in front of the laydees!

Best red run

The Jerusalem red run from the top of the dreaded *St Martin drag lift* (being replaced this season) all the way back down into town is hard to beat for beginners taking the step up and intermediate cruisers. Wide open piste with excellent snow quality all season.

Best blue/green

The Grand Lac, **Pelozet**, **Biolley** run down from the top of *Grand Lac* traversing across and then down to *St Martin* is a real winner. In fact a 1300 metres vertical drop of a winner. Tiring but a great achievement, particularly for the ambitious beginner. Give it a go!

to get anywhere as the lift system is good and efficient. There's plenty of beginner and intermediate slopes straight up from the village on the **Bruyère**, **Bettex** and **Doron l**ifts, with Doron leading to the *pretty-damn-good* snowpark. For more serious stuff, get up to the north face of *La Masse*, particularly for off-piste blacks.

Après

Chalet des Glaciers and **Les Clarines** are recommended for the top-end diner. You could also try **Le Ménuire Hotel** or **Auberge des Balcons** for the raclette or fondue option. The **Marmites du Géant** is good for a meat fest.

Otherwise, down the budget scale, there's the **Perdrix Blanche** or the **Trattoria** for pizza, and **La Haçienda** for the obvious alpine mexican meal you are bound to be lusting after!

Particularly if it is your first trip out of the *Méribel Valley*, the runs down to *St Martin* are a great way to get used to the vastness of the area - try stopping at **Brewskis** or **La Voûte** for a congratulatory beer.

Because the resort has a high percentage of package holiday clients, it is not as blessed with options as neighbouring *Méribel* for example. Many people are self-catering and there are plenty of fast food options all over the place.

Get down to the Dutch **Yeti** in *Preyerand* for the best of the apres ski, with happy hours, shooters, load music and large sessions being the norm.

For clubbing options, head up to *Reberty* to the **Leeberty**. In *Croisette* there's Passport - a typical French 'deescotek', **Rocks Café** if you want to offload a decent amount of cash on not much in particular, and **La Mousse** is a reasonably laid-back hangout, often frequented by resort workers (and it has web access).

TROIS VALLEES

MONT BREQUIN
3130 m

LA MAURIENNE

3 VALLEES EXPRESS

ORELLE
900

POINTE DE LA MASSE
2804 m

①

LAC DU LOU

⑤

②

③

③

④

masse

longet

crêtes

rochers

LA MASSE

MASSE 2

lac-noir

LES ENCOMBRES

LAC NOIR

dame blanche

⑥

⑧

vallons

MASSE 1

ROCHER NOIR

rocher-noir

envers

⑦

⑤

1. Masse : This area is off-piste central, however it is unpisted, unpatrolled and un-signposted so do not go without a guide and all the correct safety equipment. Masse is a great run - lots of moguls & easy to show off on over 1100 metres vertical drop back into town.

2. Fred Covili : Can get very windy up here. However, a good long run that holds the snow well and is quite steep in places.

3. Longets, Crêtes : Good challenging reds with spectacular views. Don't take Lac Noir lift unless you want to hike up to the start.

4. Lac Noir : Really good storming black run, full of beastly moguls and funnels. Good advanced skiers will love this.

5. Rochers, Rochers Noir : Excellent red/black piste from the top of La Masse lift down past the huts and into the steep black part. Expert slope. Off-piste options with a guide abound.

6. Dame Blanche : Real exhilaration here - steep, vertigo-inducing and amazing views. Not always open. Experts only.

7. Vallons : Very sunny blue - normally all day if the sun's out, but does therefore have a tendancy to get slushy & green especially down the bottom.

8. Les Enverses : Steep, quality red that splits at the bottom to Tortollet or back to Reberty. Stunning views down to town.

TROIS VALLEES

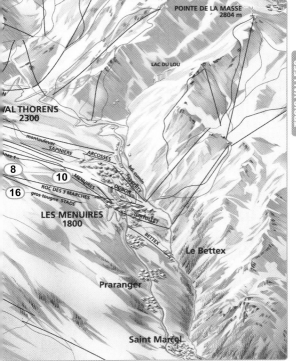

Mont de la Chambre

1. Plan du Bouquet : At the bottom of Pluviomètre and one of the busy routes back to the 3 Valleys cable car.

2. Mont de la Chambre : Long wide-open blue with great off-piste options on the way back to Méribel.

3. 4 Vents, Montaulever : Brilliant, very long red with open groomed piste from the top of Les Bruyères down to link up with Montaulever into town.

4. David Douillet Haut : The much-used red down from the top of Mont de la Chambre with black piste options to get back into town.

5. Léo Lacroix : Turn left off the David Douillet at the top for this quiet black with good snow conditions and testing pitches.

6. Etele : Bumpy black with a couple of steep pitches back into town.

7. Combes, Beca, Lac des Combes : The trio of reds at the top of Beca chair - a real intermediate playground for non-stop red run skiing and boarding.

8. Petit Creux : A welcome release for those of you with tired legs from David Douillet, **Pylones** red or Combes down to town.

9. Pylones, Croisette : A choice of two good blacks from the top of **Etele**.

10. Ménuires, Boyes, Reberty : Three blues close to town - nice and easy options for beginners and improvers.

3 Marches

11. Snowcross Park : At the top of Beca lift on the right hand side. The best snowpark in the resort.

12. Allamands : Alternative red option to 3 Marches back into town.

13. 3 Marches : Good intermediate cruisey red back into Les Ménuires.

14. Grand Lac, Pelozet : All the way back into St Martins via a 1300 metre vertical drop, linking up with Pelozet. A new six seater is being installed at Grand Lac for this coming season.

15. Teppes : Nice wide-open red with good snow all season. Flattens out at the bottom to take you to either Les Men or down to St Martin.

St Martin

16. Gros Tougne : Very long blue, great for beginners to get confidence up, from the top of St Martins back to Les Men.

17. Pramint : Wide-open piste that remains good all the way through the season. They are also replacing the St Martin drag lift this year. At last!

18. Riondaz : Another good red - wide-open piste just waiting to be carved up!

19. Chat Frère : Excellent beginner slope - great snow, well piste-bashed and long.

20. Verdet, Biolley : Nice long tranquil blue, away from all the hustle and bustle of the resort bringing you back down to the bottom of St Martin drag.

21. Jérusalem : Cruisey red run for developing intermediates to get time on skis/boards. Holds snow well through the season.

TROIS VALLEES

Val Thorens

Val Thorens is often thought of as the jewel in the crown of the Trois Vallées, and with some justification. It is the highest alpine resort in Europe at 2300 metres. The resort nestles in a valley beneath the peaks of Aiguille de Peclet (3562 metres), Pointe de Thorens (3266 metres), Pointe du Bouchet (3420 metres), Sommet des 3 Vallées (3230 metres) and Mont Brequin (3130 metres) and is quite rightly famous for it's enormous expanse of off-piste and glacier riding.

Being this high means that if there's snow, **Val Thorens** will have it - from late November all the way through to spring, with good quality summer glacier skiing. Many of the pistes face north, adding to the snow quality and making it even better when the sun shines. There is a flip side to all of this though, and that is driven by the weather. It can be bitterly cold, icily windy and regular whiteout territory (so don't forget your thermals!)...

...and you know what? If this does happen, it's just a simple matter of shooting across to *Méribel*, *Les Ménuires* and *Courchevel* for some lower altitude treeline skiing or taking advantage of the all the non-snow activities the *Trois Vallées* offers.

One important point to note though that often catches people unaware: watch your times, particularly if you came from *Courchevel*. You have to make the connection to the *Méribel/Mottaret* side and then the *Pas du Lac Bubble*. It can take quite a bit of time at the end of the day when pistes are busy anyway and the taxi ride back is very expensive.

Val Thorens is also a really quite attractive place to hangout, given that it is a big purpose-built set-up, the village itself is compact with many facilities including bars and restaurants, and a large amount of the accomodation is slope-side and ski in ski out.

Pistes are generally very well-maintained and the lift system (30 lifts from town) is incredibly efficient, even in peak times and French school holidays. Hard to knock VT, that's for sure.

Zoom-Agence

TROIS VALLEES

The weird irony about **Val Thorens** is that it is famous for its amazing challenging black runs and off-pistes, but in actual fact, the majority of its slopes are beginner and intermediate slopes. Its even got an awesome Snowpark with a quality boardercross area.

Just about every other alpine sporting activity can be found here for those days where you've had enough of the snow (which we can more or less guarantee will be few!).

Zoom-Agence

My favourite runs

Best off-piste
The classic **Cime de Caron** at the top of the téléphérique de *Caron*. There are many variations here, including getting a guide to take you into the *Fourth Valley* for the experts.

Best black run
My favourite black run is the **Plan de l'Eau** (to the right of the summit of the *Boismint* chair, 900m of gradient steepness).

Best red run
The Glacier and **Lac Blanc** runs over on the *Glacier du Peclet* are challenging, steep in places and fast. Finish on the *Stade* run back into *Val Thorens* for the piece de la resistance. The *Col de L'Audzin* down from *Cime de Caron* is authentic back country skiing.

Best blue/green
Moraine or **Genepy** from the top of *Moraine* lift back down into town is a good long leg-stretcher. Otherwise take the two *Trois Vallées* chairs out to *Col de la Chambre* and shoot down through the valley on *Pluviomètre*.

Best bar/eats
Definitely the **Rhum Bar** - the place in VT to drink rum and enjoy life. A friendly crowd. I also like the **Irish Pub** and **Le Malaysia**. To eat, my favourite places are either **Le Scapin** for traditional Savoyarde dishes, **La Cabane** for a night out, or **L'Oxalys** down the bottom of the resort.

Zoom Agence

Starting from the highest you can sensibly go, try **Etape 3200** at the top of *Cime de Caron* (and effectively the *Trois Vallées* themselves). Amazing views. Also check out **La Bar Marine** at the top of the *Cascades* lift.

All the beautiful people, and many others besides, rave about the new kid on the block, **L'Oxalys** (the usual drill of *book-early-and take-out-a-second-mortgage* apply) but also, great Savoyarde food can be had at **Le Scapin, Le Vieux Chalet, La Joyeuse Fondue** and Bar Marine. Others heavily recommend **La Paillotte.**

Vin chaud at **Le Monde** is always a post-ski winner or the other international apres ski joint is **Bloopers.** A special little favourite of mine is breakfast in **Le Delice Café.**

The most famous Brit bar in VT is **The Frog & Roast Beef** - I'm sure you can work out what that's like, and if you can't, don't go there! 2 doors down is **O'Connells** and I'm sure you can work out what that's like too!

Another spot where it gets table-dance-y is **The Viking. Tango** is the bar to go for the scandi-fetishists amongst you (of whom there are always many and quite right too when you see the bar staff). For tequila fiends, it has to be **El Gringo.**

There is then **Le Malaysia** with quite a cosmopolitan vibe, **The Irish Pub** with a Fr-irish (french/irish) vibe, and the very cool **Rhum Bar.**

There are only 2 nightclubs - the one where we more or less guarantee you'll be is the **Underground** - hardcore partying night after night with all the expected shooters, promo nights etc.

Val Thorens

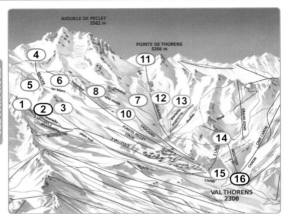

1. Pluviomètre : Very good long cruising blue run well away from the lifts and the crowds. Great place to stop off for a picnic. Watch out for the rocks and enjoy the spectacular views.

2. Marielle : Short steep and bumpy black with amazing views from the top of 3 Vallees 2. Exciting off-piste if you take a guide.

3. Plein Sud : Nice long meandering blue run as the main run back into VT. Wide slope with moguls in the middle - great for learning otherwise worth staying away from!

Glacier de Peclet / Chavière

4. Glacier de Peclet : Hop on the Funitel up to the Glacier at 3101 metres and get onto the glacier. It may get very cold and windy but the snow is awesome and this run is high, fun and has incredible views. Summer skiing here too.

208

5. Lac Blanc : The very long extension of the Glacier. Wide-open, great snow and if you get a dump of powder, the place to be.

6. Béranger : Guaranteed snow, this run gets quite steep in places and is a quality red for intermediate mile-eating.

7. Christine : A fantastic back-country run, traversing you all the way across from the glacier to join up with the Moraine blue run. Definite off-piste options all the way along but take a guide.

8. Tête Ronde : Take the right fork off Christine and either stop off at Dalles to relax at the restaurant or head further down if you're into freeride and boarding for the snowpark.

9. Dalles : Nice and easy blue leading to the town greens and snowpark.

10. 2 Combes : Take this blue from the bottom of Tête Ronde to get you across to Portet and the Montée du Fond.

11. Col : Excellent red right up under the shadow of Tete de Thorens. They do not call this the fridge for nothing but the view emerging over the top of the lift is something else. There's great off-piste including the route to the Fourth Valley! Ask a guide…

12. Moraine : A good quality long follow-on blue at the foot of Col with good powder either side of the piste if there's been a dump.

13. Genepi : Thi is an alternative run to Moraine in this excellent intermediate area.

14. Chalets : At the top of the 2 Lacs chair overlooking the lake and **snowpark**, you'll find this good intermediate blue.

15. Hermine : Winding blue off the back of 2 Lacs chair to get you across to the Caron cable car. Good little run for intro to off-piste with a guide.

16. Arolle: Quality semi-off-piste black from Moutières chair almost parallel with Hermine blue.

TROIS VALLEES

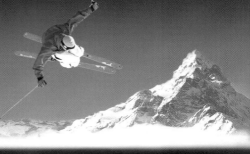

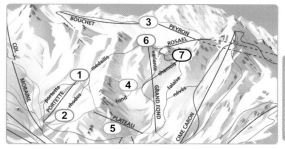

1. Portette : Straightforward red run with some bumps and quite steep in places. Nothing to trouble most intermediates.

2. Rhodos : The other side of the Portette chair, this red is actually the bottom section of **Medaille** and **Niverolles** blue.

3. Niverolles : One of the highest blue runs in VT, and therefore France. Good intro to higher altitude skiing for improvers.

4. Fond : Similar style and standard of run and snow quality as **Niverolles** - excellent for improvers making the step up from learning.

5. Plateau : Basic blue that takes you across to Caron area via the Grand Fond Funitel. Pretty standard with no surpises but great for gaining confidence if you're a beginner.

6. Médaille, Variante, Falaise : Three very similar reds serviced by the Grand Fond Funitel. Expect queues at the bottom and crowds at the top! Powder-hounds should take a look at Falaise if there's snow around. You can also take **Mauriennes** and **Gentianes** off the back to get you down to Orelles.

7. Chamois : A good option if you like your moguls. It also gets you away from the crowds and opens up off-piste options for experts.

8. Lagopède : Linking blue from Rosael via Plateau to Caron.

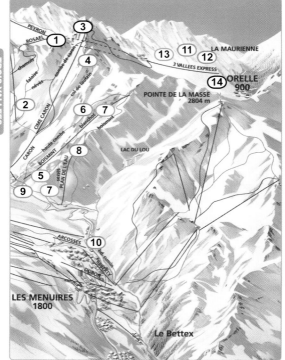

Sommet des Trois Vallées

Mont Brequin & Cime de Caron

1. Combe Rosael : A really enjoyable run for good skiers and boarders. Often very mogully and closed due to high winds & lack of snow, but get it right and it is something else.

2. Névés : Welcome to the cruise zone! Long lazy red run for developing intermediates and upwards. In the shade though.

3. Combe de Caron : Worth it for the views alone - not only of Val Thorens but the whole mountain range which is quite staggering. Very popular, but nevertheless excellent black run.

4. Col de L'Audzin : Total back-country! This steep undulating red has it all. Good when there's powder, access to off-piste, incredible views.

5. Gentiane : Just when you thought your legs were going to fall off after the red or black off Cime de Caron, a saviour blue run cruiser down to the base of Boismint!

6. Haute Combe : Another good red option from Blanchot down to Boismint. May have a bit of ice off in places.

7. Blanchot, Tétras : The blue off the back of the chairlift that links with Tétras all the way down to 1800 and Plan de l'Eau chair.

8. Boismint : Sweet red run that is out-of-the-way of the crowds and with a guide, opens up a world of off-piste.

9. Plan de L'eau : The red version of Tétras. Again, out-of-the-way and rarely too busy. Good one to get back down to Les Ménuires.

10. Boulevard Cumin : The route back to Les Ménuires - a little narrow and icy and sometimes a bit busy bit all in all, fine.

Sommet des Trois Vallées

11. Bouchet : If you can bare the amount of (very cold) time in the chair lift this is a good red run that is well worth it for the views alone!

12. Coraia : Exactly the same as Bouchet. A long old way to get freezing cold, but hey, who knows what turns you on?!

13. Peyron : Easy blue with a long schuss at the bottom.

14. Boardercross : If freeriding, tricks and jumps are the only reason to be on snow - this is where you should head.

Skishoot onshoot

Paradiski region

Introduction

Paradiski is the latest addition to the line of newly-created super-resorts or regions - linking **Les Arcs** with **La Plagne** and **Vallandry Peisey** - all in theory facilitated by the introduction of the *Vanoise Express* 'super' cable car. *Tout est super ici!* There is much *vent chaud* about whether this was ever necessary and whether anything good has or ever will come out of it, but frankly, do we really care?

Suffice it to say that there is an aweful lot of snow-bashing to be had here: from the various resorts-within-resorts at **Les Arcs** (*Arc 1600*, *1800*, the super-sexy new american-built *Arc 1950* and *Arc 2000*) to the quieter, more established **Vallandry and Peisey** villages, to the brash and much-maligned-for-its-architecture (do you see the theme developing here in France?) **La Plagne**, with its awesome, reliable snow and nicely-manicured pistes. At the risk of sounding like a holiday brochure, there's something for everyone here.

Introducing the resorts, the talented **Lesley McKenna** - an unbelievably good snowboarder - in fact, only Britain's most successful *Snowboard World Cup competitor* ever and top 5 in the world. For *La Plagne* we have asked **Fabien Bertrand**. You think you can handle the bumps? **Fabs** is the *Chef d'Equipe ski de bosses FSS*. What? Oh, he runs the French mogul ski team!

The good
- The 7km **Aiguille Rouge** from top to bottom!
- Very snowboard-friendly, especially **Les Arcs**.
- Ski in ski out to the max with high-probability snow.

The not-so-good
- The non-Savoyarde non-village *'charme'* of **Arcs** & **La Plagne**.
- Not as big a party scene as some of its neighbours.
- Privacy and lack of crowds at peak season.

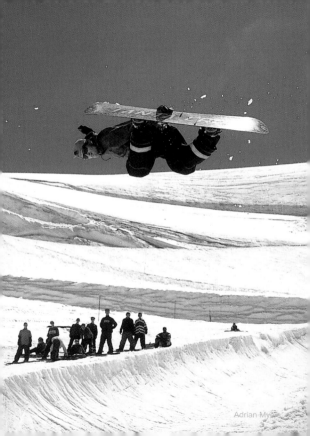

Adrian Myr

Getting There

Fly: from UK to *Geneva Airport* (120km), *Lyon* (125km) or *Chambéry* (75km) via BA, Easyjet, flybe or Bmibaby. Chambery can be adversely affected by the weather conditions.

Drive: from *Geneva* get onto the **A41 E712** Motorway through *Annecy* to *Chambéry*. Turn onto **A43 E70** to *Albertville* then **RN90** to *Moutiers*. From Lyon take the **A43 E70** to **Chambéry** then the same route.

Coaches: run regularly from *Geneva & Lyon Airports* - book on-line at www.altibus.com, as well as taxis.

Train: The nearest rail station is *Moutiers* (25km from **Paradiski**). There is a very good bus services from the station to the resorts via *Aime*.

www.snowfinder.co.uk

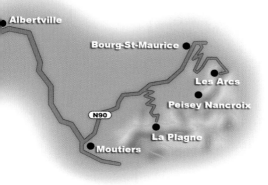

Albertville

Bourg-St-Maurice

Les Arcs

Peisey Nancroix

N90

La Plagne

Moutiers

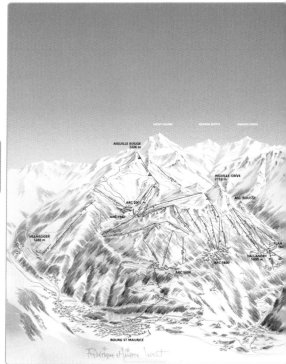

MONT POURRI GRANDE MOTTE GRANDE CASSE

AIGUILLE ROUGE
3226 m

AIGUILLE GRIVE
2732 m

AIG. ROUSSE

ARC 2000

ARC 1950

AIGUILLE ROUGE

PLAN PK

VILLAROGER
1200 m

VALLANDRY
1600 m

ARC 1800

ARC 1600

BOURG ST MAURICE

Frédérique et Hervé Smet

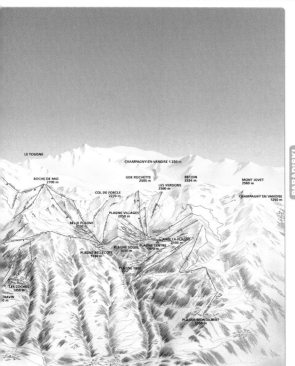

LE TOUGNE

CHAMPAGNY-EN-VANOISE 1 250 m

ROCHE DE MIO
2700 m

GDE ROCHETTE
2505 m

BECOIN
2504 m

MONT JOVET
2560 m

COL DE FORCLE
2270 m

LES VERDONS
2500 m

CHAMPAGNY EN VANOISE
1250 m

PLAGNE VILLAGES
2050 m

BELLE PLAGNE
2050 m

AIME LA PLAGNE
2100 m

PLAGNE SOLEIL
2050 m

PLAGNE CENTRE
1970 m

PLAGNE BELLECÔTE
1930 m

PLAGNE 1800

LES COCHES
1450 m

HAVIN

PLAGNE MONTALBERT
1350 m

Need to know

Tourist Office

Les Arcs	+ 33 (0)4 79 07 12 57
Peisey Vallandry	+ 33 (0)4 79 07 94 28
La Plagne	+ 33 (0)4 79 09 79 79

Main office

105 place de la Gare
73700 Bourg Saint Maurice
France

General website/email

www.paradiski.com
lesarcs@lesarcs.com
bienvenue@la-plagne.com

Resort websites

www.lesarcs.com
www.peisey-vallandry.com
www.la-plagne.com

Paradiski passes

In brackets, Les Arcs or La Plagne - only pass prices. Discounts available for seniors, under 16, season passes, early season.

Day	€46	(€39)
6 Day	€229	(€186)

Insurance

Carré Neige	€2.50 per day

Skishoot offshoot

Les Arcs - Peisey-Vallandry

Les Arcs was one of the first of the big ski resort developments to take place in the swinging sixties, designed for functionality, ski in ski out and to open up the slopes to the masses. Well it has certainly managed that! The first and lowest of the now 4 purpose-built resorts was Arc 1600, containing most of the chalets. No prizes for guessing what the architecture is like. We think the guy who designed the apartment blocks was on the same stuff as the guy who did La Daille in Espace Killy!

Not content with this, and partly due to the success of what the planners set out to do with the resort, they have subsequently built **Arc 1800**, **Arc 2000** and the newly developed (and very nicely done) American-built **Arc 1950**.

Arcs 1600 and **1800** have everything the good intermediate skier and snowboarder could dream of - stacks of easily accessible reds and blues, with 1800 linking easily with the next-door resorts of *Vallandry* and *Peisey*. In fact **Les Arcs** itself has over 200km of runs.

Arcs 1950 and **2000** open up access to the fantastic *Aiguille Rouge* (3226 metres) and its black run glacier skiing and boarding, excellent off-piste options and the awesome *Aiguille Rouge* black/red run all the way down (just the full 7 km) to neighbouring *Villaroger*.

If it's après ski and nightlife you're after, **Arc 1800** is where it happens. It is no coincidence that the busiest and most crowded ski area (and believe us, it can get seriously crowded) is also the place where it all goes off at night! Also there's the **Apocalypse Snowpark** at the top of *Clair Blanc* chair lift which is as good as any in the French Alps. One last point to note is that it is a very good place for families to bring kids too.

So there's stacks to do in **Les Arcs**, as you'd expect from such a big purpose-built resort, no matter who you are or what you ride. Don't be put off by the bad press about the place *looking like a housing estate* and give it a go...

Current British Olympic medal hopeful.
Top 5 in Snowboarding World Cup.
Has won two Snowboard World Cups in 2003.

Nowhere near as popular with the Brits as the bigger, brassier neighbours, these two tranquille villages lodged in the middle of forestry are still great options for families, beginners and those who just want a bit of peace but to benefit from access to the bigtime snow and nightlife of the rest of Paradiski - and this place could not be served better for that purpose by the Vannois Express.

Both village have their fair share of restaurants and bars that all tend to be less busy than *Les Arcs* and *La Plagne*. In **Peisey** try **La Buvette, La Cordee** or **La Ferme.** A real little gem in these parts is **L'Ancolie** but booking is recommended.

PARADISKI

Skishoot offshoot

My favourite runs

Best off-piste
Powder-hounding off-pisters head straight for **Aiguille Rouge** or off the back of the *Col de la Chal*. Despite being overshadowed in this area by neighbouring *La Plagne*, you'll still find plenty to keep you happy. Get a guide.

Best black run
It has to be the massively long **Aiguille Rouge black/red**. Either get the *Lanchettes* lift up from *Arc 2000* for the red or ski the black version of the same name from the cable car at the top of the glacier. Super long and finishes through the trees at *Villaroger* village.

Best red run
Again from the cable car at **Aiguille Rouge** take the *Arandelières* down the *Glacier du Varet* all the way round the bowl into *Arc 2000*. Great views down towards the resorts too.

Best blue/green
I am a big fan of the long **Mont Blanc** blue from the top of *Mont Blanc* chair through the trees into *Arc 1600* (particularly if you have just come down the black *Deux Têtes* from the summit). Otherwise, **Villard** or **Grand Melezes** from *Arpette* down to *Arc 1800*.

Best eats
Belliou la Fumée is perfect for the original French mountain experience - great food, beautiful scenery and isolated from the rest of the world. Fabuleuse.

Après

An absolutely lovely mountain hunting lodge restaurant in **Pré-St-Esprit** in the *Arc 2000* region (not the easiest to find up this way) is **Belliou la Fumée.**

We also like the **Ferme** at the bottom of the *Villaroger* for those of you who need to rest your legs (most of you!). More straightforward and functional, but good and reasonable is **La Crêche** at *Transarc Gondola.*

Arc 2000 has the popular **Latino Loco** for typical Italian mountain fare, and **St Jacques** for good local french. Fairly devoid of alternatives though.

Arc 1800 offers the very cool Italiano, **Casa Mia**, for a bit of a celebration in a modern and elegant setting, nip to **Le Petit Zinc** in *Hotel du Golf.* **La Marmite**, **L'Equipage** or **Plante d'Baton** are also recommended. *In Arc 1600*, try **Yeti** for standard French alpine and **L'Arc a L'Os**, for the up-market version. **Mountain Café** and **La Santaline** are the pick of the budget eateries.

Bar life is centred around *Arc 1800*, and indeed the apres ski mecca of **La Gabotte** and **Bar le Thuria** in *Le Charvet.* **Red Rock Bar** is probably the trendiest bar of the moment with very late night opening, and the **Crazy Horse** in *Arc 2000* get busy too. **Benjis** is where the workers hangout (also known for its stripper nights!).

The main club for dancing an generally unacceptable behaviour is **Apokalypse** with **Le JO Rock Bar** for live music being a good shout.

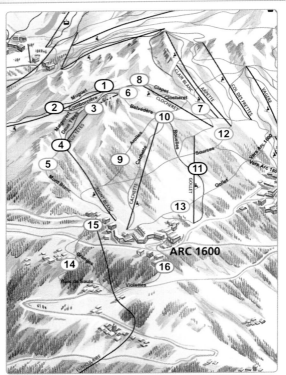

1. Muguet : When well groomed this can provide an exhilarating schuss onto the **Comborcières** piste. Not really the most hardcore of black runs.

2. Comborcières : Basically one long mogul field. This is the run to confront your bump demons. Always worth trying out.

3. Malgovert : One of the most fun runs in Les Arcs. Trees, rock drops and plenty of off-piste to the side. Not to be missed.

4. Deux Têtes : A great run for trying out you bump technique. Can be tough and some great off-piste below the rocks.

5. Mont Blanc : Good warm up run for learners and improvers or a fun schuss into 1600.

6. Belvédère : A track that takes you round to the main ski area with really stunning views of the valley.

7. Clapet : An easier route down from the top of the Clocheret chair.

8. Clocheret : Can be bumpy and gets carved up at the top but great for carving. Get your GS head on and charge!

9. Arolles : Very nice intermediate red twisting and turning down through the trees. Attracts fewer people than neighbouring Cachette.

10. Cachette : Can be quite icy but a great varied run for carving, bump skiing and slalom.

11. Rouelles : Another long, thigh-burning mogul run. Good, big bumps. Always quiet.

12. Sources : The track most people take to return to the resort. Easy and pretty but very busy at the end of the day. Look out for kids!

13. Gollet : Very flat track heading back into resort. Vers Arc 1600, Vers Arc 1800 : Easy options to get back to 1800 avoiding a longer ski.

14. Bois de Saule : A fun easy ski along the road but only when conditions are good as it loses snow quickly.

15. Granges : Avoid with poor snow but it's more fun than the Funic, that's for sure - especially when it is crowded. Remember to press the button if you want the Funic to stop!

16. Violettes : No-one has the slightest idea if this run is ever open.

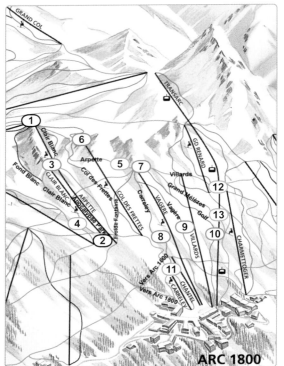

1. Fond Blanc : A short but steep and tricky black mogul run off to the left of Arpette chairlift. A good challenge with great views.

2. Apocalype Park : Plenty to keep everyone amused. The park improves every year and is less indimidating than in some resorts. Very high pose rating given proximity to Clair Blanc chair.

3. Clair Blanc Rouge : This should not be a red - it's pretty steep and bumpy. If you like bumps, here's your run.

4. Clair Blanc Bleu : It can be icy and busy but it is a nice run in good conditions.

5. Arpette : Much improved since the ridge was widened but still very busy but can't be avoided.

6. Col des Frettes : Does not always appear to be a piste-basher priority. Really good wide pistes for speed and GS turns.

7. Froide Fountaine : The perfect run to perfect those carving turns. Good snow, good gradient.

8. Carreley : Much quieter, but longer than Froide Fontaine and slightly flatter.

9. Vagère : Can suffer from poor snow in places but a good long run back to 1800.

10. Golf : Frequently unpisted red reached from the top of Vagère chairlift. Long and exciting, especially if it's a powder day.

11. Chantel : The main run into the resort used by most of the ski schools. Gets heavily crowded.

12. Villards : Some fun rollers over what is the golf course in the summer.

13. Grands Mélèzes : A fun run back down into town through the trees but attracts the crowds.

PARADISKI

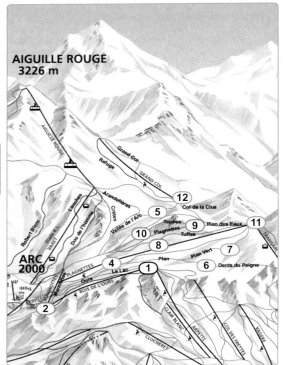

www.snowfinder.co.uk

Col des Fretes- Col de la Chal

1. Ours : Excellent *"Hollywood"* mogul run under the chair with several different routes to choose from.

2. Lac : A gun-barrel of a run which is best avoided during busy periods.

3. Edelweiss : A good alternative to Lac for less competent skiers and avoids the long flat Plan track.

4. Plan : A long flat track which involves plenty of polling all the way to 2000. Borders avoid this at all costs and take lac or Edelweiss.

5. Vallée de L'Arc : A long motorway serving as the main run back to 2000 and so can be very busy.

6. Dents du Peigne : Fun and easy with some easy rollers. Stays empty and good for beginners.

7. Plan Vert : Superb motorway and always quiet now the drag has been taken away. Good for a schuss.

8. Tuffes : Usually remains un-pisted and becomes a fun mogul run with lots of natural hits in the river bed.

9. Plagnettes : Good gradient for some high-speed carving with long run out. Try the gun barrel to the side of the piste next to the drag.

10. Teppes : Plenty of opportunity for high speed carving wth long run out. Quieter than Plagnettes.

11. Plan des Eaux : The best option for less competent skiers but plenty of speed is required to avoid the flat at the bottom.

12. Col de la Chal : Get plenty of speed up to get to the Grand Col chair aong this track. Borders especially take note!

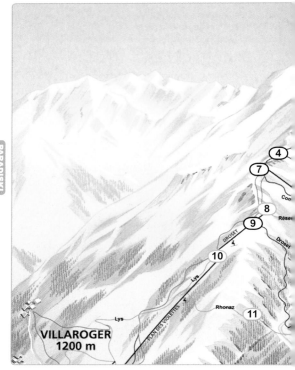

PARADISKI

VILLAROGER
1200 m

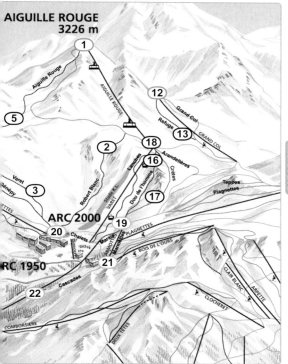

AIGUILLE ROUGE
3226 m

Aiguille Rouge

AIGUILLE ROUGE

Grand Col

Refuge

GRAND COL

Arandellières

Crêtes

Teppes

Plagnettes

Robert Blanc

Varet

VARET K.L.

Lanches

Dou de l'Homme

Vendpy

Varet

ARC 2000

Chalets

Marolts

PRENOTS

Marmottes

PLAGNETTES

BOIS DE L'OURS

RC 1950

Cascades

CLAIR BLANC

ARBETTE

CLOCHERET

COMBORSIERE

DEUX TETES

1. Arandelières : Take this piste if you want to avoid the longer route down the ridge. It provides access to some fantastic drops of Aiguille Rouge or an easy yet busy route off the mountain.

2. Robert Blanc : Steep, frequently moguled run is a good challenge and plenty of off-piste opportunities.

3. Varet : Frequently closed due to wind-swept snow but in powder this can be one of the best runs if caught in the right conditions.

4. Genepi : Can suffer from lack of snow but should not be missed in deep, fresh snow.

5. Aguille Rouge : This piste should not be missed even for intermediate skiers. You should choose this over **Arandalieres**. Stunning views with great snow on what is one of the longest runs in the Alps.

6.Aguille Rouge : A long, varied piste with stunning views, good snow which still remains relitively quiet despite the new Droset lift. For a real test of the thighs ski this from the top of the Aiguille Rouge down to Villaroger.

7. Combe : Good mogul run when snow is good.

8. Réservoir : Easy access back to Arc 2000 if you don't want to continue towards Pré St Esprit or Villaroger.

9. Droset : With deep snow this piste can provide a real challenge. Frequently has some good bump skiing and the drop off the para-avalanche over the road can make for some impressive snaps!

10. Lys : The easier route through the trees down to Villaroger. A good option for beginners or tired legs after skiing the Aiguille Rouge.

11. Rhonaz : Take this piste if you want to avoid ending up in Villaroger. It's a stunning track through the trees but maintain plenty of speed for the lower flat section.

12. Grand Col : Can be very busy as the snow stays good but on the whole this is a wide, well groomed high slope which should not be missed. Also a great way to access some of the off-piste and the rock garden which an awesome playground in powder conditions.

13. Refuge : A good bump run and great for acessing the off-piste on either side of the run.

14. Arandelières : As with Vallée de l'arc, a long, steady flatish motorway serving as the main access to the bottom of the 2000 bowl.

15. Vers Grand Col : A good way to access the Grand Col chair but keep the speed up to avoid pushing when you reach the Grand Col piste.

16. Crètes : Good long mogul run and easy to access the blues if you've had enough of the bumps.

17. Dou de l'Homme : One of Les Arcs best mogul runs. Long and steep in places.

18. Lanches : Slightly trickier than **Dou de l'homme** but another long mogul run.

19. Marais : Excellent beginner run. If you have ever skied or boarded play about on this piste as the St Jaques chair lift is free so no need for a lift pass.

20. Chalet : Flat track back into Arc 2000.

21. Marmottes : A busy run giving acess to some of the main lifts and the new 1950 resort.

22. Cascades : A good long Schuss into Pré St Esprit. Keep the speed up to reach the Comborcières chair lift.

PARADISKI

VALLANDRY

1. **Accès Transarcs** : Easy to miss but take this to avoid heading all the way back into the resort.

2. **Plan Bois** : Keep the speed up along this beautiful track through the trees - a joyous run for the tree-lovers amongst us!

3. **Barmont** : One of the ski area's many track through the trees. Lovely laid-back skiing and boarding as it was intended.

4. **Belotte** : Wide, nicely-groomed piste with excellent snow reliability and conditions. Perfect for those GS and Super G carver dudes and the boarding fraternity.

5. Piste des Bosses : A fun piste down the old drag lift track. Full of kids.

6. **Renard** : Wide open run with fab skiing. Typical of the pistes in Peisey. Why can't all blue runs be like this?

PARADISKI

7. Rhodos : Massive rollers for huge air on this new piste. Awesome fun at speed for all standards and all snow users. Get on it!

8. Maitaz : The track through the trees taking most skiers back to 1800 so it tends to get crowded at the obvious times.

9. Forêts : A long, flat pretty run through the trees - again, pretty typical of the sorts of runs you get in the area.

10. Coqs : A useful connecting piste to access the Plan Bois chair.

11. Myrtilles : Can be icy first thing but again, the perfect for carving when the sun is up.

12. Perdrix : Snowsure and fast route from the highest point in Peisey. Great thigh-burner.

13. Aigle : Perfect gradient for hooning down to the resort. Ideal in a white-out.

14. Morey : As with Aigle. Sharpen your edges for some high-speed carving. Improvers as well as intermediates will love it here.

15. Blanchot : The widest piste you'll ever see. Empty and not to be missed. Now this is what red runs are all about!

16. Ours : A very wide run through the trees. Not as steep as the others leading to the resort which makes it a really good place to get to know your way around red runs if you're starting out.

17. Grive : Ideal for beginners who want to ski at high altitude.

18. Ecureuils : Look out for the rocks and take in the stunning views of Bellecôtte. Great to access the off piste.

19. Stade : Usually closed for competitions but worth ducking under the nets if there is no-one around (obviously we did not tell you that or recommend it!).

20. Ourson : Look out for the ice but take this to access the Vanoise Express to get to Les Arcs or La Pagne. Very busy at times.

21. Retour plan : An easier route down for beginners.

22. Combe : Stunning views and always quiet. Stunning views and always quiet.

Lone rider / Sarah Winterflood

La Plagne *By Fabien Bertrand*

World Cup mogul skier from 1991 to 1997.
Second in World Championship 1993.
First in World Cup events at La Plagne 1993 &
Tignes 1996.

I have a special love for La Plagne and am delighted to give a little insight into the place.

PARADISKI

La Plagne is known throughout the *Alps* for its incredible high altitude off-piste skiing, nestling in a northwest-facing bowl 20km up the valley from **Aime** down beneath the peaks of *Le Biolley* (2100 metres), *Le Becoin* (2594m), *La Grand Rochette* (2505m), *Roche de Mio* (2700m) and the daddy, *Sommet de Bellecote* (3416m).

It is actually a collection of satellite mini-resorts around **Plagne Villages** in the centre of the bowl, the most attractive of which is the aptly-named **Belle Plagne**. So many of the apartment complexes are on the slopes that this place is ski in ski out central.

Most of the action takes place above **Plagne Centre** via the rapid but busy *Funiplagne cable car* or the equally busy *Becoin chair*, and **Bellecôte** via the *Roche de Mio cable car* with its amazing views.

Some people harp on about **La Plagne** being too 'intermediate', mind you, you never get to see these people ski or board themselves, eh? **La Plagne** is in our view unfairly maligned. It has much to offer all on-piste skiers but the real USP, as the marketing trendies call it, is the off-piste.

The north face of the **Bellecôte** has to be one of the most hardcore off-piste zones in the *French Alps*, rivalling *La Grave* and *Chamonix*. The queues to get up there are worth the wait for serious skiers and boarders. It is not just extreme couloirs though, this is the place to

My favourite runs

Best off-piste
North face of **Bellecôte Glacier**. Take the *Bellecôte cable car* up to the summit of the *glacier* (3250 metres) then take the left hand chair onwards. Be sure to take a guide with you.

Best black run
Les Rochus (from the *Bellecôte Glacier*). Take exactly the same route as above. A fantastic winding and bumpy black that will challenge good advanced and expert skiers, cutting all the way back down the valley towards *Les Bauches*.

Best red run
Le Mont de la Guerre (from *les Verdons* until *Champagny*).

Best blue/green
L'Esselet near *Montchavin*. You can take one of the blues down from *L'Arpette* down to the restaurant and then *L'Esselet* take you down through the treeline all the way into *Les Coches* or on to *Montchavin*.

grab a guide for a few days and get into off-piste - try **Grand Rochette**, **Roche de Mio** and **Biolley** for plenty of options.

There's a world of quality pisted runs for all and of course, access to the rest of **Paradiski**. It is not the biggest party resort as each of the mini-resorts have their own bars and restaurants and they are a bit spread-out. However, you have to be fairly geeky or just plain miserable to have a bad time here!

...And on your day off the snow, there's all the usual non-ski activities such as skidoo-riding, parapente and a fantastic 30 degrees big outdoor big swimming pool, to name a few.

Après

Plenty of good few options on the slopes. Up from Plagne Centre, is popular, and for the most excellent views, **La Grand Rochette**. **Le Biollet** above *Aime Plagne* is a suntrap and suitable busy as a result, or try **Au Bon Vieux Temps**.

If you're skiing down to *Montalbert*, stop off at **Le Fornelet L'Arpette** is the cool spot from *Belle Plagne*. **La Bergerie** is a good option up from *Bellecôte*. Further afield, there's the beautiful little huts of **Plan Bois** and **Les Bauches** in *Les Coches*.

In *Plagne Centre* **Le Refuge** is the oldest spot and the real deal local hangout in town. **Le Chaudron** is cosy, laid-back and offers great, reasonbable-priced food. **La Crèpe** and **Le No-Blèm Café** (for TV sport-watching with the locals) are also personal favourites.

In *Belle Plagne* head to **Cheyenne** for tex-mex and shooters, **Saloon** for more cowboy action from apres to very late! Eat at the mega-busy **Matafan**, drink at **Matt's Pub** or the **Hotel des Balcons**, or try **Carlina**.

In *Bellecôte*, there's **La Grange**, **Le Cairn** and **Le Cosi** and for apres ski and onwards into the night, **Show Time**. In *1800* one of the top restaurants in the resort is **La Mine**, but also try **Le Petit Chaperon Rouge**. And in *Aime 2000*, **La Terrasse** or **Le Montana** do the job properly.

The other late-night party options are **King Café, Luna Bar, Bleu Night** in Aime or a bit further afield, the French favourite **L'Oxygène** in *Montchavin*.

PARADISKI

La Plagne - Glacier Bellecôte

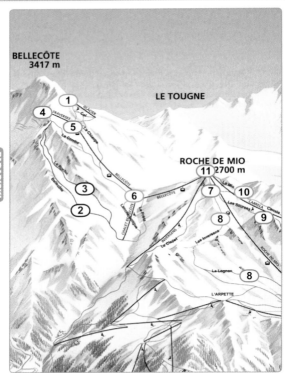

BELLECÔTE
3417 m

LE TOUGNE

ROCHE DE MIO
2700 m

Glacier Bellecote

1. Col, Col 2, La Chiaupe, Deversoir : A selection of the highest, potentially coldest blues with the most panoramic views in the Alps - up at 3400 metres!

2. Bellecôte : Sweet black run that has it all. If you like peace, tranquility and powder, this could be your dream come true. Off-piste central zone.

3. Le Rochu : A fantastic winding and bumpy black that will challenge good advanced and expert skiers, cutting all the way back down the valley towards Les Bauches.

4. La Combe : Lovely red run - conveniently situated for those of you who decide to bottle the two blacks!

5. La Chiaupe : Red off the other side of the Bellecote cable car that joins up with La Combe at the bottom section. Quality snow but gets cut up due to the volume of skiers/boarders using it.

6. Lanche Ronde, La Frete : Two isolated and quiet blues taking you down to the Chalet de Bellecôte. Stop here for a picnic sometime.

Roche de Mio

7. Le Clapet : Long scenic red run down from the restaurant on Roche de Mio to Le Carroley to join up with Les Crouzats to get you down to Les Bauches where you deserve a cool beer! Nearly 1000 metres of vertical descent!

8. Les Inversens, La Lognan : Ski through a tunnel (The Tunnel Des Inversens) then hail the view down to Belle Plagne. One of the most memorable runs in the France Alps.

9.Les Sources : Nice long wide-open red - the back way into Belle Plagne.

10. Carella : Really chilled out-of-the-way blue run down into the Col de Forcle area.

11. La Mio : Isolated red off the right hand side of Carella chair. Short, relatively steep and mogully.

PARADISKI

Belle Plagne - Plagne Bellecôte

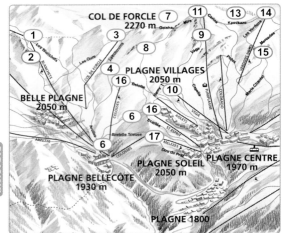

1. **Les Blanchets** : Busy main blue run into Belle Plagne - always well-groomed and a fun early morning run to fire those tired legs up.

2. **Les Rhodos** : Short and sweet bumpy red run.

3. **Les Ours** : Simple blue linking Belle Plagne with Plagne Bellecote. Always busy but never a hassle.

4. **Leitchoums** : Surprisingly relaxed blue off the top of Col de Forcle lift that hooks up with Arolles piste. The high pose-factor Snowpark is at the bottom.

5. **Arolles:** Similar to Leitchoums - always busy.

6. **Trieuse, Bretelle Trieuse :** Long linking blue that carries you between Plagne Bellecôte slopes, Plagne Village and onwards into town.

La Grande Rochette

7. Geisha : Link run from the Roche de Mio and Grand Rochette over to Champagny.

8. Mira : Beautiful long blue with a relatively steep top section leading to a shallow back-country run through the bottom of the valley to the Village.

9. Véga: Steep red along the ridge below the Funiplagne. Bottom section is wide-open and perfect for carving turns.

10. Ramy : Simple blue looking out over the town - last run of the day for many.

11. Carina : Nice red in a south-facing valley. Always seems to be sunny and crowd-free here. Good moguls.

12. Pollux, Capella : Two similar cruisey blues, good for fast skiing back down to Plagne Centre.

13. Kamikaze : The access run to Champagny side of the mountain where you will find the wonderful Mont de la Guerre red. If it is open, it is an absolute must for good skiers and boarders.

14. Les Verdons, Marie Chantal : Very long winding blue run across lovely open terrain finishing through trees into the top of Plagne Centre. One of the best.

15. Mercedes : Bumpy and twisting red run with a 500 metres vertical descent and on eof the best views across La Plagne. Very sunny.

16. Belotte, Ecartée : Two good Plagne Village blues.

17. Dou du Praz : Peaceful little blue run in Plagne Soleil off the top of Mélèzes chair.

PARADISKI

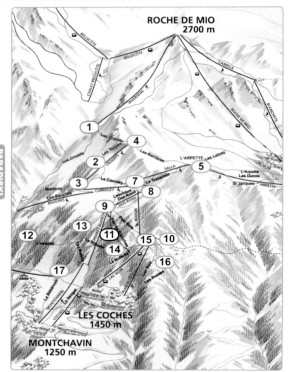

1. **Les Crozats** : A beautiful back-country style red run down to Les Bauches with a nice tree-line finish. Access to plenty of off-piste.

2. **Les Teppes** : Long winding and undulating blue through a wide open bowl. Take you to the other red route options down to Les Bauches.

3. **Malatray, Les Bauches** : Groovy reds - fast at the top in the open section then tree-lined piste sections to finish (recommended for lunch/beer).

4. **Les Barrières** : Shallow traverse across to L'Arpette - links to the blues of Arpette chair and Belle Plagne.

5. **Les Laines, L'Arpette, Les Dunes, St Jacques** : Four similar cruiser blues with lovely views down to Belle Plagne. Reliable quality pistes, nicely groomed.

6. **La Traversée** : Simple run linking Dos Rond with L'Arpette.

7. **Le Carroley** : Typical blue in this excellent learner/improver little area. Great place to watch the freeriders in the Snowpark doing their tricks.

8. **Dos Rond** : Like Carroley. Nicely groomed piste ideal for learners.

9. **Leschaux** : More of the same for all standards!

10. **Plan Bois** : Lovely American-style blue run down through the trees down to Plan Bois where there are a couple of good lunch options.

11. **Pierre Blanches** : Short black through the trees. Bumps and steep pitches. Watch out for the ice though. In powder, a must do!

12. **L'Esselets** : A great cruising run down through the trees.

13. **Les Pelées** : More of the same!

14. **Le Bijolin** : Even more of the same - this area above Les Coches is an excellent beginner and improver playground.

15. **La Buffette, Lac Noir** : Meandering reds down through the trees above Les Coches. Great for short swings with a few bumps thrown in.

16. **Les Preizes** : Quiet blue run - it's really a cross-country run.

17. **Le Réservoir** : Two long cruiser blues all the way back down to Montchavin through the trees. Snow can be patchy as it is so low down, but they have snow-making facilities.

18. **Le Sauget** : Standard blue.

PARADISKI

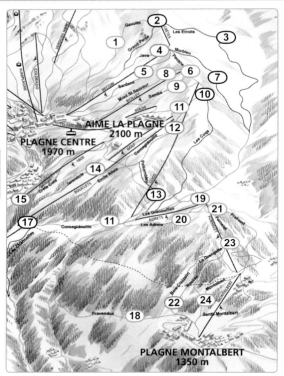

PARADISKI

AIME LA PLAGNE
2100 m

PLAGNE CENTRE
1970 m

PLAGNE MONTALBERT
1350 m

1. **Gavotte** : A spectacular blue off the top of Biolley (2350 metres) winding through tranquil terrain to finish in the trees at Plagne Centre. Excellent powder spot.

2. **Grand Pente** : Steep bumpy black with a challenging top section dropping off the ridge from the top of Crêtes on Biolley.

3. **Les Etroits** : Amazing back-country black run that is just so long. Variety of terrain to test all good skiers and boarders. Take a guide over here to look for off-piste.

4. **Java** : Red version of **Grand Pente** (the black joins Java for the open section back into town) off the Biolley ridge.

5. **Sardane** : This is the piste for night skiing in La Plagne (as it has lights!!!). Good GS red.

6. **Pavane** : Blue run used as a link from the top of Becoin chair to open up the Aime la Plagne area.

PARADISKI

7. **Morbleu** : High quality black run off the back of Crêtes. Always seems to be sunny, quiet and peaceful. Off-piste abounds if you take someone who knows their way around.

8. **Mt St Saveur** : Shallower version of **Sardane**. Good spot to practice those carving turns.

9. **Samba** : Uncrowded blue run looking down over Aime La Plagne.

10. **Les Coqs:** Sweeping long black run along the Biolley ridge then dropping down through some trees to join the motorway down to **Charmettes**. This can be one of the longest runs you'll do.

11. **Cornegidouille** : Blue run, often nearly empty, down through the valley between Aime and Le Fornelet into the Plagne 1800 area.

12. **Emile Allais** : Very long north-facing run through the forest which is usually deserted as there are only a couple of drag lifts to bring you back up.

13. **Palsembleu** : Testing steep black run starting just above **Emile Allais** cutting through the trees down to Coqs chair and beyond.

14. **Jarandole** : Similar piste to **Emile Allais** - good demanding red on tree-lined piste but a very boring long drag lift back up.

Adrian Myers

15. Crête-côte : More of the same above Plagne 1800.

16. Lovatière : Simple blue up a drag lift of the same name in Plagne 1800.

17.Les Charmettes : The steep bottom piste below Emile Allais. Quiet, tree-lined skiing with bumps and gullies to test you. Expert skier slope.

18. Pravendue : Picturesque blue run through trees all the way. Sketchy snow in places but a quality run down to Montalbert.

19. Les Grenouilles : South-facing sunny red run into the bowl below Le Fornelet.

20. Les Adrets : Nice blue run through trees linking back to Cornegidouille. Some of the most assured snow in Montalbert.

21. Fornelet, Pralioud : Two north-facing blue pistes cutting through the trees with good views of the lovely village below.

22. Bois Croizelin, Roclise : A pair of reds in the trees. Snow can be patchy, being so low down, but the snow cannons are good.

23. La Grangette : Main village blue runs for all standards. Snow-making facilities ensure the pistes are packed.

24. Montalbert, Gentil Montalbert : As above.

PARADISKI

Graham Bell

Introduction

Espace Killy. The name shows you the regard in which **Jean Claude** himself is held by the french. The fact that one of the worlds largest ski areas, containing two of the world's best known resorts could be named after one person says alot.

Val d'Isère has the lot: massive extensive skiing and boarding over a huge area, stacks of off-piste, beautiful scenery, rocking nightlife and a chic village with excellent restaurants both up the mountain and in-resort. Lots of chat about this place being *Fulham-on-ice*, but that should not put you off, if it is true.

Tignes: a bit of a modern monstrosity (mind you la Daille in Val ain't exactly Versailles Palace); much easier access to the snow from **Tignes Le Lac** and **Val Claret**; a great snowpark and freeskiing area; plenty of good nightlife and restaurants.

There is so much to do in these two resorts it is quite unbelievable, both of whom have reliable snow and a great variety of non-skiing activities. The orginal ski-resort playground.

We've asked **Graham Bell**, one of Britain's best known skiers, *5 times British Olympian* and now presenter of *BBC Ski Sunday* for his opinion on **Val** and **Hugh Hutchison**, *author*, *double Olympian* and mogul-basher extraordinaire as to what he thinks of **Tignes**.

The good
- Massive, scenic ski area with challenges for everyone.
- Brilliant nightlife in both **Tignes** and **Val**.
- **Val d'Isère** - possibly the best ski resort in the world.

The not-so-good
- A good 2.5-3 hours from the big airports.
- The icy Face run back to resort at **Val d'Isère**.
- The traffic to **Bourg & Moutiers** on changeover.

Sarah Winterflood

Albertville

Getting There

Fly: from UK to *Geneva Airport* (160km/3 hours), *Lyon* (125km) or *Chambéry* (75km) via BA, Easyjet, flybe or Bmibaby. *Chambéry* can be adversely affected by the weather conditions.

Drive: E26 to *La Tuile* then left onto **N90** to *Bourg St Maurice*. Just before *Bourg*, turn left onto **D902** for 30kms, past the **Lac** to *Tignes*. Beware Saturdays turnarounds - it can take 7 hours to get to *Geneva*.(Snowchains definitely for **D902**). They can send you back down to *Bourg* if you don't have them, so buy some.

Coaches: run regularly from *Geneva Airport* - book online at www.altibus.com, as well as taxis.

Train: The nearest rail station is *Bourg* (30km from Espace Killy). There is a good bus services from the station to the resorts.

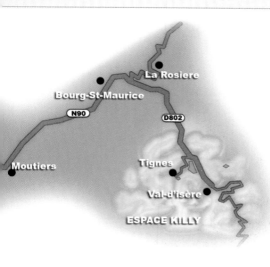

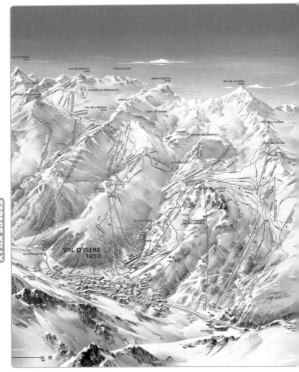

ESPACE KILLY

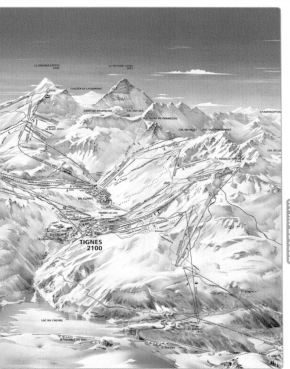

ESPACE KILLY

Need to know

Tourist Office

Val d'Isère + 33 (0)4 79 06 06 60
Tignes + 33 (0)4 79 40 04 40

Main office

BP 51
73321 Tignes
France

General email

info@valdisere.com
information@tignes.net

Resort websites

www.valdisere.com
www.tignes.net

Espace Killy passes

Discounts available for seniors, under 16, season passes, early season, spring skiing.

Half day €29
Day €40
6 Day €192.50

Insurance

Carré Neige €2.50 per day

The Big Moutain RPM' with slope simulator, demonstrated by Graham Bell.

....*YOU CAN BE WITH A SKIER'S EDGE!*

Call Freephone **0800 8494051** for a brochure
or visit our new website www.skiersedge.co.uk

Skier's Edge is a registered trademark of The Skier's Edge Company U.S.A.

Sarah Winterflood

Val d'Isère *By Graham Bell*

Val d'Isère is a rarity in amongst French ski resorts. It has grown from a traditional farming village to one the world's best ski resorts, without sacrificing its charm to the high-rise crazed 1970's architects. The satellite village of La Daille accepted, all the new buildings are built in the traditional stone clad style.

The Premier Neige downhill race held in December marks the start of the European leg of the World Cup tour, and was the closest we ever got to a home race. British resort workers in **Val d'Isère** out-number the local French population, and chalet girls provided rich pickings for testosterone fuelled ski racers. I should know, it is where I met my wife **Sarah. Val de Dooh Daah** is truly the *Fulham Road of the Alps*.

Linked with *Tignes* by the *Espace Killy*, the pistes are well prepared and served by some very speedy modern lifts. There is also easy to access the challenging off-piste, no need to hike for hours here. If you have no intention of skinning up (a mountain), make sure you book a table a **La Fruitière**, on the *Bellevarde* for a long lunch.

Val d'Isère has definitely benefitted from the link up with *Tignes*. The breadth of the region is staggering, for example It is possible to ski all the way from *Bellevarde*, directly above Val all the way to to *Tignes Les Brévières* via the unbelievable black *Sache* run - a staggering distance - just check it out on the piste map and you'll see what I mean.

It has also meant that there are plenty of options to get home for tired or inexperienced legs where previously, the options were the daunting

ESPACE KILLY

Best off-piste

Off the back of *Le Fornet*, there is more than enough to go round. Feels like you're a million miles from anywhere! Pack your beeps and shovel.

Best black run

La Face Bellevarde – home to the Olympic downhill in 1992, and due to be used again for the 2009 World Championships. Do some non-stop runs down here and your legs will know about it. Renowned as a 3-4pm icy side-slip of a route for all but the most competent. Sometimes ressembles a rugby field!

Best red run

Arcelle – From the easy *Madeline express*, you can drop down to *Le Manchet* down a wide open run with lots of inviting rollers. A real blast.

Best blue/green

Genepy – The only challenging part is the first section as you leave the *Borsat Express lift*, then it is an enjoyable cruise down to *Fontaine Froide chair*. Complete the loop by taking the *Mont Blanc*. Great for the kids.

Best eats

In the evening the **Perdrix Blanche** is always fun, and the **Lodge** good value, but if you want to push the boat out visit the **Grande Ourse**. As for Bars your choice is simple, English (**The Morris Pub** or **Pacific Bar**), French (**Café Face/Bar d'Alsace**) or Scandi (**Petit Danois/Victors**).

black **Face** run that overshadows the whole resort and can be an icy side-slipping hell at 4pm as the weather comes in, the blacks and reds of **Solaise** or the challenging 'blue' chute that is **Piste L**!

Val is a serious resort - serious boarding (with an awesome snowpark) & skiing, serious partying, serious snow and serious scenery.

Après

Probably has to be visited once in the lifetime of every serious snow user. Enjoy to the max! **Val** has an embarrassment of riches when it comes to Après - although not necessarily up the mountain. It's not always the cheapest place to go but you can find amazingly good value. It can often be better to shoot over to *Tignes* for lunch.

We are big fans of **Signal Restaurant** just up from *Fornet cable car*. Stunning views and good food. **La Fruitière** and **Le Trifollet** over on the *La Daille* side are good for different reasons - the former is all about partying and has a rocking apres ski, the latter being a good place to chill by the piste on the balcony and eat good trad food (it's mid price). There's also **Marmottes** at the top of *Bellevarde* and the balcony at the restaurant at **Tomeuse** has incredible views out to *Tignes*.

Après ski haunts for the cool, seasonaires and ski bums include **Bananas,** any of the bars at the base of *Solaise* and the fantastic **Café Face,** for really good value beers and great live entertainment. It is jam-packed full early on and then becomes a smokey cosmopolitan club later. **Victors** is quite scandi and grungy, **Pacific Bar** is another resort-workers and clubby hang-out and there's the **Petit Danois,** the excellent **Moris Pub, Café Fats** (for all day breakfast), **Le Pub** and plenty of others for more of the same.

For the once-a-holiday splash out, go to **Chalet du Cret** or **La Grande Ourse** (both are always booked very early so get it done quick, and don't forget the credit cards!!!). **Perdrix Blanche** in town is a good place with a massive menu, including fresh fish and seafood. Just wander up thurough town and your sure to find the good quality old favourite raclette, fondues and other savoyarde classics in the many restaurants you'll pass.

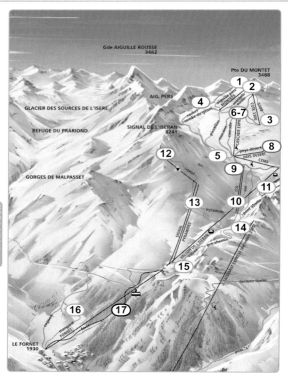

Val d'Isère - L'Iseran & Fornet

1. **Aiguille Pers** : Nice easy wide Blue always empty can get very cold and windy.

2. **Montets** : Simple, short wide run ok if you can use a Tbar lift. Good to access the Pays Dessert off-piste run.

3. **3300** : Only open in the summer - seems to be rarely opened dependent on the winter season.

4. **Rocher** : Only just a red. Nice long run for your first red piste not to steep can involve poling at the end not so good for boarders.

5. **Pissaillas** : Fairly steep blue but wide, snow is always good can access off-piste in between the pistes.

6. **Moraine** : Cruisy red the snow is always good being on the glacier watch out for crevasses in the off piste.

7. **Cascade** : Much the same as **Moraine**.

8. **Pays Désert** : Very short narrow piste down to the drag lift.

9. **Céma** : Very flat slow run to the cascade chair lift.

10. **Col** : Has a long steep schuss but probably easier than Pont Abatte.

11. **Pont Abatte** : Can be very flat and a lot of shussing but ultimately worth it.

12. **Signal** : Very steep and narrow at the top can be sheet ice, most people can't get up the long steep button lift but a good run to get the adrenalin running.

13. **Pyramide** : The bottom part of the **Signal**. Nice easy blue, good for those who don't fancy the steep **Signal**.

14. **Pré-chemin** : Natural gully good fun for those young at heart who don't venture into the **snowpark**.

15. **Vallon** : Can get very busy at lunch times as all the piste join here to get to the Signal restaurant but ultimately a nice blue.

16. **Mangard** : A very challenging piste not recommended for beginners has a very steep schuss at the bottom always skiable due to good snow cannons.

17. **Forêt :** This can vary on the time of year recommended for very good skiers only, narrow in places and can have large moguls.

ESPACE KILLY

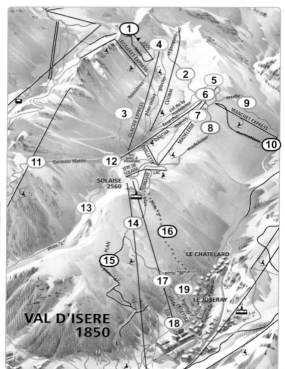

ESPACE KILLY

VAL D'ISERE
1850

1. 3000 : Very steep mogul field opens half way through the season.

2. St Jacques : A slow two man chair lift takes you to the top, which is very narrow and steep for no more than 20 metres then opens up to a very pleasant red. fantastic cugnai powder run off the back best with a guide.

3. Leissières : A undulating run can involve some polling if snow is heavy.

4. Glacier : All round cruisey blue with a fast chair lift. stunning views don't forget the camera.

5. Col de la Madeleine : Easy blue with shuss at the bottom.

6. Fourche : Slightly steeper than the Col De Madeleine very nice piste.

7. Marais : Very much the same as above.

8. Madeleine : Easy green run for getting those ski legs back watch out for the ski schools.

9. Arcelle : Long challenging red the sun comes round late morning can get quite heavy under ski.

10. Marmottons : Very much the same as Arcelle, some great skiing with powder snow. Watch out for the partly hidden foot high fences

11. German Mattis : Perfect tree run for those white-out days some very good skiing with fresh snow. A good way to end a day on the hill.

12. Lac a Mountons : A narrow section to access the marmottons lift or German Mattis.

13. Piste L : Natural gully can ski back to Val centre does involve some polling at the end. Can be closed due to avalanche risk.

14. Plan : Open wide piste get very busy at peak times.

15. Piste A : Narrow piste through the trees nice alternative to the blue Piste M.

16. Piste S : Can be a steep mogul field very challenging.

17. Piste M : Steep choppy and narrow in places not an easy blue run.

18. Stade : Small piste sectioned off with a small slalom course.

19. Legettaz : Good for beginners to practise on has a small drag lift.

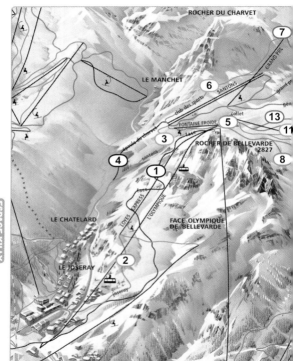

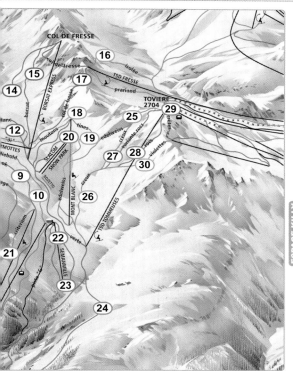

Val d'Isère - Bellevarde

1. Face : The legendary Olympic downhill, this piste changes by the minute, from flat open piste to three foot Moguls best to be skied around lunch, a great achievement to tell your friends back home.

2. Joseray : a challenging piste, the conditions are very much like the **Face**.

3. Santons : A natural half pipe can get very overcrowded at peak times but a good way to Finish the day, at the bottom is The Clochetons which has a good sun terrace for that well-earned vin chaud.

4. Epaule du Charvet : A very open faced black can be very moguled and patchy, an alternative to the Santons for the more experienced skiers.

5. Fontaine Froid : This is a nice fast red run can get quite choppy.

6. Club des Sports : A rolling blue good for the morning warm up, often close due to avalanche risk. Some good skiing with fresh snow.

7. Grand Pré : Fantastic wide easy green for beginners for there first experience off the nursery slopes. A very good off piste section off the back recommended to take a guide as known for its avalanches.

8. Orange : A steep wide piste can find some icy patches. Follow it down through the trees to the Funival.

9. OK : It shares the top part with the Orange then splits and goes past the famous Follie Douce restaurant down to La Daille. A nice red with great views.

10. Diebold : Starts at the top of the Bellevarde is a wide open blue with a long knee aching schuss. it follows the OK down to La Daille.

11. 3i : Very much like the top of the Diebold but finishes before the schuss at the Marmottes lift.

12. Verte : The top part is a smooth piste for beginners wanting to progress, once past the Follie Douce it gets quite steep and narrow not recommended for nervous skiers or beginners. Can access the off piste valley called Vallée Perdue (The lost valley).

13. Mont Blanc : Wide open piste for beginners.

14. Genepy : Steep and can develop moguls at the top but a very nice piste to get back to the Grand Pré, a good area for picnics and easy to reach off-piste.

15. Borsat : A cruisey green with some schussing at the end. The Borsat chair lift can get very cold.

16. Isolée : A fairly steep blue joining the flat Tignes piste **Genepy** towards Val Claret.

17. Col du Fresse : A road way piste to access Tignes.

18. Moutons : A steep challenging piste to get to the Borsat and Marmottes chair some good off-piste and well skied valleys.

19. Tines : Easy short blue can access the snowpark.

20. Slalom : A professional timed Slalom course. Good for challenging your mates to a race. Pay at finish.

21. Criterium : A good tree run for the white out days, fantastic with fresh powder.

22. Stade de Sémanmille : Short drag lift for those extra couple of runs.

23. Stade de Slalom : A fantastic run is frequently closed for slalom practise, but when it is open its flat, fast and empty.

24. Triffolet : It has a short season due to lack of snow but when it is open it is a superb run through the trees and gullies.

Tovière

25. Edelweis : A rolling piste good if you are wanting to get to the Follie Douce or lifts back to the Olympic Express.

26. Creux : A very long challenging blue can get very busy at the top. A good place to stop for lunch with lovely views.

27. Tovière Rouge : Very steep mogul field not often pisted and hard on the legs.

28. Rocs : Steep red can get some moguls but easier than the **Tovière rouge**. A more challenging alternative than the **Creux**.

29. Crêtes : Very short red to drop over into Tignes. Can access some good skiing in fresh powder.

30. Violettes : Easy blue back over from Tignes Combe Folle drag lift. Again good to access the off-piste.

ESPACE KILLY

Sarah Winterflood

Tignes *By Hugh Hutchison*

Adrian Myers

Britain's most successful mogul skier.
Double Olympian at Tignes and Lillehammer.
Four times British Champion.

Tignes… my home for 4 years! Well, not exactly known for its beautiful Savoyard architecture and village charm. Quite the opposite – the main resort of Tignes is a purpose-built, concrete jungle in a treeless lunar-like landscape – not a million miles away from Milton Keynes on ice!

But that's not what you come for when you visit this spot. No, it is the massive ski area of **Espace Killy**, with great snow all year round, joined to *Val D'Isère* – a whole different ball-game with it's pretty village, pumping nightlife and trendy Brit-cool scene. With 300km of pistes, some serious off piste and two snowparks this is a destination for intermediate to expert skiers and boarders.

I based myself in **Tignes** for several years when competing and many national alpine, freestyle and snowboard teams do the same. Home to the 1992 Olympic freestyle events the pistes are right by *Val Claret*.

So if you fancy trying an Olympic mogul run, this is your place. In fact, there is a maximum vertical distance of 1900 metres from the top of the *Grande Motte* (3450 metres) all the way down to *Les Brévières* (1550 metres), and you can ski the whole distance without stopping.

ESPACE KILLY

My favourite runs

Best off-piste
Try the off-piste runs down from the **Grande Motte glacier** (there's some amazing stuff of the back, but you need to take a guide with you). Come down the *Grand Plan* red from the top and then as you get to a sharp right, drop left into the big bowl and choose your run. Finish down by the snowpark at *Les Lanches*.

Best black run
The legend that is **Sache**. Get all the way up to *Aiguille Percée* from *Tignes* then take *Corniches*. **Sache** is glorious, has a back-country feel to it and can be steep, bumpy and icy. If powder has fallen, this could be one of your great moments!

Best red run
One of my favourites is the very pacey **Stade** run. Always sunny, with a bumps training section off to the left. Very good for poseur racers who like showing off to the lift voyeurs.

Best blue/green
You can do a lot worse than the very long linking run from *Val* to *Tignes* which starts at the top of **Tovière** into *Val Claret* - a thigh-burner. Otherwise the blues down from **Aiguille Percée** into *Tignes Le Lac* offer spectacular views, small bumps, and wide open pistes.

Best eats
The restaurant at the bottom of *Grattalu*. If it's sunny, that's the place for a long deck-chair lounging lunch.

www.snowfinder.co.uk

Après

Up the mountain, **Tovière** offers stunning views from the balcony and good nosh, **Panoramique** at the top of *Grand Motte* is unbelievably high up and if the sun is shining it can be -25 degrees outside and feel hot! The restaurant at the bottom of *Grattalu* is brilliant or check out the restaurant on the left at *Anémone*.

In town, head for *Val Claret* to eat - try **Le Caveau** for food and dancing, the noisy tex-mex **Daffy's** or **Le Clin d'Oeil** - the whole resort is pretty reasonable on the cost front. For a special occasion, dive down to **Les Boisses** to the quaint, chilled **La Cordée**.

In *Le Lavachet*, try **Censored** that used to be **Harri's Bar** –for a lively evening of live music, beach parties and theme nights etc. **TC's** is a good local bar that screens football on TV and has "fetish" evenings! Right?!

In *Le Lac*, head to **The Loop** a good all rounder, does food, and is very popular for après ski and DJ nights. **Angels Bar**, run by 3 beautiful blonds and serves wine in nice glasses! **Kawama Bar** very cool and trendy – brand new this year and has great deco. **The Red Lion** is a classic Brit bar with live music and footy, and then there's the in-the-lounge zone - **Alpaka Bar** for nice cocktails – and like being in your living room!

Val Claret has plenty to offer - head to **Fish Tank** which is very popular for sports screening and general chilling – does food as well. **Crowded House** is as the name suggests with a very cool crowd. **Yorin** is an insane Dutch bar – very lively and fun with lots of special promotions and bar dancing, and **Mover** has a great atmosphere with good live music.

For a more authentic and chilled beer, seek out **The Studio**, a small wine bar done out in old wood – beautiful but full with 15 people! **Arobaz** is the cool French hang out. Then on the more clubby front, **Drop Zone** – is trendy and alternative with DJs cranking drum and base etc. Very popular with scandies...and the old late-night favourites of **Caves du Lac & Jacks** in *Le Lac*, and in *Val Claret*, **Blue Girl** and **Sub Zéro**.

279

Tignes - La Grande Motte

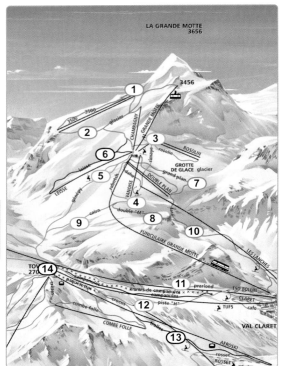

LA GRANDE MOTTE
3656

3456

① ②

3500 3500 glacier

CHAMPAGNY

GRANDE MOTTE

③ ROSOLIN
rosolin

⑥

GROTTE
DE GLACE glacier
grand plan

⑤ ⑦

LESSE glaciers
VANOISE

DOUBLE PLAN

④
cairn double "M"
⑧
⑨

FUNICULAIRE GRANDE MOTTE

⑩

LES LANCHES

TOV
270 ⑭

envers de campaniles
campaniles ⑪ prariond

TSD BOLLIN

CLARET
piste "H" TUFS cafo

combe folle crocus ⑫

COMBE FOLLE trolles

VAL CLARET

⑬

AEROSKI

rosset
ROSSET

www.snowfinder.co.uk

Tignes - La Grande Motte

1. **3500** : The highest you can get in Tignes - this is 3456 metres above sea level. However, definitely approachable for intermediates.

2. **Glacier** : Stunning views. If the powder is fresh, this is perfection. Leads onto the lower Glacier run which is a nice easy shuss down to Ski d'Eté. Very often sunny and very often crowded.

3. **Rosalins** : Short and sweet easy blue run down from Eté to prepare your legs for Grande Motte.

4. **Rimaye** : Great linking blue run taking you onto Cairn and all the way in to Val Claret.

5. **Genepy** : Well-groomed thigh-burner for all standards, from Ski D'Eté back into Val Claret.

6. **Leisse** : Challenging, tight black run with beautiful views of the nature reserve. A rare moment of peace in the jungle. Plenty of off-piste options for those with a guide or local knowledge.

7. **Grand Plan** : A testing, undulating red running right down into town, making a good final challenge before the vin chaud.

8. **Double M** : The link from the top to **Face**. Left off Cairn for those who get a sudden itch for a more challenging route in. Good advanced skiers and boarders' piste.

9. **Cairn** : Pretty straight forward blue - make sure you get your speed up or prepare for muchos shussing. Joins up with **Isolée** blue from the top of Fresse.

10. **Face** : Link from Grand Plan. There is plenty of good off-piste around, pretty close to the piste. Ask a guide to show you around.

11. **Priarond** : From the top of Borsat Express below Tovière.

12. **Piste H** : Cruisy blue from Tovière to Val Claret. Option to go black via **13. Trolles** to Tignes-Le-Lac for good advanced and expert skiers and boarders.

14. **Paquerette** : Mogully black run for showing off to the punters heading up the Aéroski to Tovière. One of those great mogul runs where there's always one insane novice determined to go down on their own!

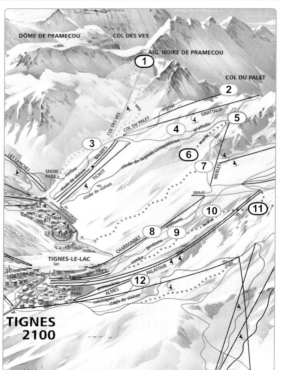

DÔME DE PRAMECOU COL DES VES

AIG. NOIRE DE PRAMECOU

COL DU PALET

COL DES VES

COL DU PALET signal GRATTALU

grattalu

merle

MERLES

stade de lognan compétition

SNOW
PARK carline

stade de slalom

TICHOT

stade de slalom

LES LANCHES

PERLAT

ocelot

prémou

génépi

chardonet gentiane

combe gentiane

chartreux

TIGNES-LE-LAC
lac

ARCOSES

PALAFOUR

GLISS
PARK prémou

ALMES

mélèzes stade de slalom

**TIGNES
2100**

1. Col Des Ves : Now designated "The Spot" freeride zone - a variety of black semi off-piste, often mogully and icy options. Awesome ski are for advanced and expert skiers. Snowboarder half-pipe heaven in the SnowPark at the bottom.

2. Signal : A long button takes you to this undulating and crowd-less blue run with bumps. Epic when there's powder. Great place for improvers to try powder.

3. Carline : The extension down the mountain of Signal. Nice blue to burn the thighs on. Good warm-up for the SnowPark.

4. Grattalu : Reddish moguls at the top, but a lovely long and wide piste, leading down to the sunny restaurant at Tichot.

5. Competition : Stade de Slalom area, providing break-neck speeds for the punters heading up the Grattalu chair. Very often closed for races or race training.

6. Merles : black semi off-piste providing stunning views down to Val Claret and Tignes. Experts only or take a guide with you.

7. Lac : Turn off to the left on Grattalu for this wonderful long blue that can take you out to Aiguille Percée or down all the way into Tignes via 3 different blues. Quality piste for everyone.

8. Anémone : Basically the bottom part of route from Col du Palet. Lovely views down into town and a great restaurant.

9. Gentiane : More of the same as Anémone.

10. Combe : Even more of the same, though good if you want to access Les Brévières or just go back up and do it again.

11. Oeillet : Excellent black off-piste for quality skiers. Often very quiet and if there is snow, you can guarantee it'll be good here. Best to get up early if there's been a dump.

12.Colchiques : Good short red, excellent for boarders wanting to warm up for the GlissPark. Two other reds off to the right used for race training.

ESPACE KILLY

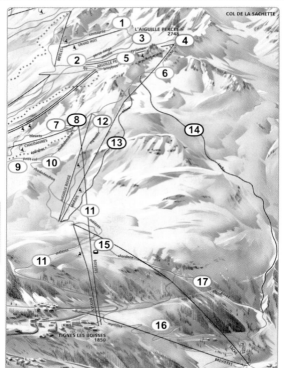

COL DE LA SACHETTE

L'AIGUILLE PERCÉE
2748

ESPACE KILLY

TIGNES LES BOISSES
1850

Tignes - Les Brévières

1. **Centaurée** : Straight up the Grand Huit chair. Feels like you are miles away from anything. Beautiful, high altitude scenic run. Often amongst the best snow about.

2. **Perce Neige** : Round to the right of the chair lift. Stunning views.

3. **Ancolie** : Quality red, around a bowl and then down to join the crossroads at the bottom of the Aiguille chair. Excellent off-piste prospects for those in the know off the back of Aiguille Percée.

4. **Cyclamen** : Amazing, comprehensive red run that feels like the furthest away from the towns you can get whilst still on-piste. Great views.

5. **Bruyères** : Nice blue - relatively steep in places but ok for most.

6. **Corniche** : Very much a link run takings you down to Rhododendron and onwards for a super long blue into Les Boisses or Les Brev. The gateway to the legendary black **Sache** and a world of off-piste with a guide.

7. **Bleuets** : Turn off from Corniche to take this solid red down on sunny slopes into Tignes if you're feeling a bit punchy after lunch at the restaurant!

8. **Epilobes** : Freeride, advanced skier black run with jumps, bumps and an easy end bit into Tignes.

9. **Petit Col** : Right off Rhododendron for this lovely back-route to Tignes.

10. **Rhododendron** : At the top of Chaudannes lift a stunning long blue that links up with **11. Mélèzes** : turn left off Rhododendron towards the end for long route through trees at the bottom into Les Boisses.

12. **Myosotis** : Challenging bumpy red at the top of Aiguille Rouge chair.

13. **Silène** : solid black with genuine steep drops for the good advanced plus skier. Rarely more than one or two others sharing the piste.

14. **Sache** : Legendary long route down to Les Brev. Known for stunning snow and no people, although get very icy down the bottom often. Favourite with guides for off-piste options.

15. **Chardons** : Winding red that comes down through the trees into Les Boisses. Can get icy and rocky if no snow for a while. Links to the easy blue 16. **Myrtilles** onto Les Brévières.

17. **Pavot** : Continue left on Chardons through the trees for a good pisted way into Les Brev ending up at the base of the Sache cable car.

Adrian Myers

Introduction

Not a fact known by every snow-afficionado on the planet, but this region is the fifth largest in France. This is a vast area with nearly 250km of skiing, the hub of which is the town of **Alpe d'Huez** at 1860 metres and the gateway to the mountain-top glacial runs of the *Pic Blanc* at a wopping 3330 metres.

Alpe d'Huez is surrounded further down the mountains by the satellite villages of **Vaujany, Oz En Oisans, Villard Reculas, Huez 1500** and **Auris En Oisans**.

The town itself does come in for a fair amount of abuse for its lack of Savoyarde charm...blah blah blah...turn the record over guv'nor! If it's skiing and snowboarding you want with maximum variety and a solid apres ski party scene - you can do a whole lot worse than here. That's all we can say!

And just to show that we're not all boring, moaning old Brits, we decided to ask **Laure Pequegnot** for her view on the place. Who, you may ask? Watch *Ski Sunday* for chrissake! **Laure** was only the *World Cup Slalom Champion in 2002, Olympic silver medallist* at *Salt Lake City in 2002* and in the *world top 10 for women's slalom* from 1998-2003 - she knows a thing or two about this place!

The good
- Massive piste and off-piste ski area.
- Excellent linked lift system for such a large area.
- One of the best alpine views available from **Pic Blanc**.

The not-so-good
- Extreme wind conditions hig-up can shut lifts quickly.
- Can be very busy given proximity to **Grenoble**.
- Couloir blue run around 3-4pm. Have insurance!

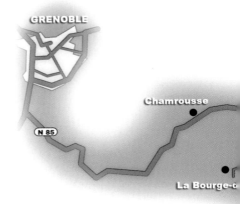

Getting There

Fly: from UK to *Lyon Airport* via BA, Easyjet, flybe or Thomsonfly. **Alpes d'Huez** is 160km from *Lyon* (approx 2.5 hours), 65km from **Grenoble** (1 hour), served by Air France.

Drive: take **A43 E70** Motorway from *Lyon* to *Bourgoin-Jallieu*. Turn off on **A48 E711** to *Grenoble*. Follow **A480** South of *Grenoble* then turn off on **N85** at **J8**. At *Vizelle* turn left on **N91** for approx 40kms. Turn left on **D44** to *Vaujany* or continue on and take **D211** for 13km to *Alpes d'Huez* (snow chains are recommended).

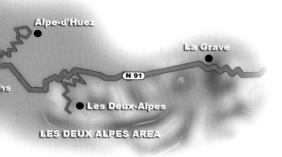

Alpe-d'Huez

La Grave

N 91

Les Deux-Alpes

LES DEUX ALPES AREA

Getting There

Coaches: run regularly from *Lyon Airport*.
Book online at www.altibus.com, as well as taxis.

Train: The nearest rail station is *Grenoble* (65km away). There is a very good bus services from the station to the resorts.

Tourist Office

Alpe d'Huez + 33 (0)4 76 11 44 44

Main office

Place Paganon
38750 - Alpe d'Huez
France

General email

iinfo@alpesdhuez.com

Resort websites

www.alpesdhuez.com

Visalp passes

Covers the whole Grand Rousses area including Auris-en-Oisans, Huez, Oz-en-Oisans, Vaujany and Villard-Reculas. Discounts available for seniors, under 16, season passes, early season, spring skiing.

Day	€36.20
6 Day	€187

Insurance

Carré Neige €2.50 per day

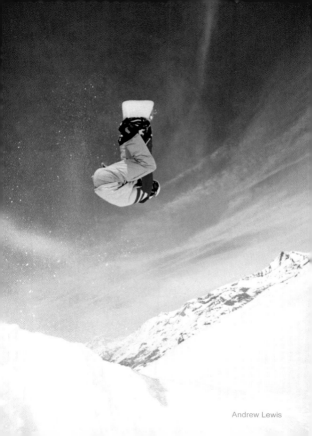

LE DAHUT

LE POUTAT

OUVERT OPEN

Skishoot offshoot

Zoom agence

By Laure Pequegnot

Alpe d'Huez began its journey to becoming the well-known alpine resort it is today in 1936 - famous for its incredibly high skiing. The resort was developed at an altitude of 1860m on the Grandes Rousses Massif, above the old village of Huez, in the heart of the Oisans mountain ranges. The resort is built on a very high plateau that gives rise to its colloquial name, 'the island in the sun'.

Pic Blanc, the highest point of this massif at 3330m, has a panoramic view rating three stars in the *Michelin Guide* with amazing views out over over the *Ecrins National Park* and its beautiful mountain peaks of *Rateau, la Meije, la Muzelle, Les Aiguilles d'Arves*, the *Belledonne Chain* and, of course, the legendary *Mont Blanc*.

The resort is now well-known for being big, busy, big, having masses to do both for skiers and no-skiers, and big!

The Grandes Rousses ski area is vast - connecting the village resorts of *Auris, Oz en Oisans , Villard Reculas, Vaujany* and *La Garde*, with 230 km of alpine ski runs, 54 km of cross-country trails ans 30 km of ramble tracks. Not only that, it is one of the few resorts around the world with a lift-served vertical of over 2000 metres - the highest point of which is the stunning *Pic Blanc* (at an altitude of over 3300 metres). There are 125 miles of pisted runs served by 85 lifts.

The mountain is served by 2 fast gondolas from town and there are chair and drag lifts up from the surrounding villages.

Alpe d'Huez is the place to go for non-stop activity - no matter what you're after from a mountain resort - both sporting and cultural in

ALPE D'HUEZ

My favourite runs

Best off-piste
You will definitely need a guide for this one. Go up the mountains to the top of *Pic Blanc*. You can drop right down from the **Glacier des Rousses** all the way down through the valley round into *Vaujany*.

Best black run
No prizes for guessing that it is the amazing **Sarenne** black run. It is not the most difficult black run but definitely the longest. I am always excited as I get the *Pic Blanc cable car* and look down over the ridge to the run. For variety you can try the bumps of *Le Tunnel*.

Best red run
les Rousses from the top of *2700* is a lovely run with great views down towards *Vaujany*. You can then cut left into *Variante* and left again onto *Alpette* to continue skiing down all the way into *Oz en Oisans*.

Best blue/green
Couloir from *Lac Blanc* down into the nursery slopes is a good one. I also like **Petit Prince** from *Signal 2100* down into *Villard* is long, fun and has amzing views.

Best eats
My favourite place for an evening meal is **Le Petit Creux**. However, I'm still a professional athlete so I cannot go too mad after skiing!

winter or summer. The big thing for **Alpe d'Huez** is its seriously consistent snow record, making it a winner resort for all standards and groups of snow users - the highlight of which must be the unbelievably long and relatively forgiving black run of '*Sarennes*' - a full 16 km of pisted run from *Pic Blanc* all the way back in.

Après

You can't miss the little bit of alpine history that is **La Bergerie** on the red down from *Signal* to *Villard*. **Combe Haute** at the bottom of *Sarenne* is a welcome rest and carb-load spot after the insane 16km trip you've just been on!

The other best known spots are **Tetras** in *Auris*, **Signal** for the panoramic views above the resort and **Plage des Neiges** for a great little stop-off at 2100 on the last trip back to the land of apres ski.

A really good place to eat local fare and also drink is **Les Caves**. If not, **Le Petit Creux** or **Le Dahu Grill**. The best place in town for pizza is **Pizza Pinocchio.**

A good spot for Après and on is **Crowded House** in town. Try also **Zoo Music Bar** or **O'Sharkey's.**

If it's bars and clubs you're after, *Alpe d'Huez* kicks. **The Underground** and **Le Sporting** are very well known and well frequented spots.

Similar stuff at **Smithy's, Pacific Bar, L'Etalon** or the **Freeride Café** all of which are resort worker hangouts offering the usual happy hour, shooter, stay-till-you-fall-over, quality evenings. **Sphere Bar** is yet another option. **Les Caves** and **Magoo's** also go off.

DTs Tapas Bar and **Cactus Winebar** are a bit more relaxed and chilled out.

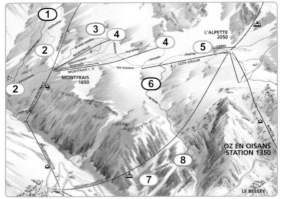

1. Roche Melon : Very out-of-the-way steep, sometimes rocky and bare black run with access to serious off-piste. Experts only.

2. Edelweiss, Vaujaniate : Lengthy, windy blue from the top of Vallonet down to the Montfrais cable car. Patchy snow quality.

3. Grand Combe, Montfrais : The 2 main village reds in Vaujany - both short with plenty of width and good snow-making facilities.

4. Etourneaux, Eteaux, Myrtilles, Cascade : A selection of improver and intermediate blues with a freeride area in between.

5. Chalets : Good long blue that links up with Les Travers to take you down to Montfrais. Good confidence building run.

6. La Fare : Quiet and pretty, winding black that suffers if there is not much snow (start/end of season) as quite low, but in powder...!

7. Fontbelle : Lovely run down to Enverins d'Oz through the trees. Novices beware - you have to do **La Fare** first!

8. Combe Bénite : The tail-end of La Fare down to the cable cars.

Alpes D'Huez - Plat des Marmottes

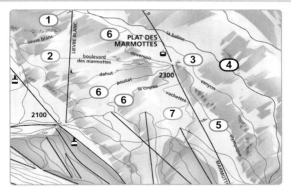

1. **Lièvre Blanc :** Short, winding red with a good descent gradient at the top. Joins Couloir.

2. **Bvd des Marmottes :** Easy blue as an alternative to taking Couloir all the way back to town. Joins Dahut for more of the same.

3. **Canyon :** From the top of Lièvre Blanc, a good intermediate area, particularly for freeriders. A long tiring red with good views of the town.

4. **La Balme :** Exceptional and quiet black run, often overlooked by people gazing towards Pic Blanc. Many off-piste options down towards the Canyon too, and can suffer if lack of snow. Forms the bottom section of a massive run starting at Pic Blanc down Brèche. Serious rival for **Sarenne** without the crowds.

5. **Olympique :** Fast racer run from the top of Marmotte 1 telecabin back down into town. Gets pretty busy, as does the telecabin!

6. **Déversoir :** Turn off right from Canyon to stay the town side of the ridge. Joins up with Poutat or La Course for more cruisin'!

7. **Vachette :** Long blue through the nursery greens down to the altiport. Very busy with improvers.

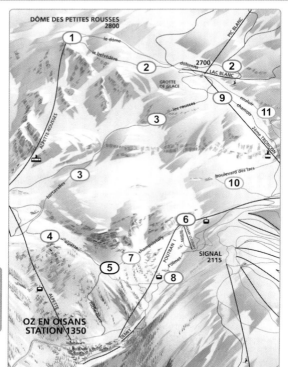

ALPE D'HUEZ

Oz en Oisans

1. Le Dôme : Take the cable from Alpet to the top of Rousses (2800m) to access this back-country red in an off-piste area. Advanced riders' run. Highest red in this intermediate playground area.

2. Belvédère, Dolomits : Belvédère is a good thigh-burner red, often sunny and pure joy when there's been snow. **Dolomits** takes you further onto the base of Lac Blanc chair.

3. Les Rousses, Bartavelle : Totally awesome reds. When there's snow and sunshine this is an absolute must for intermediates upwards. Hire a guide to take advantage of the off-piste options.

4. Alpette : Extends on from **Bartavelle** to take you all the way down to Oz station - a firm favourite.

5. Roche Noir : Steep, short and demanding black run. Often icy and rocky. Take the blue unless you really know what you are doing!

6. Hutin : Small but nice, wide-pisted green. Ideal warm-up the blue.

7. Champclotury : Excellent blue for all standards - good wide piste, often in the sunshine to take it easy and cruise down to Oz.

8. L'Olmet : Good red, relatively steep to start with some bumps . The extension of **Poutran** red.

Alpes D'Huez 2700

9. Chamois : A 900m vertical drop just waiting for you to charge from the top back into town. Excellent.

10. Bvd des Lacs : If you are too knackered to finish **Chamois**, turn off onto this laid-back intermediate cruiser run and soak up the scenery.

11. Couloir : Not often you come across a blue couloir, I'll wager, but basically a simpler version of **Chamois**.

ALPE D'HUEZ

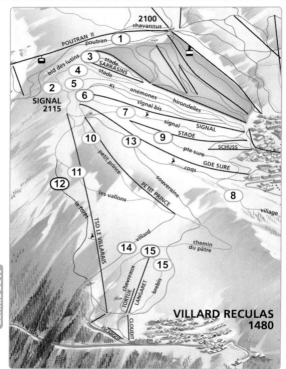

2100
chavannus

POUTRAN II poutran ①

③ stade
SARRASINS
bld des lutins ④ stade
② ⑤ KL anémones hirondelles
SIGNAL ⑥ signal bis
2115 ⑦ signal SIGNAL
⑩ ⑬ ⑨ STADE
pte sure SCHUSS
coqs GDE SURE
⑪ petit prince souveraine
⑫ les vallons PETIT PRINCE
⑧
village
la forêt

TSD LE VILLARAIS villard chemin
du pâtre
⑭ ⑮
⑮
chevreaux
TORTUE LANGARET brebis
ESCARGOT CLOUDIT VILLARD RECULAS
1480

www.snowfinder.co.uk

ALPE D'HUEZ

Signal

1. Poutran : Excellent long cruisey intermediate red. Can have patchy snow and slush down the bottom if not much snow about.

2. Bde des Lutins : Blue version of Poutran.

3. Stade : Short slalom-type slope. Either short swings or bomb it down! Intermediate but a good improver run for those who have got their ocnfidence up on the blue of the same name next door.

4. Hirondelles : More of a challenging green! Not often you hear that said! Get our speed at the bottom up or you're poling through slush!

5. Anémones : Another good testing blues, steep in places.

6. KL, Signal : Typical intermediate reds, not much steeper than the blues next door, but epitomising the style and quality of this area.

7. Signal : Typifies the blue runs in this solid intermediate area. Gets crowded. Check out the half-pipe at the bottom for freeride action!

8. Village : At the bottom of Coqs, this is the route back to Huez 1500, and a nice quiet pretty run it is too!

9. Pte Sure : Yet another good little intermediate red. You won't get bored of them in these parts!

Villard Reculas

10. Petit Prince, Chemin de Patre : One of the best blues in Alpe d'Huez. Surprisingly challenging. Wonderful scenery and rearly crowded. What more can you want. Even artificial snow down the bottom on the Chemin run.

11. Les Vallons : Another classic blue as a different option to Petit Prince. Not unsurprisingly busy.

12. La Forêt : Steep, isolated and difficult black with the added issues of ice and rocks.

13. Coqs, Souveraine : Coqs takes you off back into town to the bottom of Grande Sure. Souveraine hoons you off down the mountain into Villard. GS yourself up!

14. Villard : Straight down to Villard with off-piste options if there's snow.

15. Chêvereux, Berbis : Basic short Villard-Reclus town runs.

ALPE D'HUEZ

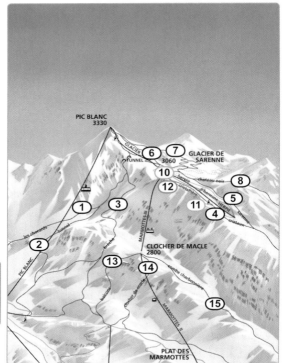

1. Les Chocards : Welcome to Pic Blanc! Massively long 600m vertical descent very quickly down to 2700. Breathtaking views. Off-piste central but essential to have a guide.

2. The Tunnel : An alpine legend. Legendary beast of a run through an old mining shaft, that drops sharply off into a monster mogul field. Expert skiers only.

3. Brêche : Amazing black with the finest views. Enables you to link up with **La Balme** and ski on to town - a full 1500m vertical descent!!!

4. Cristaux : Ridge-line steep black that links up with the legendary **Sarenne**. Don't even think about it if you don't like heights!

5. Sarenne : The world famous 16km Sarenne run - very very long back-country black with amazing views into the Gorge de Sarenne. Loads of off-piste but only with a guide.

6. Super Signal : The definition of mogul fields! Super hard as very often icy, carved-up and short of snow. You've got to love the bumps to even think about it!

7. Glacier Noir : Reached via the new Marmotte 3 telecabin which brings big crowds and can be closed due to high winds and poor snow. However, when open an unbelievable expert ski area. Enjoy!

8. Chateau Noir : Real deal, winding and undulating black which winds its way down through the valley on the other side of the ridge from **Sarenne** before bringing you back over the ridge to join it again.

9. La Fuma : Awesome steep black moguls that are regularly bare and rocky. Psycho extreme riders only.

10. Herpie : Phew! A blue run. You don't have to even see a black run if you don't want to. Go on, give it a go!

11. Cristallière : Amazing blue that gives all standards the feel of being an extreme skier, and the view to match.

12. Hermine : Not really sure why this piste is here, other than a warm up for what lies ahead!

13. Balcon : Short and sweet, but definitely unyielding! This black can be empty and is always the genuine thing.

14. Clocher de Macle : Similar to **Balcon** but straighter descent!

15. Combe Charbonnière : Fast, steep, incredibly long racing black with the added benefit of being nowhere near as busy as **Sarenne**.

ALPE D'HUEZ

Adrian Myers

Introduction

Les Deux-Alpes area is the second oldest in France after *Chamonix*, just across the valley from near neighbour, *Alpes d'Huez*. It is effectively a resort built around a very long ski-lift spanning three or four successive valleys heading east to *La Grave*. **Les Deux-Alpes** is a large, Brit - and party- friendly (often synonymous) resort, with the convenience of hitting any lifts by a 5 minute walk from the middle of town.

La Grave is a beautiful unspoilt village with the emphasis on steep, challenging skiing with plenty of exciting off-piste options. Also noted for a really reliable powder count, given that the ski area is between 2500-3500 metres! It is a one-lift ascent/descent from the village at 1450 metres and mostly unpisted. A late afternoon descent can be a pretty hairy affair for all but the most competent of skiers and boarders.

Introducing the area, someone who exhibits the qualities that epitomise the area - fearlessness, determination and adrenaline-rushing is **Chemmy Alcott** - *current British Olympian* and *top 10 World Cup downhiller*. Not only that, this is the only skier or boarder we have yet met who refers to herself as "*still a virgin to the sport despite my 14th at Salt Lake City in the 2002 Olympics and top 10 WC place in DH in Cortina*". Wow!

The good
- Steep, challenging off-piste in **La Meije Valley**.
- Reliable snow.
- Well-organised, Brit-friendly resort.

The not-so-good
- Not the most sensible for beginners.
- Relatively long transfer from **Lyon** if you can't fly to **Grenoble**.
- The long lift trip back from **La Grave**.

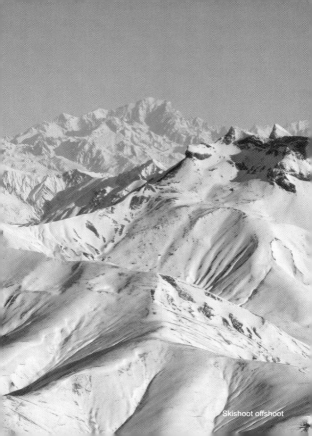

Skishoot offshoot

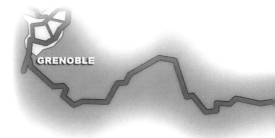

GRENOBLE

Getting There

Fly: from UK to *Lyon Airport* via BA, Easyjet, flybe or Thomsonfly. **Les Deux Alpes** is 160km from *Lyon* (approx 2.5 hours), 65km from *Grenoble* (1 hour), served by Air France.

Drive: take **A43 E70** Motorway from *Lyon* to *Bourgoin-Jallieu*. Turn off on **A48 E711** to *Grenoble*. Follow **A480** South of *Grenoble* then turn off on **N85** at **J8**. At *Vizelle* turn left on **N91** for approx 40kms. Head through *Bourg-d'Oisans* for 15km and turn off on **D213** to *Les Deux-Alpes* (snow chains are recommended). Continue on **N91** for another 15km to *La Grave*.

Coaches: run regularly from *Lyon Airport*.
Book online at www.altibus.com, as well as taxis.

Train: The nearest rail station *is Grenoble (*65km away). There is a very good bus services from the station to the resorts.

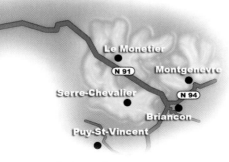

Tourist Office

Les 2 Alpes	+ 33 (0)4 76 79 22 00
La Grave	+ 33 (0)4 76 79 90 05
Valloire	+ 33 (0)4 79 59 03 96

LES 2 ALPES

Main office

BP 7
38860 Les Deux-Alpes
France

General email

les2alp@2alpes.com
info@la-grave.com
info@valloire.net

Resort websites

www.2alpes.com
www.lagrave-lameije.com
www.valloire.net

Super Ski passes

Full access to all 51 lifts. 6 day pass gives Grand Galaxie access: 2 days Alpes d'Huez area, 1 day Serre Chevalier, Puy St V, Montgenèvre (including Italian resorts in the area). Discounts available for seniors, under 16, season passes etc. (In brackets for Valloire Ski Passes).

Day	€34.70 (€27)
6 Day	€165 (€135)

Insurance
Carré Neige	€2.50 per day

Current British Olympic medal hope.
Placed 14th in Olympic Downhill in Salt Lake 2002.
Placed 8th in a World Cup Downhill.

Les Deux Alpes is popular with coachloads of Italians and Dutch, mainly because Sportura, the Dutch travel firm, is based here. More recently plenty of Russians are about too. It's always been Brit-friendly - there is an international ski school here where a number of home-grown talent hang out. Like many french alpine resorts, it suffers from the 60-70s accomodation design - I'm pretty sure there is only one wood chalet in whole resort. However, the high altitude/glacier/all-year skiing give this place a very big tick.

I tend to go to **2 Alpes** for pre-season ski-testing because of the reliable snow…this gives rise to my favourite memory from there. Last time I went the *Tour* was there and I decided to combine an afternoons physical session with a mountain bike tour to see the best viewing point. Things got a little crazy and I ended up rallying down a hiking path and to cut a long story short, got totally out of control, rolled my bike, badly messed up my ankle and got royally winched up in a helicopter. Had THE most spectacular view - the pain was almost worth it! But these are the stories that you remember the most!

What you don't get is the old chocolate-box image, but then, who needs romance when you're busy carving up the slopes? **2 Alpes** has very strong snowboarder appeal - a cool board park in particular.

The pistes and slopes tend to feel a bit disjointed because the resort has a glacier and it sometimes seems to take a lot of time to get from A to B. There is alot of different terrain and the snow quality is often sweet and pretty reliable. Consistency is very good with lots

My favourite runs

Best off-piste
Where do you start? An impossible question to answer for *La Grave* I'm afraid. There are just so many options to suit all different skiing and boarding tastes. The one definite is that you must take an experienced guide with you.

Best black run
My favourite pisted black run has to be **Diable** - it has all you really expect from a challenging black run with the pose factor thrown in, and it has to be the steepest easily-accessible powder to your place in town. All this means you have to get there early!

Best red run
Dome from *Dome de Puy Salie* across and down the *Glacier de Mantel* to link up with the laid-back scenic *Signal* blue.

Best blue/green
Route de la Fée is the answer on this one, taking you all the way down the valley into *La Fe*. For a very different green option, if you can hack the lifts, get all the way up to *Soreiller* - surely one of the highest green runs on the planet?!

Best eats
I suppose it has to be **Joe's** for the old tex-mex option washed down with a few margaritas.

of pre-season skiing. There are fields of manicured bumps on the run into resort. Avalanches occur and there are frequent blasting - safety definitely comes before lie-ins here! It can also get crowded - watch out for the bottlenecks at the Tbar for the glacier and the Gandri Express.

If you're taking time off try the bungee jump off the cable car over the valley, mountain biking, the skate park or even the gym, and there's great whitewater rafting down the valley.

Après

My personal advice to people is to look past the exterieur. As in other French resorts don't be put off by first impressions - delve below the surface and you'll find a bunch of crazy skiing, adrenaline activities and great bars - I love it.

Après

Up the mountain, the eats options are really quite limited, given the status of the resort. The best place for a bella vista is right up at the glacier, funnily enough called **Les Glaciers.** A little closer to home, **Chalet de la Toura** at the top of *Toura* comes recommended.

Otherwise, down in the town **La Patate** is a bit of an institution, **La Spaghetteria** does Spanish tapas (spot the deliberate mistake), and **Le Four a Bois** gets the traditional duck, meat, cheese vote. Some good other options too though.

Mike's will be on everyone's agenda at least once while you're out here. **Smithy's** and **Smoky Joe's** are typical alpine resort bars, catering for the young drinking crowd - both going on late. Smithy's is good all round, Joe's is where it's at for some dancing and you can also eat good tex-mex there.

The big late night venue option is the **Opera** (Music Temple, for heaven's sake!), which even drives you up the hill to get you there in a free bus! Now that is what I call customer service!

If you still can't get to bed, look for the **Avalanche Bar** - a real local late night drinking den, and a good place to make friends with Boris da Russian - a legend 'vodka by the litres!'

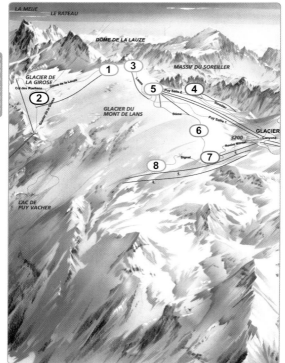

La Grave - Dôme de Puy Salie

La Grave

Off-piste notice: Please consult the resort map and off-piste security rules before taking any off-piste route. Do not leave without appropriate gear and all the relevant information (weather conditions, off-piste rules). Always ski with a professional guide. La Grave area is not a resort adapted for skiers, but here it is the skier and boarder who must adapt to the area. The whole mountain is off-piste with no groomed trails. Just remember that 25 people have perished in La Trifide Couloir alone. You have been warned.

1. **Dôme de la Lauze :** Famed as the biggest pisted vertical drop in Europe from 3550m via the Col de la Lauze into the Vallon de la Selle in the National Parc des Ecrins - this is the highlight run for anyone who is not off-pisting it. You can guess how crowded this little number gets! Just try to imagine what it would be like empty…

2. **Col des Ruillans, Glacier de la Girose :** The skiing and boarding in these two *'land-of-the-extreme'* areas is incredible. An experienced guide is a must. You start at the top on the wide open, vast glacier and then the sky is the limit - spectacular open bowls, small chutes, glacial morains and onwards into a mass of shutes and powder in the forest as you get to the bottom. Words do not do it justice.

3. **Lauze:** A variation of Dôme de la Lauze. Gets cold up here, doesn't it?

Dôme de Puy Salie

4. **Soreiller :** If you can handle the long lift links all the way out here, this green is definitely the place for beginners and improvers to warm their legs up a few times before hitting the blues and reds.

5. **Puy Salie 1 & 2 :** Next step up from Soreiller. Well known for having good early season snow, these runs are busy but good for all standards.

6. **Dôme :** Surprisingly steep in places, effectively a traverse route across Glacier de Mantel with plenty of off-piste access points.

7. **Roche-Mantel :** Nice and with amazing views across the valley.

8. **Signal :** Good, busy long blue. If you join it from Dôme then you get a full 600 metres vertical drop to 2800. Spectacular views over La Grave in the valley across to La Meije glacier.

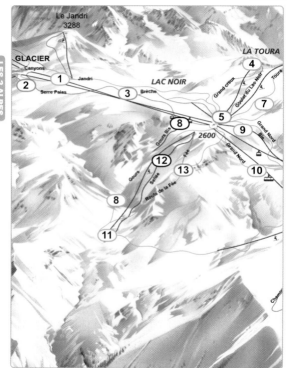

Glacier 3200

1. Couloir, Canyons, Jandri : 3 variations on a theme. Uncomplicated but very consistent blues with excellent snow quality. Good early season.

2. Serre Pallas : Nice long red linking Toura with Glacier. Gets busy particularly on the way back home at the end of the day.

3. Brèche : More of the same as Serre Pallas - a good route to cut across over to the Toura blues and the Snowpark.

Toura

4. Grand Creux : Fast, winding blue run - great for practising those little short turns. Fabulous views.

5. Goulet le Lac Noir : Straight descent red run - a few bumps for posing on under the lift and plenty of GS potential.

6. Snowpark : Excellent snowpark for the freeriders and boarders, of whom there are many. Choose your zone according to your ability: the big air hounds go left, and the rest of us right!

7. Toura : Lovely blue run with relaible quality pisted snow conditions and a great place for first-time powder if the snow has fallen.

8. Gours Bis, Gours : Steep, fast and challenging black run straight down from Toura into La Fée via the valley, close to some known off-piste, linking up with the long scenic blue of the same name.

9. Grand Nord Bis : The higher Grand Nord run - always fun and nearly always busy.

10. Grand Nord : The alternative (lower) Grand Nord run taking you back into Lac du Plan. Great views across to Pied Moutet mountain.

11. Route de la Fée : Epic long blue run that will feel like an off-pister to the beginners and improvers taking the challenge of this run. Well worth it and a nice finish in La Fée and onwards to Crêtes - 5-600 metres of vertical drop. Not bad!

12. Sellée : A steep monster black from the top of La Fée lift. Narrow pitches, bumps, amazing views and speed .

13. Fée : Take this run and turn off for **Sellée**. The left fork is a pretty demanding, short intermediate red option.

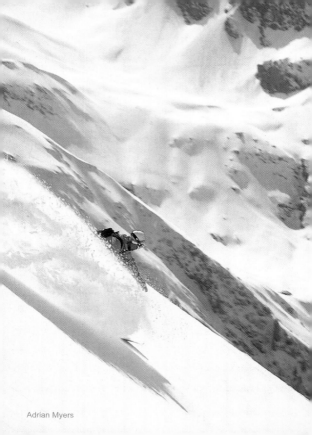

Adrian Myers

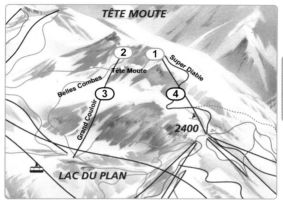

1. Tête Moute : The definition of thigh-burner warm-up runs. Get on the first lift and get straight back down into Toura. You'll do it again and again, particularly if the snow has fallen as it really holds the powder well.

2. Belles Combes : This red/blue run hangs a left off Tête Moute for a step up in difficulty. Once again, stunning scenery and good snow. Get used to it!

3. Grand Couloir : Tête Moute's signature black dish! It's really an off-piste run but very well known. Steep expert couloir skiing and boarding - a great intro run before heading over to La Grave.

4. Super Diable : Great black for the onlookers on the Diable chair to watch. Beautiful snow after a fall on this partially south-facing slope (a bit of a rarity in these parts!) - an early rise will guarantee powder. Amazing views south out towards La Muzelle and Tête de Lauranoure.

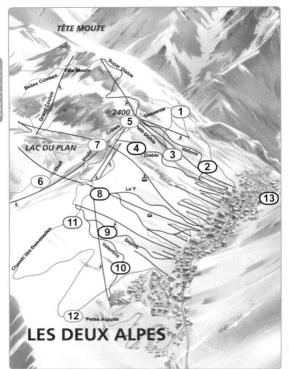

TÊTE MOUTE

Belles Combes

Tête Moute

Super Diable

Grand Couloir

2400

Descente

5

Crêtes

Petit Diable

Vallons

LAC DU PLAN

7

Voûte

4

Diable

3

Tunnel

1

2

Thuit

6

8

Le Y

13

11

9

Sapins

Chemin des Demoiselles

Valentins

10

12

Petite Aiguille

LES DEUX ALPES

1. **Descente** : Brilliant long red that gets you all the way back to Deux Alpes via some lovely back-country tree-ski off-piste with a guide.

2. **Vallons** : Out-of-the-way black run that is often quiet. You can cut across through trees off-piste to join up with **Diable**.

3. **Petit Diable** : Short red run that serves as a middle section from the **Super Diable** run down to **Diable**. This is one exhilarating and tiring run to do the whole way.

4. **Diable** : When there's been a snow dump, get to the top very early for powder central. Everyone heads up from town here first off so get there quick.

5. **Crêtes** : Straightforward blue run down from **Diable** across to Crêtes - pretty busy as a conduit for **Desmoisselles** run back to town.

6. **Thuit** : Standard blue under the cable car down to the bottom of Cretes chair from Lac du Plan.

7. **Voule** : Tidy little red run to hoon down from **Crêtes** to grab the chair up to **Diable**.

8. **Le Y** : Steep top section that follows the fall-line through the trees back with a final open section into **Diable** at the top part of Deux Alpes.

9. **Sapins** : Similar option to Le **Y**. Some good bumps here.

10. **Valentin** : A classic alternative to **Desmoisselles** for those who are bored, can't handle the crowds going home, or who are just hanging out for beer and après ski action!

11. **Desmoisselles** : Relatively narrow for inexperienced skiers and gets very busy as the home run for many. However, does have good early season snow.

12. **Petite Aiguille** and **Mont de Lans** down into Mont de Lans.

Pied Moutet

13. There are a number of good pisted runs : **Super Vénose**, **Vallée Blanche**, **Floc**, **Anémone** and **Vallons de Bons**. The highlight over on this side has to be **Pied Moutet** - A fabulous red off the back of the mountain, all the way down to Bons which is unusually for Deux Alpes, a tree-lined piste.

My favourite runs and Après

LES 2 ALPES

Best off-piste
Les Couloirs de la Sétaz is where I go for great off-piste. Not normally crowded and great quality snow.

Best black run
The long steep **Cascade** run down from *La Sétaz* into the valley is a great piste - fast, uncrowded and steep with good snow.

Best red run
From *Crey du Quart*, take either **Aigle** or **Rose**. In *Valmeinier*, try the very long **Eglantiers** at the top of *Le Roi chair*.

Best blue/green
Blue : the really long **Selles** from *Crey du Quart* or *Perce Neige* from the top of *Gros Crey* in *Valmeinier*.
Green : **Myosotis** from *Thimel* all the way back into *Sétaz*.

On the slopes, head for **Chateau Ripaille** or **Les Meregers** up above *Les Salles*.

There's a good range of restaurants including **Plancheur de Vaches** crêperie, **La Chautagne** for pizzas and **Bistro "Chez Fred".** My favourites are **La Sétaz** and **Le Crey du Quart.**

For traditional Savoyarde dishes **La Ferme de Point Ravier** or **La Grange de Thelcide.** A good pizza joint is **La Glisse Pizzeria.** Also try **La Fondue** for you guessed it, fondue! or **Le Chardon Bleu** which is good value.

Barlife is pretty good in *Valloire* - **Bar Centrale** is busy and likewise, **Club Bar L'Igloo,** both of which cater for the young rowdy crowd. Alternatively, try **Le Mastrock** or **Pub l'Atelier.**

For clubbing into the early hours it has to be **L'Odysée** or **Le Village**.

Valloire *by JB Grange*

Alpine skier: Slalom and Giant.
French national junior champion 2004.
Podiums in Europa Cup in 2005.

Valloire is a beautiful picturesque old Savoyarde village situated about 20km north east of La Grave a few km south of the Trois Vallées. It is reached by taking the A43 from Chambery and going south on N902 or the same route from Grenoble to La Grave, then north on the N902 at Col du Lauteret (definite snowchain requirement).

We have asked **JB Grange** to give us some insight into the place. He is widely tipped to be the *'coming man'* in mens *Slalom and Giant Slalom*, was *French Junior National Champion in 2004.* and is already making podium in the *Europa Cup* this year.

Valloire is a small village with a wonderful *'esprit'*, sitting at the baseof the *Galibier Pass*. There are around 150km of ski area and the resort links with *Valmeinier* to the east.

The pistes are open from early December to April (and there is often good snow late, so much so that the French Junior Snowboard Championships took place in the first week in April here). This is because alot of the skiing actually take place between 2000-2500 metres.

There are a high proportion of red runs - it's a very good intermediate location. There's also a very good snowpark on Crey du Quart offering boardercross, a good half-pipe and more.

The village, with its many hameau, has all the facilities for non-skiers including swimming pool, ice-rink and one of my favourites, parapente from the summit of *La Setaz*, and many good bars, restaurants and shops. There is even an *Altiport* at *Les Verneys*. So there is no excuse to come and visit **Valloire**.

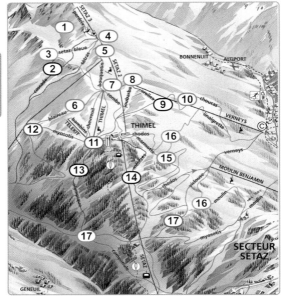

1. Perdrix : As far as you can get on-piste towards the summit of Setaz. A short red with views out across either side of the ridgeline and access to off-piste.

2. Cascade : The reason a lot of people do **Perdrix** - as a warm up for this monster of a leg-burner black run. Can be shady and icy. Experts level. Off-piste area with good powder.

3. **Sétaz** : Nice start-at-the-top blue to warm the legs up and take you down to a variety of other options to play on.

4. **Tétras** : Short red that links to the steep black **Cascade** run.

5. **Bouquetin** : Another short red off the first Setaz drag lift. Good intermediate starter run before attemting **Blaireau** or **Chevreuil**.

6. **Blaireau** : Relatively steep and fast red run. Be aware that the second section is the green **Myosotis**.

7. **Chevreuil** : Similar type and standard of piste to **Blaireau**.

8. **Joubarbe** : Simple short green run for confidence-building.

9. **Arolles** : Very short black mogully link up to **Choucas** red run.

10. **Choucas** : Long winding and undulating red run, wide open at the top then finishing through trees.

11. **Bambins** : Short starter green run - favourite of the ski schools for those people taking their first trip up the mountain.

12. **Myosotis** : Very long winding green right round the base of the mountain back into Secteur Sétaz.

13. **Olympique** : Fast black that follows the line of the Olympic run. A really challenging run at speed.

14. **Mélèzes** : Short steep black run through the trees from Thimel station, joining up with **Marmotte** red eventually.

15. **Marmotte, Silène** : Really excellent red run from Thimel station meandering down thorugh a series of pitches in the trees into the centre of town. Do this as a final run of the day.

16. **Rhodos, Moulin** : The main route back to Valloire for most people. As you can imagine, gets busy. Take a left at the second big bend for Linaigrette to ski in to Les verneys.

17. **Verney, Viclouse** :Two good greens going off left and right from Moulin Benjamin drag - good for improvers to get the speed up.

17. **Campanule** : Fast tailend of the **Olympique** run for that final hoon back into town and the awaiting après ski!

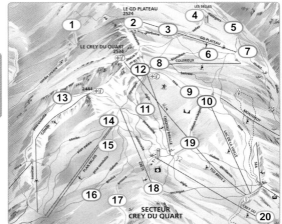

1. **Combe Orsière** : The only pisted run off the back of Grand Plateau. However, you only have to look over the edge to see that this could be a great off-piste area. Ask a guide if your hunch is correct?

2. **Primevère** : The blue from the top of Grand Plateau drag that opens up this whole ski area, getting you to the access points for Crey du Quart.

3. **Gerboise** : Nice bumpy little red run with off-piste options to the left of the piste. Known for holding the powder.

4. **Selles** : Long, winding out-of-the-way blue taking you out to Les Selles - one of the top spots to eat lunch or have a picnic in the sun.

5. **Mérégers** : A steepish red that cuts the corner off the big bend at Selles. Off-piste access to join up with Mulots red run too with local knowledge, or rejoin Selles to take you down to Les Diseurs hameau.

6. **Blanchon** : Typical Crey du Quart red run. Links with **Mulots**.

7. **Mulots** : Open groomed piste at the top section followed by a tree-lined bottom section. Rarely busy.

8. **Belette** : More of the same as **Blanchon**.

9. **Rose** : Good red linking the Crey du Quart area with the Vieille Lac chair to get you back to Valloire 1430. Off-piste options off the ridge.

10. **Escargot** : Linking green run taking you down to the Chateau Ripaille restaurant area and much further onwards to Sea draglift eventually. Relatively busy.

11. **Pervenche, Aigle** : Two similar intermediate reds with well-groomed pistes, serviced by Chateau Ripaille drag lift.

12. **Escargots** : Straightforward from the top of Colerieux drag that crosses Escargot and links with **Pervenche**.

13. **Praz Violette** : Excellent pisted red from the summit of 2444 along the ridgeline overlooking the Valmeinier valley. Great views not for the vertiginous. Serious off-piste potential but take it seriously.

14. **Plan Palais** : One of three similar reds with solid descents and great views, serviced by the Plan Palais drag.

15. **Praz Conduit** : The blue version of **Plan Palais**.

16. **Slalom, Goulet** : Both of these reds are right hand turns of **Armera** blue. Nice steep pitches and possible off-piste.

17. **Armera** : Exceptionally long and mellow motorway piste down to L'Armera station through the trees.

18. **Soldanelle** : Reached via Plan Palais or Crêt drag lifts.

19. **Gentianes, Slalom** : Both of these pistes are reached via Liaison Escargots. Drop off left for some fast advanced fall-line action.

20. **Martagon** : A laid-back winding blue from the Crêt de la Brive cable car down to the restaurant just above Les Charbonnières. Nice place for a chilled lunch. Take the winding **Lutins** green or **Chamois** red onwards down to Le Pontet.

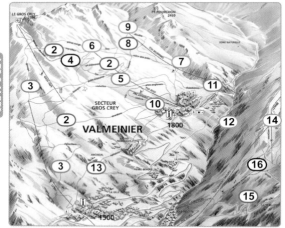

1. Edelweiss, Chamois : Two ski in ski out red runs - many people use them as home runs, but actually they are good fun to get on if you only have a couple of hours on the snow on a day off, for example.

2. Myrtilles, Petit Déjeuner, Chardons : Three interlinked greens which must vie for the best green descent in the Alps! Start at Gros Crey (2594 metres) and finish up in Valmeinier 1800. It doesn't get much better than that!

3. Génépi, Eglantières : The signature run of the resort - descending more than 1000 vertical metres from Gros Crey into Vameinier 1500. You will definitely earn your vin chaud after this one!

4. Grand Choulet : Steep black run which normally has very good snow conditions, and accesses good off-piste. Definitely take a guide.

5. Lys : The bottom section of Grand Choulet - a winding open red piste, very well-groomed, back into 1800. Solid intermediate slopes.

6. Perce Neige, Violets, Lac : The blue option from Grand Crey taking you to Jeux station. From there the long, winding Lac or Violets blues or hook into the **Petit Dejeuner** green - ideal for learner and improver skiers and boarders.

7. Reine des Prés : Also a blue from Jeux chair - very open piste with excellent snow above 1800.

8. Lauzes : The green off the top of Inversins chair lift. It interlinks with many others so you never get bored. Simple!

9. Rhodos : Slightly steeper blue that is very often uncrowded and gets long hours of sunshine.

10. Slalom : The race piste for Valmeinier (obviously!). Often closed with racer training and competitions.

11. Chaudanes : Interesting red that forks off Rhodos blue above 1800 - also a good ski-in option for the chalets in this part of town.

12. Neuvache : Flattish run through the base of the valley down to the lower hamlets of 1500.

13. Epilobes : Long flat linking green for traversing between Valmeinier 1800 and 1500.

14. Combe, Mine, Arcosses : Lovely blue playground in the Combe area, often sunny, and a way over to Valmeinier.

15. Grapil : Long winding green alternative to Armera with a restaurant half way down.

16. Grand Droses : Fall-line black reached via Grapil green run if you suddenly get itchy for powder on the way down to Armera and 1500, which you might well do!

Introduction

Serre Chevalier is really a series of resorts stretching from *Briançon* (*Serre Che 1200*) at the bottom of the the *Guisane Vallée* up through *Chantemerle* and *Villeneuve* (*Serre Che 1350-1400*) to *Monetier les bains* (*Serre Che 1500*). Combined, the area has over 250km worth of pisted ski runs.

Almost synonymous with **Serre Chevalier** is the name of their favourite son, the legend that is **Luc Alphand** - winner of an astonishing *10 World Cup downhills*, and now a racing-driver and competitor in *Paris-Dakar* and *Le Mans* for fun...who is giving us his insight into the region.

We also cover **Montgenèvre** in this section. Whilst the two regions are in no way linked (they are separated by *Briançon*), it is easy to travel between the two, and many people do. **Montgenèvre** is the gateway to the massive Italian *Milky Way* region of 320km of pistes, and a busy intermediate-friendly resort in its own right.

We have the benefit of the local knowledge of **Patricia Chauvet** , *2nd in the World Championship in 1996 in Slalom* for the *French National team*, and *15 podiums in World Cup Slalom* events from 1993-97.

The good
• **Serre** - 4th largest ski area in *France* - stacks of runs.
• **Montgenèvre** - good value and close to *Italy*.
• Great base for ski travellers to explore the region.

The not-so-good
• **Serre** - a string of resorts with no real '*soul*'.
• Neither the place for a wild party week.
• The whole region is best explored by car.

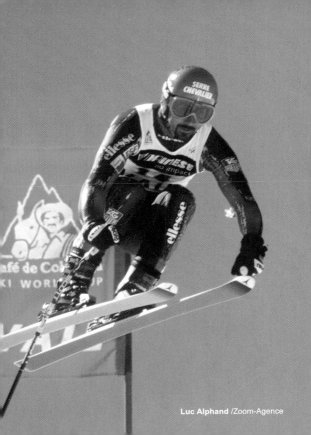

Luc Alphand /Zoom-Agence

GRENOBLE

Getting There

Fly: from UK to *Turin* via BA and Ryanair. It is then 110km (approx 2-2.5 hours). Fly to *Grenoble* via Air France (90km) and then a 2 hour drive.

Drive: take **A32** from **Turin** west through to *Oulx*. Turn off on **S24** past *Sestrière* and you'll come to *Montgenèvre*, and continue on for approx 20km to *Briançon*. Take the **N91** 15km up the valley to *Serre* and *Monetier*. From **Grenoble**, take **A51** south to the **N85** then onto the **N91** at *Vizille*. Head through *2 Alpes* and *La Grave* to *Monetier* via *Col du Lautaret* (snowchains recommended).

Coaches: - From **Turin**, get the *Sadem bus* to *Porta Nova station* then take a train to *Oulx* and the *Serre Chevalier 1200* to *Serre*.

Train: The nearest rail station is *Briançon* (15km away). There is a very good bus services from the station to the resorts.

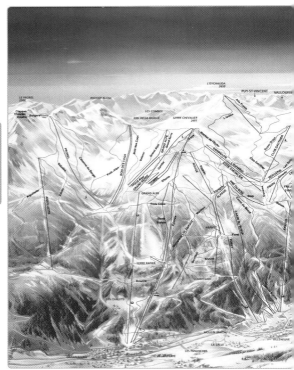

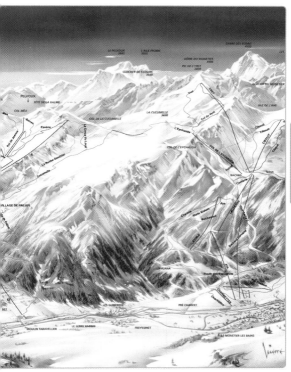

Tourist Office

Serre Chevalier + 33 (0)4 92 24 98 98

Main office

BP 20
05240 Serre Chevalier
France

General email

contact@ot-serrechevalier.fr

Resort websites

www.ot-serrechevalier.fr

Grand Serre passes

Covering the whole of Briançon (Serre Che 1200), Serre Che (Serre Che 1350-1400) and Monetier (Serre Che 1500). Discounts available for seniors, under 16, season passes, early season.

| Day | €35 |
| 6 Day | €170 |

Insurance

Top Glisse €2.60 per day

Serre Che *By Luc Alphand*

Serre Chevalier is a collection of about half a dozen small villages that link to the ski area of Serre Chevalier.

The best thing about it is the weather, because of the altitude and the fact that it is further south than most resorts, it has a great sunshine record.

The countryside is also different from the Savoie. The *Mélèze* trees are not your standard pine, and will drop their needles in the winter. That means that you can do some excellent tree-skiing, and even stop for picnics in the woods. The *'resort'* of **Serre Chevalier** has many difference faces:

Briançon is an old town with all the facilities you'd expect but is the lowest access point.

Chantemerle, which is a mecca for french families, teens and kids during the holidays.

Villeneuve, being the largest and busiest of the villages with the most pumping nightlife.

Monetier, the quiet and highest of the villages - an unspoilt little spa village with access with little to offer in terms of nightlife but by far the best access to the snow for the advanced and experts amongst us.

All in all, you don't tend to hear too much griping about the area. Most people who have been are happy to go back - particularly if they are families, on a budget, boarders, students or after quieter slopes during peak periods.

SERRE CHEVALIER

My favourite runs

SERRE CHEVALIER

Best off-piste
The best off-piste run is **La Montagnole**, which runs down behind the glacier at the top of the skiing at *Monetier*. It is very popular, but if you can be there first on a powder day, then it is incredible.

Best black run
The best Black run is the **Casse du Boeuf**, fed by a fast 800m vertical drop chairlift it is where *Serre Chevalier* is planning to build a new Downhill run. The run is very steep and exciting with everything you expect from a world class downhill run. Fantastic.

Best red run
My two favourite red runs are, in *Briançon*, the tranquil and picturesque **Eduits** run down from *Prorel* through the trees to *Les Eduits*. In *Monetier*, I love **Clos Gaillard**. Again, it is through the trees and typifies the best *Serre Che* pistes - long, winding and undulating.

Best blue/green
I think that the best for the kids or learners are the runs from *Monetier*, the beginner slopes are close to the terrace so you can sit and watch them from the bar. However, try the amazing green **Route de Fréjus** from the mid-station back into *Villeneuve* through the trees.

Best eats
There are lots of good restaurants, but my favourite is the **Café Soleil** in *Chantemerle*, because it is closest to my home.

Après

Up in 1400 the main spot is the **Café Soleil,** and at *Chantemerle* **Le Relais du Ratier** (don't be put off by the name. Ratier means the rat-catcher not the place to eat for the mountain rat posse!).

A good option at *1500* is the well-known **Peyra Juane** (worth booking), which is the definition of the classic French mountain hut restaurant.

Shoot up the valley to *Monetier* if you want to do the special-night-out thing and find **Auberge du Choucas** - probably best to book too.

In *Villeneuve*, the fondue/raclette scene is dominated by the very nice **Le Refuge** or **La Marotte.**

Starting down at *1350*, the **Extreme Bar** and the **Underground Bar** will give the discerning party animals amongst you a good go of it - very popular with French and English boarders and students. Also the **Irish Bar** serves up a very passable pint of zee old black stuff. For the less grungy, a good place for a cold beer in the sunshine on a day off the slopes is the **Yeti Bar.**

Further up in *Villeneuve* there's the petite-but-perfectly-tuned **Loco Loco,** a personal favourite the **LB** (good chilled atmosphere with a pipe-and-slippers fire - bar of choice for many of the resort workers), and the out-of-control **Noctambule**. Après ski venue of choice is the **Grotto du Yeti,** particularly for the many Scandies.

Fewer options up in *Monetier* - it's almost certainly going to be the **Rif Blanc.**

For a bit of later-night action in *1350* head to **La Dune** or in *1400* the **Bam Bam.**

SERRE CHEVALIER

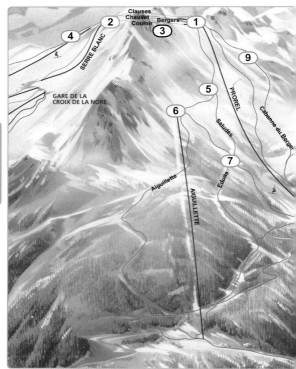

SERRE CHEVALIER

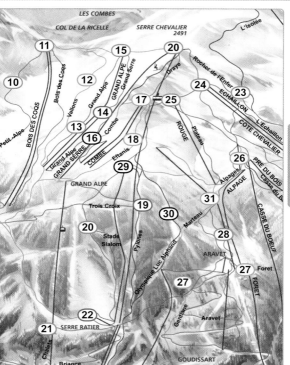

LES COMBES
COL DE LA RICELLE
SERRE CHEVALIER 2491
L'Isolée

SERRE CHEVALIER

Briançon

1. **Clauses, Chauvet** : Southerly slopes so watch out for slush and patchy snow at the bottom. Nice and sunny and lovely with fresh snow.

2. **Bergers** : Regular blue from the top of Propel. Can have patchy snow dependent on conditions.

3. **Couloir** : Short steep and often icy black run for experts only.

4. **Club de Ronde** : Nice red down from the top of Propel cable car that links up with the other Briançon reds.

5. **Saludes** : Very nice open red run with lovely views.

6. **Aiguillette** : Turn off Saludes to take this open-pisted, undulating red down through the trees. Rarely busy.

7. **Eduits** : As above but slightly narrower and steeper in places and quiet.

8. **Myrtilles** : Linking blue, get you across from Prorel to Grand Alpe.

9. **Cabane du Berger** : Out-of-the-way, open red that joins up with Petit-Alpe. The bottom tree section can have icy and slush but there are snow-making machines.

Villeneuve

10. **Petit-Alpe** : Red down from the top of Bois-des-Coqs. Bottom section links with Cabane du Berger.

11. **Bois-des-Coqs** : Steepish start to this red and a bit mogully, then the pistes open up for fast carving turns.

12. **Vallons** : Relatively tame but very long blue from the top of Serre Che down to the mid-station. A full 600 metre vertical drop.

13. **Grand Alpe** : Tree-lined, narrow and often very icy make this run a special challenge for the best skiers and boarders at speed.

14. **Grand Alpe** : Simple green that criss-crosses the black run through the trees. Good place for the less-confident to watch and learn!

15. **Grand Serre** : Short steep and often icy red run for intermediate skiers and boarders.

16. **Mur du Grand Serre** : Good short black for posing under the the Grand Serre chairlift.

17. Combe : Standard wide-open blue run. Bottom section has artificial snow-making as it often gets patchy.

18. Eftanis : Basic blue from Combe down to Grand Alpe station. Good last-run-before-lunch slope.

19. Trois Croix, Celvan : Brilliant long green all the way through the trees from Grand Alpe station to Chantemerle. Essential first run after lunch!

20. Draye, Stade Slalom : Very long red - great to try if you have just done Vallons and the confidence is up. Turn off left at the bottom if it is open for the race course.

21. Chalets : The windy red from Serre Ratier back to Chatemerle. Can be crowded and suffers from ice and slush at the bottom.

22. Briance : Really nice cruising green for that last run of the day back into Chantemerle for Vin Chaud!

23. Rocher de L'Enfer : Solid red, often chilly that acts as the gateway from Chantemerle to the reds and blacks at the far north of Villeneuve.

24. Echaillon : An alternative option to Rocher de l'Enfer for intermediates.

25. Plateau : Short red run from the top of Rouge drag. Joins with Marteau for a fantastically long improver/intermediate thigh-burner.

26. Alpages : Short blue that links Fangéas with Marteau. Not much more to say about it than that! All standards.

27. Forêt, Gentiane : Basic linking blues, often crowded with skiers And boarders from Villeneuve going across to Chantemerle.

28. Stade : Good, reasonably narrow slalom run through the trees.

29. Pylones : Challenging bumpy black run that winds through the trees on a narrow piste. Often icy.

30. Olympique Luc Alphand : The run to honour our author, Luc Alphand (obviously!). Give this a go and whilst you are avoiding the ice, try to imagine the speed and skill-level that Luc did it at whilst racing. Unbelievable!

31. Marteau : Very long winding and cruisey blue back down to the nursery slopes of Villeneuve. Plenty of artificial snow-making make it reliable.

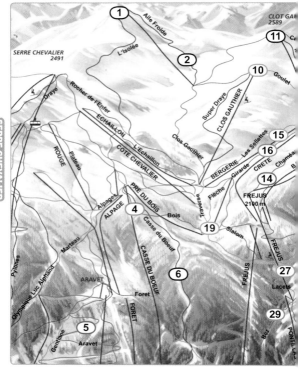

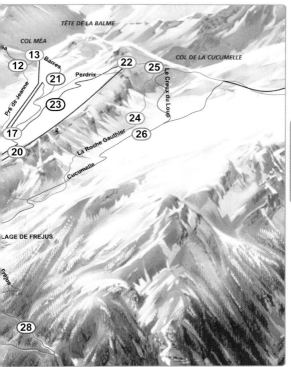

TÊTE DE LA BALME

COL MÊA

COL DE LA CUCUMELLE

Barres

Perdrix

Pré de Jeanne

Le Creux du Loup

La Roche Gauthier

Cucumelle

LAGE DE FREJUS

réjus

SERRE CHEVALIER

1. Isolée : The furthest north of the resort you can go, hence the name. Steep, difficult start on the ridge but then a fantastic drop into valley for experts. Often very cold up here.

2. Aile froide : Steep, isolated and tranquil black. You can often get this alone! Good skiers and boarders only.

3. Fangéas : Linking piste from L'Echaillon passed the Bivouac restaurant down to the Echaillon station.

4. Bois : Long scenic red down through the trees that is often used as the top part of the run back to Le Bez from Villeneuve.

5. Aravet : Brilliant winding green through the trees. Perfect last run of the day to hoon it down.

6. Casse du Boeuf : Very demanding long black dropping nearly 700 vertical metres under the chair of the same name into the nursery slopes. You deserve a beer after this one!

7. Stade Slalom : Often closed for race-training. Come and watch the five year old stars of the future hurtling down the slopes.

8. Clos Gauthier : Long wide-open piste red with good panoramic views from the top of Clot Gauthier. Good warm-up before going back up the chair for **Super Draye** black.

9. Super Draye : Short, steep-to-start black with moguls. Levels out in the second section. Good step-up piste for basic advanced skiers.

10. Goulet : Excellent blue, surpisingly steep in places at the top. Nice intermediate carving slopes.

11. Les Blocs : Another short steep black in this cold and sometimes windy advanced skier/boarder playground.

12. Crête de Méa : The other red option off the back of Clot Gauthier drag. Can be windy and cold up here.

13. Pré de Jeane : Simple short blue to finish the Crête de Méa red run.

14. Chaméant : Good green that links up with **Barres** to take you down to La Fermière restaurant for lunch!

15. Les Sellettes : The blue off the top of Bergerie drag lift. Well-groomed wide pistes.

16. Girarde : The red option if you go right at the top of Bergerie. Storm down it after lunch a couple of times then head north if you're advanced plus.

17. Cabane : The blue run that acts as a link for people coming up from Fréjus to get them over to the far north of the resort.

18. Lys : Basic wide-open linking red run.

19. Traverse, Flèche : Simple shallow blues linking Fréjus with Echaillon. Often busy with beginners.

20. Slalom : Excellent slalom run enabling you to race past the Fréjus station and impress the onlookers (if that's your thing!).

21. Barres : Really nice sweeping green run favoured by the ski schools. Tends to have good snow.

22. Perdrix : A blue that enable you to cross from Monetier to Villeneuve side and vice versa. Tranquil and quiet. Provides access to good off-piste with a guide.

23. Choucas : Good black that has a number of off-piste options. Take a guide with you and go for it.

24. Roche Gauthier : Effectively the other half of Perdrix over the back of the Balme mountain. Real back-country stuff.

25. Creux du Loup : Excellent short sweet red with access to good off-piste down through the Cucumelle valley. Good skiers and boarders head here if there's been a powder dump.

26. Cucumelle : Beautiful, hidden valley-type run enables a run from Cucumelle (2698 metres) all the way back into Villeneuve. Highlight of the pistes if the snow is good.

27. Lacets : Short simple blue into Village du Fréjus.

28. Route de Fréjus : Excellent long winding run through the trees. Watch out for the slush at the bottom, but good snow-making facilities.

29. Bez : The red down from Pontillas if you decide the green is a little too easy for the last run of the day.

SERRE CHEVALIER

SERRE CHEVALIER

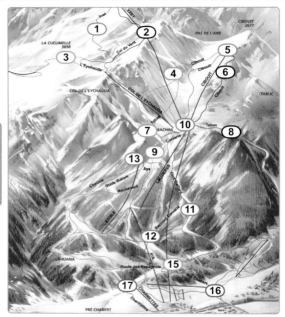

1. Yret : Short and sweet, steep-to-start red with good access to off-piste and great powder after a dump.

Try La Montagnole with a guide for some of the best off-piste around.

2. Col du Vent : Interesting black down through the Neyzets bowl with excellent off-piste options.

3. Eychauda : Lovely long and exhilarating blue down the back of La Cucumelle into Le Bachas station.

4. Cibouit : Beautiful picturesque blue run with nice views of the bowl area and good off-piste powder close to the piste.

5. Cibouit : More challenging version of the blue, slightly steeper and finishing up through the trees at Le Bachas restaurant.

6. Cibouit : Third of the trio of Cibouit runs. Black, bumpy and plenty of off-piste nearby make this a great expert run.

7. Tétras : Basically a branch off the bottom section of Eychauda.

8. Tabuc : Awesome black run - one of the highlights of the resort. Very long with some steep and narrow pitches through the trees and access to off-piste. What more could you ask for?

9. Rochamout : Lovely long blue from Bachas all the way down through the trees to Charmettes. No improver should miss this.

10. Corvaria : Steeper version of Rochamout underneath the Lauzières chair lift. Good powder through the trees.

11. Clos Gaillard : Amazingly good red run thorugh the trees. Very long and exhilarating. Real quality powder if there's fresh stuff about.

12. Racord Corvaria : A right hand fork off Clos Gaillard half way down for more of the same, ending up at Aya.

13. Chaume, Stade Slalom : Two short steep and narrow slalom courses. Sometimes a bit icy but always great fun, serviced by Etoile drag lift.

14. Aya : Excellent long red back into town from Etoile. Snow can be variable but stack of artificial snow. Often busy at peak times.

15. Route des Espagnols : Alternative route left off from Rochamout to get you back into the top of Monetier. Nice and cruisey through the trees but a bit of a motorway.

16. Charmettes, Pré Chabert : The two nursery green runs in town, popular with ski schools and families.

Tourist Office

Montgenèvre + 33 (0)4 92 21 52 52

Main office

Route d'Italie
05100 Montgenèvre
France

General email

info@montgenevre.com

Resort websites

www.montgenevre.com

Milky Way passes

Covering the whole of Montgenèvre, plus Sestrière, Clavière, Cesana, Sansicario and Saux d'Oulx. Or you can get a Grand Galaxy 6 day Pass giving access to Serre Chevalier, Puy St Vincent, Deux Alpes and Alpe d'Huez.

Day €36
6 Day €190

Insurance

Top Glisse €2.60 per day

Montgenèvre *By P. Chauvet*

2nd in World Championship Slalom in 1996.
15 podiums in World Cup from 1993 to 1997.

Montgenèvre is a really stunning old village resort just 20km north east of Briancon and 2km short of the Italian border (100km from the nearest airport in Turin).

It is the only French resort with direct access to the *Milky Way* resorts, an enormous 320km ski area including the Italian resorts of *Sestrière*, *Clavière*, *Sagnalonga* and *Sauze d'Oulx*, which has been chosen to host the *2006 Winter Olympics*. However, the lift links not the easiest so the best way to explore the area is by car.

Montgenèvre is 1850 metres above sea-level. Alot of the skiing takes place on north-facing slopes at 2500 metres so it tends to have very reliable snow record with good snow from December to April, and an amazing 300 days sunshine per year. Over half of the pistes are red runs, so it is a very popular intermediate resort with some really good slopes accessed from the Gondrans chairlift. It is also known for high-quality teaching for beginners and good nursery facilities.

The pistes are a combination of bowl skiing higher up and some relatively tame tree-line stuff down to the resort, with the most challenging pistes (and off-piste options) around *Col de l'Alpet*.

This combined with ski in ski out accessibility from many of the chalets, lack of crowds in the week and two very efficient gondolas taking you quickly up to either of the two main mountain areas of the *Les Chalmette*s and *Chalvet*, make it a very convenient resort.

It is even possible to go and get a pizza in Italy 10 minutes away! Whilst the centre of town is compact and bijou, it can be full of traffic for much of the day, which tends to ruin the alpine village feel. Watch out for the weekend traffic and associated parking difficulties when there's an influx of Italian weekenders.

SERRE CHEVALIER

Best off-piste
Le Vallon de la Doire is as it should be - the place to go in *Montgenèvre*. There are some very experienced ski and snowboard guides to help you out and make the experience as enjoyable as it should be.

Best black run
I am a big fan of **La Grand Charvia** black run at the top of *Rocher de l'Aigle* - right on the border between France and Italy. Worth it for the views alone.

Best red run
Le Chalvet red is my favourite red run - actually very remote and quiet but you get a really long descent. This place can be magical if you are on your own with fresh powder under ski. If not, try the **Col de L'Alpet** for a mellow run on really well-packed snow.

Best blue
Try the **Les Anges** blue run - a very long cruising blue for everyone to have fun on, from families and beginners upwards.

All in all, **Montgenèvre** offers variety, flexibility and if you happen to have a car and want to stack up the snow-miles and resort-visits, access to many different ski resorts both in France and Italy within half an hour.

There are 5 restaurants in the mountains, but it is best to head for *Clavière* for the best options. Try **La Coche** in *Les Monts de la Lune* area for classic Italian food.

The main mountain stop on the *Montgenèvre* side is **Les Anges** which may not be pretty but does the job. **Les Chalmettes** is another good piste-side option.

Le Refuge and **L'Estable** are typical French spots offering good value food, and **La Capitainerie** is worth a go.

Pizzerie Le Transalpin is the place for pizza (ironic, given the fact that Italy is a few hundred metres away).

In the village, the well-known **Le Jamy** is pretty cool for early evening drinks or **La Cal de Sol**, whilst the Brit-run **Le Graal Café** is a very popular bar/après ski venue.

Another option is **Chaberton Pub** which is more of a French/Italian hangout with karaoke, but it goes off at the weekends!

Blue Night is the only place to head for to get your dancing shoes on - the only place!

SERRE CHEVALIER

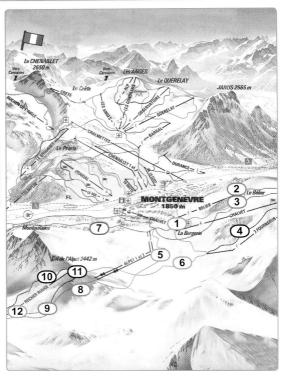

SERRE CHEVALIER

www.snowfinder.co.uk

1. **Combe du Bélier :** Classic cruisey blue run for beginners to build confidence or as a warm up for the other Bélier reds.

2. **Combe de la Loup :** Tranquil back-country style red run for intermediates plus. Crisp and chilled in the fresh snow!

3. **Le Chalvet :** One of the more remote runs in the resort - very long, wide descent of approx 800 vertical metres. Don't miss it. The bottom section can sometimes be patchy and green but there is artificial snow-making.

4. **3 Fourneous :** Fantastically isolated and quiet black run

5. **Alpet :** Really mellow long blue run for all standards. Normally has quality snow conditions. Lovely.

6. **Réservoir :** More of the same as Alpet only longer. Great run to get the miles on the clock at the start of the week.

7. **Suffin :** Simple long green down through the trees from the top of Chalvet telecabine back into town.

8. **Ch du Rocher Rouge :** Beautiful long out-of-the-way red with access to plenty of off-piste. Very remote with link to Baisses blue down into Clavière.

9. **Le Loup :** Alternative to the bottom section of Ch du Rocher Rouge.

10. **Trois Scies :** Steep, isolated and often empty black run with a couple of bumps and narrow pitches. Access to off-piste with a guide.

11. **Chabreton :** Excellent long and testing black run with great views from the top down to Clavière. Wide-open access to lots of off-piste.

12. **Baisses :** Long pretty descent down to Clavière from Rocher Rouge - an impressive 5-600 metres vertical decent.

SERRE CHEVALIER

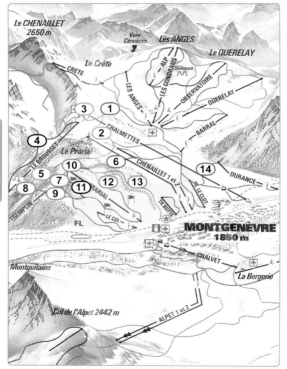

1. La Crête, Le Lac : Nice laidback green run for all standards to get the legs going before heading over to Les Anges and Querelay.

2. Chenaillet, Chateau Jouan : Standard blues that are generally well-groomed pistes with good quality snow all season.

3. Traversée : Linking run from the top of Chenaillet down to Chalmettes or on to Rocher de l'Aigle chair.

4. Les Rhodos : Middle-of-the-road black off Le Brousset chair. If the snow is good, it can be great down here in the trees.

5. Le Vallon : Very long blue descent from Prarail down to Tremplin - often in the sunshine. A take-it-easy run!

6. Le Bois : As the name suggests, an easy run down through the trees to get beginners off Prarail and back to the nursery slopes.

7. La Jauffret : Short red off the back of Prarail.

8. La Doire : Stunning little winding red run down through the trees from Tremplin onto the valley below.

9. L'Office : The red off the right of Tremplin drag lift.Snow can sometimes be sketchy but there is artificial stuff to make up for it.

10. Prarail : Good racy red slalom piste. Low down so the snow can sometimes be dodgy at start and end of season. Enough snow-makers though.

11. La Chauvet : The black slalom race piste named after none other than the legendary *Patricia*, herself.

12. La Mandarine : Another typical slalom slope.

13. L'Envers : Good little racing red where the crazy boardercross lunatics do their stuff!

14. La Durance : Nice little out-of-the-way learner piste favoured by the ski schools.

SERRE CHEVALIER

Adrian Myers

Les Anges & Le Querelay

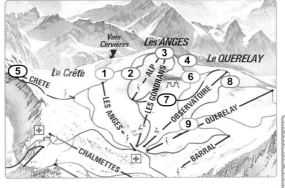

1. **Sagnes** : Seriously long cruiser blue run from the top of the picturesque Anges mountain. Great powder after a fall.

2. **Les Prés** : Very good popular intermediate run - busy and long queues but worth it.

3. **Les Sources** : The red under the Gondrans chair lift for muchos posing about - turn left off it for the Snowpark for even more posing!

4. **L'Alp** : Short red with some bumps for intermediates.

5. **La Réserve** : Sexy black run serviced by Crête drag lift. Steep bumps and off-piste access the order of the day here!

6. **Les Poussins** : The blue off the right of Observatoire lift.

7. **L'Observatoire** : Nothing challenging here but good bumps.

8. **Le Querelay** : Very good popular intermediate run.

9. **Pré Chare, Janus** : This is a chilled out undulating pair of blue runs with good groomed pistes.

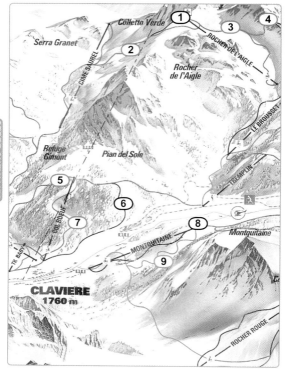

Rocher de l'Aigle - Clavière

Rocher de l'Aigle

1. Grand Charvia : Distant black run for good advanced and expert skiers and boarders. Take a guide to explore the off-piste down to the Italian side of Coletto Verde.

2. Collette Verte : Highlight of the resort red which is on the border of France and Italy. Very long, picturesque and quiet. Perfect!

3. Soureou : Lovely open carving piste to get your Super G head on and charge down.

4. Les Chamois : Red run off the back of Crête - pretty steep in places and a long way from anywhere. Links with Soureou to get you back down to Rocher de l'Aigle chair.

Clavière

5. La Blanche : Nice bumpy red thorugh the trees from Col Boeuf chair taking you from Clavière back to the resort.

6. Pistone : Turn right off La Blanche for this fast black through trees at the top then becomes wide-open for the run in. Good run to make the step up to blacks from red.

7. Col Boeuf : Nice wide piste, flanked by the forest under the Col Boeuf chair. A couple of steeper pitches to enjoy on this carver-turn favourite.

8. Plein Soleil : The long black run served by Montquitaine chair from Clavière. Pretty busy and sometimes icy but good fun.

9. Montquitaine : A meandering blue version of Plein Soleil. Open groomed piste that gets a bit patchy towards the end of the season but pretty consistent.

Adnan Myers

Introduction

We have chosen to cover three very special resorts in the *Southern Alps region*: **Risoul Vars**, **Pra Loup** and **Isola 2000**.

Risoul (or combined with *Vars, the Domaine de la Foret Blanche*) has the feel of a relatively small purpose-built resort but the link with *Vars* gives it access to over 180km of solid beginner and intermediate pistes, and is family-friendly. It's also a little gem for the boarder fraternity too. **David Chastan** is the man with the local knowledge - he is the *French National Team Giant Slalom coach*.

Pra Loup has a vast amount of skiing, linked to the *Allos area* and is actually the *8th biggest ski area in France*. Bet you didn't know that? It is a well-kept secret - it also has great, relaible snow as it is pretty high. **Christel Pascal** lets us in on her home town secrets here. Christel has been a *top 3 in the world ranked Slalom skier*, representing the *French National team* and a *World Championships silver medallist*.

Isola 2000 is a purpose-built resort in *Alpes Maritimes*, conveniently situated close enough to the *Cote d'Azur* to mean you can ski in the morning and then make it hme for an evening dip in the *Med* at *Nice*, only 90km to the South. Since this was the first resort **Hugh Hutchison** ever skied in outside of Scotland, we thought it only fair to get him to tell you about it to keep him happy!

The good
- **Risoul Vars'** extensive skiing and brit-friendliness.
- **Pra Loup's** breadth of ski area and reasonable prices.
- **Isola's** April snow & proximity to the *Cote d'Azur*.

The not-so-good
- **Risoul Vars'** limited nightlife.
- **Pra Loup's** transfer time to *Marseilles airport*.
- **Isola's** sometimes low snow count.

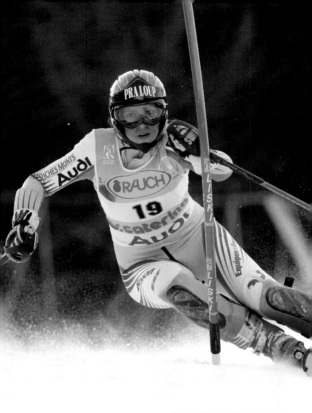

Christel Pascal / Zoom-Agence

Tourist Office

Risoul	+ 33 (0)4 92 46 02 60
Pra Loup	+ 33 (0)4 92 82 10 04
Isola 2000	+ 33 (0)4 93 23 15 15

General email

info@risoul.com
info@praloup.com
info@isola2000.com

Resort websites

www.risoul.com
www.praloup.com
www.isola2000.com

Ski passes

Risoul

Day	€27.50
6 Day	€143.50

Pra Loup

Day	€26.50
6 Day	€130

Isola 2000 Prestige

Day	€26.50
6 Day	€130

Insurance

Carré Neige	€2.60 per day

SOUTHERN ALPS

Risoul Vars *By David Chastan*

French National Team Coach Giant Slalom.

Risoul is a relatively new resort, purpose-built in the 70s on a high sun-kissed plateau and linked to the next door neighbour resort of Vars 1850 with 174km of ski area. It is 250km from Marseilles, the nearest international airport. The nearest train station is Montdauphin/Guillestre, 15 km (9 miles) to the north via the D902, and about 40 minutes south of Briançon.

Risoul is known for it's reasonable prices, late season skiing and being a southern resort, sunshine. The *'good value'* motif has made the resort attractive to a whole host of new snow-tourists from eastern europe to complement the not inconsiderable Brit and Dutch package crowd. **Risoul** can suffer lack of snow although the resort continues to invest in snow-making facilities to counter this.

It is an attractive and compact resort, with a good quantity of ski in ski out slope-side chalet-style buildings and a real French atmosphere. It is not the resort to head to for extreme couloirs, fast-and-furious black runs...you get the picture? The steeper runs tend to be over the Vars side.

However, it is a beginner and intermediate playground with a wide range of runs in the bowl above the trees, and many pretty and laid-back tree-lined runs, all of which end up back in the centre of town where you'll find the ski schools and nursery slopes conveniently co-located. In particular, the many good blues and reds make it a popular place for three distinct groups: families on a budget; a good proportion of local French skiers; and the young boarding and freestyle fraternity.

In fact, **Risoul** has an unbelievably good snowpark at *L'Homme de Pierre, Risoul Surfland, Super Pipe* (allegedly the longest in France), boardercross and a modules zone with various jumps and bumps. In our view, this is one of the best places to do your first 'big air' aerial!

SOUTHERN ALPS

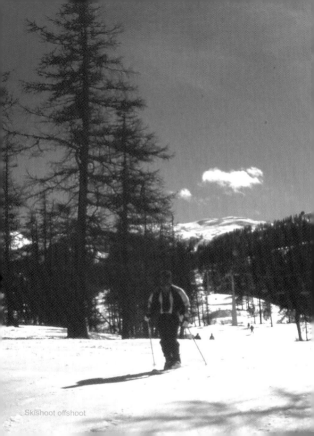

Skishoot offshoot

My favourite runs and Après

Best off-piste
Off-piste is not big in *Risoul*. The best bet is to get a guide to take you to the **Clos Chardon** area or you can ski amongst the trees.

Best black run
Either from the top of *Peyrefolle*, the **Epervier** which is steep and can get bumpy, or the really steep **Evasion** run down from *Col de Crevoux* into the valley. Or **La Plate de la None** via *Vautours*.

Best red run
From *Vars Les Claux*, go up **Peynier** and take the amazing red all the way back through the trees to *Vars Sainte Marie*. In *Risoul*, the massively long **Pinatiaux** from *Pointe du Razis* has stunning views and steep treeline descent into town.

Best blue/green
From the top of *L'Homme de Pierre*, the **Combe de la Meyt** is long, fun and finishes through the trees back in *Risoul 1850*.

There is a young, lively atmosphere in *Risoul* with many snowboarders and bars catering for the *'surf'* scene. Nightlife is a bit limited but there's fun to be had.

The cool après ski hangout is **Cherine** - a popular meeting place straight from the slopes before moving up to the **Yeti Bar** where it goes off every night, and **L'Apache**, where the serious business of partying takes place.

For local food/hangout, try **La Pitchounette** or **Les 3 Ours** to eat. Otherwise it's **Bar Rock, La Place** or **Le Rhum Café.**

La Scala and **Le Morgan** are the late night club options.

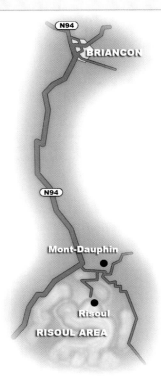

www.snowfinder.co.uk

Getting There

Fly: From UK to *Turin* via BA and Ryanair or Nice via BA, Air France, Bmibaby and Easyjet. It is then 280km (approx 4 hours).

Drive: From *Nice airport*, take the **A8** west and turn onto the **N202** then follow directions for *Digne Les Bains* on **N85** and onwards to *Sisteron* via the **A51** as far as *Gap*. At *Gap* take the **N94** to *Mont-Dauphin*, then the **D902** to the resort.

Train: The nearest rail station is *Mont-Dauphin* (5km away). There is a very good bus service from the station to the resorts, and taxis are easy to get.

Risoul - L'Homme de Pierre

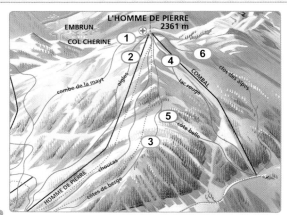

1. **Combe de la Mayt** : Fantastic long blue for all standards. Open and fast at the top section, then into the trees and a bowl section to finish nearer Risoul.

2. **Aigles, Choucas** : Two high-quality pistes down thorugh trees, known for their good snow and often uncrowded.

3. **Côtes de Berge** : Blue version of Choucas. Amazing views out across to St Clément down the valley.

4. **Lac Rouge** : Steep, out-of-the-way red that follows the fall-line from L'Homme de Pierre down to Combal lift. Off-piste options around here.

5. **Côte Belle** : Shorter version of Lac Rouge. Rarely busy and some good powder seems to hang around here.

6. **Clos des Alpes** : Very long, tranquil, back-country blue that has great views and great snow up top then ski through trees to the lift.

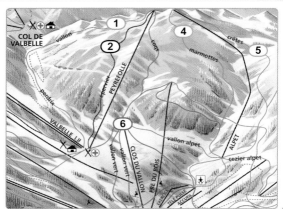

1. **Vallon, Perdrix** : Rolling, shallow-gradient blue for cruising. Take a guide to sample the off-piste treasures around this area.

2. **Epervier** : One of the few black runs on the Risoul side. Bumpy, mogully and undulating descent for good skiers and boarders with serious off-piste access.

3. **Coqs** : Best described as a red version of **Epervier** with good quality snow and a back-country feel to it. Unlikely to be crowded.

4. **Marmottes** : Good quality thigh-burning blue run with assured snow conditions.

5. **Crêtes** : Another isolated beautiful run with great scenery and off-piste. Joins up with Combe de la Mayt.

6. **Clos du Vallon green runs** : A number of good greens for beginners to get their confidence up before heading up Peyrefolle to tackle some blues. Crowded and ski school-friendly.

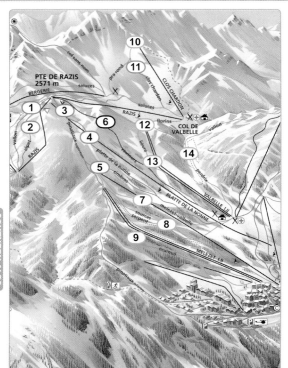

SOUTHERN ALPS

1. **Vallon, Vallon Rouge :** Highlight of the resort - extremely long blue with nearly a km's worth of descent through forest to Vars St Marcellin. Amazing. Take **Vallon Rouge** off left at the top if you want to stay up high!

2. **Alpet :** Relatively short and quiet red with good snow and some bumps to keep it varied.

3. **Pinatiaux :** Superb red. Steep at the top (Supérieure) then onto the ridge-line (Inférieure) all the way back into 1850. A 7-800 metre vertical descent. Not to be missed.

4. **Platte de la Nonne :** Turn off left at the top section of **Pinatiaux** for this good steep red run down through trees to Valbelle.

5. **Cimbros :** Another chance to hang a left off **Pinatiaux** and bang down thorugh the trees. Links up with **Platte de la Nonne** in a bowl section before going back into the trees to finish.

6. Vautours : Difficult black for experts. Steep and mainly fall-line descent. Can be icy but great views.

7. **Mélezet-Valbelle :** Starts on the ridge-line at the top of Mélezet lift. A good, short, fast blue down to Valbelle with a good schuss over to the lift station.

8. **Source-Serpent :** A favourite well-groomed piste to practice GS turns on, with trees either side of the pistes.

9. **Ecureuil :** Long blue that follows the ridge-line parallel to **Pinatiaux** the drops down into perfect tree-lined piste. If there's fresh snow, a good introduction to powder piste for learners.

10. **Pra Rond :** All the way over the other side of the Pointe de Razis, a high blue with amazing views and great quality snow.

11. **Clos Chardon :** The red option off Chardon chair. Muchos off-piste to be had in these parts to the left of the run.

12. **Florin :** A linking blue from **Valbelle** to Razis.

13. **Lièvre :** Classy blue off to the right of Valbelle chair. The top is great when there's fresh snow, and the bottom is tree-lined and pretty.

14. **Perdrix :** Good little blue that joins up with the **Vallon** run from Peyrefolle. Look out for the off-piste in the trees if there's powder.

SOUTHERN ALPS

Adrian Myers

Pic de Chabrières - Col de Crévoux

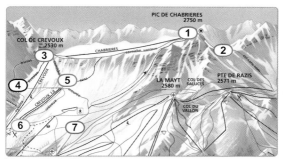

Pic de Chabrières

1. Corniche Supérieure : A breathtaking red run with incredible views which heads along the ridge to Col de Crévoux, offering much steep off-piste for experts with guides.

2. Col sans Nom : The highest pisted ski run in the region - 2750 metres above sea level at the start. Steep back-country red with great snow and never crowded. Excellent off-piste area too.

Vars - Col de Crévoux

3. Barres : Quality, steep and mogully red - a good off-piste zone.

4. Evasion : Steep and short mogul field black to test the best!

5. Corniche : Steep, demanding red run for better skiers. Can be a real treat on powder days. Also provides access to good off-piste.

6. Crévoux : Straightforward blue run for all standards. Good warm-up run for skiers heading up Crévoux to the summit slopes.

7. Mourée : Nice winding and undulating green that is often sunny and has good snow.

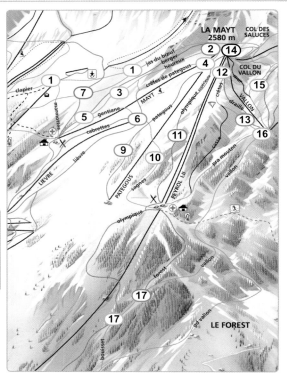

LA MAYT
2580 m

COL DES
SALUCES

COL DU
VALLON

jas du boeuf
berger
heureux

crêtes de pategous

clapier

MAYT

gentiane

cabrettes

pategous

olympique

crêtes

drailles

VALLON

pra mouton

vallon

LIEVRE

lièvre

PATEGOUS

saqnes

PEYROL Lift

olympique

forest

vallon

gd vallon

LE FOREST

bouisset

www.snowfinder.co.uk

1. **Jas du Boeuf, Calpière, Marmottes** : Long, open and often sunny set of blue runs for all standards. Start at the top on Jas du Boeuf then at Chabrières lift go left on Marmottes or straight to Clapière.

2. **Berger** : Nice sunny red from the highest point on La Mayt down to the base station of Mayt chair. Fast and undulating piste.

3. **Heureux** : Often crowded because it is a good option for first run of the day for all standards coming up on St Marie and Peyrol chairs.

4. **Crêtes des Pategous** : Simple warm-up blue taking you down to the red **Lièvre** below - a wide-open Super G style piste to carve turns.

5. **Gentiane** : Simple blue linking Lièvre with Mayt chairs.

6. **Cabrettes** : Nice red from the top of Lièvre down to the green **Adroit**. If there's a fresh dump the bottom part through the trees is fun.

7. **Adroit** : Learner piste, used by the ski schools a fair bit.

8. **Plans** : Blue traversing piste taking you to the Peynier secteur.

9. **Pategous** : Fast, rolling, open red that narrows through the trees half way down. The top section catches the sun nicely.

10. **Sagnes** : Very good little blue from Lièvre down through the trees across to Peyrol chair or to access the big red **Olympique**.

11. **Olympique** : Combines both of the Olympic runs to offer speed and carving to the max. Gets crowded and can be quite icy in late afternoon.

12. **Crêtes** : Blue run that packs a punch as it leads straight into **Casse** - a steep, sometimes narrow and bumpy run thorugh the trees for good advanced skiers and boarders. Get it when there's powder.

13. **Draille** : Good red option for those who decide to bottle **Casse**!

14. **Mur** : Short, steep, mogully black. Gets icy and patchy. Only good skiers and boarders need apply!

15. **Saluces** : Blue run down the back of Col du Vallon.

16. **Pra Mouton** : Very nice blue down through the trees above the **Vallon** piste to Peyrol.

14. **Forest** : Well-bashed red through the trees which can be powder heaven or icy and patchy. Hope for the former. Flattens out into the blue, **Bouisset** for the final run into town.

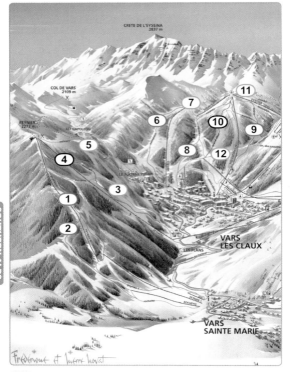

1. Peynier : Demanding and challenging red/black run that follows the fall-line directly under the chair but flattens out further down to become a red. Good advanced skiers or be prepared for embarrassment!

2. Résinière : Variation on Peynier leading down through the trees to a nice blue into Vars.

3. Cembros : Nice blue to turn off on from the Peynier ridge. Great spot in powder. Links back to Peynier or takes you down to town. Great views.

4. Ecureuils : Solid, long black run that drops off quite steeply from the ridge straight down the fall-line into town. Good for posing to the audience going up the Peynier chair.

5. Mélèzes : Brilliant blue down through the trees to Le Fournet from the summit of Peynier. Off-piste through trees possible.

6. Zakophane : Over the other side of Le Fournet up the Sibières lift - a good long thigh-burner of a red - GS carving all the way down a must!

7. Sources : The blue from the top of Escondus which links with

8. Sibières : Wide, well-groomed piste providing more carving fun.

9. Myrtilles : Short, bumpy red that runs through the trees to link up with Tétras, to form a long intermediate-friendly red.

10. Grand Ubac : Steep, fast and bumpy black run - a really demanding run to try to do from top-to-bottom in one. Good luck! Easy blue to finish.

11. Combe : Nice quiet blue off the back of the mountain with off-piste options through the trees. Links to Crévoux.

12. Escondus : Long motorway blue back into town.

Best off-piste
Take the *Costebelle cable car* from *1600* then *Bergeries chairlift* to the top of *Piste du Lac* (2500m). Take the off piste *Vallon des Agneliers*, then hop on the *Vallon Pouret Chairlift* to *La Tête de la Sestrière* (2575m), soak up the stunning view and then head off-piste on *La Foux d'Allos*.

Best black run
There's a fantastic black down from **Observatoire 2600** in *Allos* or the black down the back of **Vallon du Pouret.**

Best red run
The red run down from the top of *Le Pouret* (2500 metres) that takes you from *Pra Loup* to *Allos*. Long, exhilarating with amazing scenery.

Best blue/green
Take the **Grand Vue** run down from the top of *Tête de Vescal*.

Up the mountain, you're sure to spend some time in the convenient **Costebelle**, right there on the slopes or try **Le Peguieou.**

In town, the top spot for good local gourmet food is **Auberge du Clos Sorel** - a hotel-restaurant of much regard, just off the *Molanes* piste. Excellent traditional food. Get a pizza at **Le Loufoque** in *Pra Loup 1600*. Après ski is good at **L'Artichouette.**

This is definitely not the biggest or noisiest resort in France! The best place to relax and enjoy apres ski and a good evening is **Edouard's Pub** - apparently the place where *Jacques Villeneuve* goes to drink cocktails.

There's also the Dutch-run **Yeti Bar** which is popular with the younger boarding fraternity.

Pra Loup *By Christel Pascal*

Second in the World Cup Slalom rankings in 2000.
Silver medal in Slalom at World championship 2001.
3rd in the World Cup rankings in 2003.

Founded in 1961, Pra Loup is a purpose-built resort consisting of two main villlages Pra Loup 1500 and Pra Loup 1600 and adjoins the next-door ski area to the south of Val d'Allos. It is actually the 8th largest ski resort in France.

The resorts are actually linked by *La Foux d'Allos* at 1800 metres. And being so far South, you can expect plenty of sunshine. There are 170 km of pisted ski runs at between 1500-2600 metres. **Pra Loup** is very much a charming French family resort, very popular with French and Dutch package holiday makers, many of whom have braved the long transfer from *Marseilles* of approx 250km. This takes around 4 hours, which says something for the quality and diversity of the skiing and snowboarding, most of which is intermediate and beginner standard. The alternative is via *Turin* over the *Col de l'Arche* which takes about 3.5 hours.

The skiing is definitely enhanced when the **Foux d'Allos** pass up to **Val d'Allos** is open for business (not always through lack of snow, but this is being rectified by snow cannons) via the big red run down from **Le Pouret**.

There are many red and blue runs at treeline and above. There is also off-piste for the better skiers and the chance to rack up plenty of snow mileage in surprisingly uncrowded surrounds. **Pra Loup** takes itself pretty seriously - it hosts big competitions and is at the forefront of freestyle and boarding development - the resort recently has also linked up with *Salomon* to develop the natural *X-Pipes concept* (6 natural gulleys full of moguls and bordered by raised turns to attract the new free style fans).

So for those of you who can only think as far as an hour away from *Geneva* or 2 hours from *Lyon*, why not have a bit of a think about **Pra Loup** for a resort you may not have heard of, but you may well seriously like!?

SOUTHERN ALPS

Getting There

Fly: from UK to *Nice* via BA, Air France, Bmibaby and Easyjet. It is then 220km (approx 3 hours).

Drive: From *Nice airport*, take the **A8** west and turn onto the **N202** then follow directions for *Digne Les Bains* on **N85** and onwards to *Sisteron* via the **A51**. Take the **D942** at junction **24** then the **D900B** and **D97** to the resort.

Train: The nearest rail station is *Barcelonnette* (10km away). There is a very good bus service from the station to the resorts, and taxis are easy to get.

DIGNE-Le

N 85

SOUTHERN ALPS

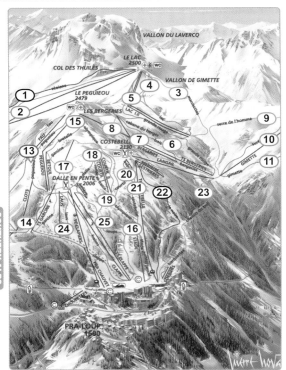

VALLON DU LAVERCQ

LE LAC
2500

COL DES THUILES

VALLON DE GIMETTE

LE PEGÜIEOU
2479

WC

LES BERGERIES

LAC

serre de l'homme

LES BERGERIES

COSTEBELL
2130

WC

BERGERIES

LANGAIR

DALLE EN PENTE
2006

SESTRIERES

CLOTE

PRA-LOUP
1500

SOUTHERN ALPS

1. Séolane : Amazing, long south-facing black run from the top of Le Lac with its incredible views. When the sun is out and the snow is good, this run is something else.

2. Quartiers : A simpler version of **Séolane** - both of which link up with Chemin des Agneliers to give you a breathtakingly long ride down to the chair to take you over to Allos. Does turn into a motorway with people heading over to Allos.

3. Marmottes : Nice open-piste to help get your ski legs ready for Lac.

4. Lac : Stunning, winding and undulating long red run with normally reliable snow. Not to be missed.

5. Grand Route : The big one down from Lac to Bergeries. Surprisingly steep in places. Genuinely challenging red.

6. Cabane du Berger : Good, busy north-facing blue with reliable snow.

7. Bois : Straightforward little red with reasonably steep top section then flatter lower down.

8. Bergeries : Good long blue run for all standards. Top section is wide-open piste, then it narrows down thorugh the trees. Great place to come if there's powder.

9. Serre de l'Homme : Isolated, tranquil long winding blue run, close to some off-piste options.

10. Surf : Similar to Gimette - off-piste options here too with a guide.

11. Gimette : Starts at the furthest northerly point you can get to in the resort. Sunny south-facing wide-open slopes. Excellent.

12. Fau : Small, sunny blue that links up with **Clot** and then Clot Soleil to make a very long cruisey run all the way down to the lifts at Praloup 1500.

13. Pegueiou : Long cruisey green. Also links with **Clot**.

14. Molannes : Alternative to Clot Soleil for a long easy run down to 1500.

15. Bretelle : Stunning little sunny piste overlooking Praloup 1500 down the valley.

16. Olympique, Stade Christel Pascal : Awesome kilometre long race piste, named after *Christel* herself. Cannot be faulted.

SOUTHERN ALPS

17. Garcine : Nice long blue that starts in a bowl-type piste and ends up flanked by trees. Joins the long green Clappe run down to the nursery slopes.

18. Dalle : Excellent bumpy red that turns into Fraises for a long thigh-burning GS-type piste back to town.

19. Combe Air France : Short, bumpy tree run. Can have sketchy snow but is quality in powder.

20. Courtil : Long blue down from Costebelle, linking up with the town red runs.

21. Costebelle : Excellent, fast racing piste that links up with Christel's run for an exhilirating finish in town.

22. La Noire : One of the only black runs here. Steep and sometimes icy run down through trees. Top spot if there's powder about.

23. Chemin du Bull : Long cruisey blue reached from Costobelle. Basically a path home!

24. Lause : Quite steep, short, sometimes icy red piste.

25. Loups : Long, well-groomed red back into town. Again, sometimes icy of not much snow about (start/end of season).

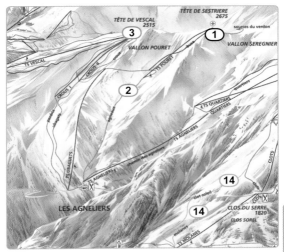

1. Buse : You are officially a long way from everywhere here! Starts at the top of Tête de Sestrière, with unbelievable 360 degree views and real off-piste options.

2. Agneaux : Challenging red down through a high-sided valley. Good, often uncrowded spot if there's powder .

3. Crous, Ubagets, Perdrix : Three excellent reds from the Tête de Vescal down through the valley to the restaurant and Baguets chair.

4. Grand Vue : The long blue run that opens up the skiing in Allos to visitors from Praloup.

Best off-piste
The area for off-piste is **St Sauver**. Take a guide and get out there and explore this excellent, varied area.

Best black run
Mesclun down from *Mene chairlift* is long, low on crowds and challenging. If you want solitude, this could be it.

Best red run
An amazing set of reds: go up *Cime de Sistron* and take **Sistron** followed by **Coutras**, then pick up **Myrtilles** all the way down to *Genisserie chairlift*.

Best blue/green
Chastillon or **Chevrette** from the top of *Col de la Lombarde* for great views, plenty of space and good snow.

The Cow Club on the slopes is a good place to meet people and the food is pretty good too. Also try **Le Petit Chamois.**

For the special meal out, it has to be **Hotel Diva** - keep your eyes out for the rich and famous up from the coast (it also has a couple of nice bars inside).

The **Goofy Bar** is quite chilled, **La Cuban Café** is pretty lively and **Le Crocodile** keeps going after the other bars give up.

La Tanière and **Cuba Loco** are the late night dancing spots.

Isola 2000 *By Hugh Hutchison*

Adrian Myers

Isola 2000 will always be special to me, as it was the first ski resort outside of Scotland that I skied in. About 1.5 hours short drive from Nice (90km) and so close to the Med made it quite a contrast!

The best route is to leave the **A8 Motorway** at St *Isadore/Digne* onto **RN202** for 30km. Take the **D2205** turn off to *St Saveur sur Tinée* and *St Etienne de Tinée* to *Isola Village*. Follow the **D97** road up to the resort.

But **Isola 2000** has some great skiing both on piste and off for a resort so far south (a full 120km of pistes) and its snow record is impressive. If you are a good weather skier then this could be for you. It is best suited to beginners and intermediates.

The development of **Isola 2000** was unique amongst the ski resorts in the *Alpes Maritimes*. The other smaller resorts of the area were built around existing communities. Isola was a new development (built in the late 60s) that was supposed to bring jobs to the community and it was intended to be a rival the large resorts of the northern French Alps.

The site of **Isola 2000** is situated 16km from the original village. Until 1945 the terrain was Italian, royal hunting grounds of *King Victor Emmanuel*. At the end of the war Italy ceded the lands to France. There are still remains of barracks and supply roads to this day.

Isola was 'founded' by a British army officer, **Peter Boumphrey** was a British army officer who represented Britain in *St. Moritz Olympics* in 1948 wanted to build his own ski resort, close to an airport to attract the growing number of British skiers.

Isola has a good snow record and is normally open from December until the end of April. This offers the possibility of a dip in the Med after skiing! There are ski touring possibilities in the surrounding *Mercantour national park*. The ski areas are large and consist of **St. Sauveur, Pelevos** and **Levant** in a U shape around the resort. There are slopes to satisfy all levels for snowboarders there is a park and halfpipe.

Getting There

Fly: from UK to *Nice* via BA, Air France, Bmibaby and Easyjet. It is then 100km (approx 1.5 hours).

Drive: From *Nice airport*, take the **A8** west and turn onto the **N202** then follow directions for *Digne les Bains* on **N85**. Turn off right on **D2205** to *St Saveur sur Tinée* and *St Etienne de Tinée* to *Isola Village*, then onwards to the resort. There is a regular bus service from *Nice* station too.

Train: The nearest rail station is *Isola*. There is a very good bus service from the village to the resort, and taxis are easy to get.

ISOLA

D2205

Isola 2000

D2202

N202

A8

NICE

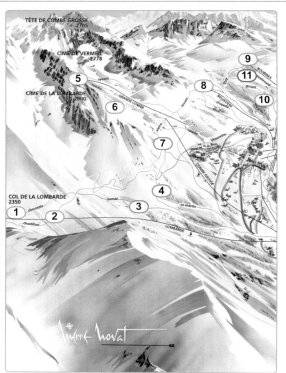

TÊTE DE COMBE GROSSE
2705

CÎME DE VERMEIL
2778

CÎME DE LA LOMBARDE
2800

GRANDE COMBE

COL DE LA LOMBARDE
2350

LOMBARDE

BELVEDERE

BOUBINES

SOUTHERN ALPS

1. **Chevrette** : Great blue from the top of Col de la Lombarde as a warm up for **Bambi** red run down below. Lovely views and rarely crowded. A must.

2. **Chastillon** : This is a real signature piste - long, undulating with a nice 400 metres vertical drop from 2350 metres down into Isola.

3. **Bambi** : Effectively an extension of the two neighbouring blues off the top of Lombarde chair. Quite steep in places, sometimes icy and patchy at the bottom, but always worth it.

4. **Jo Martin** : A good option down through the trees off the **Lombarde** blues which is also a good route across to the other side of the mountain.

5. **Levant** : The blue off the right of the top of the Belvédère lift with access to straightforward off-piste close to the piste. Amazing views from the top.

6. **Combe:** Another excellent intermediate/improver run from the Grand Combe lift. Cruisey, open and mellow. Simple off-piste to join up with **Sierra** but if in any doubt take a guide.

7. **Sierra** : Long wide-open piste off the top of Combe Gross chair. Nice views but the snow can sometimes be patchy down the bottom.

8. **Diva, Chapelle** : Two similar style **Belvédère** blues for all standards running back into the top of town.

9. **Golf** : A relatively quiet blue - a wide-open piste flanked by trees, perfect for the not-so-confident to build the miles on.

10. **Grizzly** : Similar to **Golf** - only a slightly different route through the trees. Very nice too.

11. **Boulevard** : Quality green - perfect to take you back into Isola for lunch after enjoying the blue payground in this area.

SOUTHERN ALPS

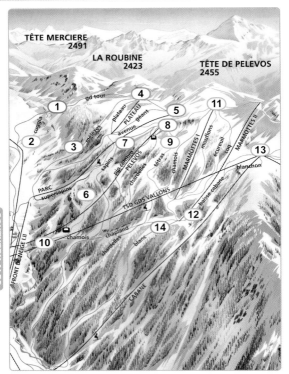

TÊTE MERCIERE
2491

LA ROUBINE
2423

TÊTE DE PELEVOS
2455

1. Grand Tour : Named because of a crazy long green from over 2400 metres up with a vertical drop of nearly 500 metres? You can't miss that!

2. Cuggia : A short blue short-cut! Take this off the green **Grand Tour** if you want a bit more schuss and a bit less poling!

3. Mélèzes : Proper run from the top of La Roubine more-or-less straight down through the trees to Parc chair. Surprisingly steep in places. Sometimes icy.

4. Plateau : Shorter bowling-type red - a little bit bumpy and catches the sunshine so not a bad place to improve your red run skills.

5. Géant : Similar option to **Plateau** going off the other side. Immaculate views and a good spot for a little picnic.

6. Avenue : Brilliant blue off Pelevos cable. Classic long run through trees that gets very crowded at lunch and the end of the day.

7. Sapins : A typical example of the quality of red runs you get on Pelevos with a couple of steeper pitches and a bit of ice through the trees.

8. Pin Cembro, Chardelles : More of the same as Sapins in this good intermediate/advanced area. **Chardelles** is very long - see if you can do it all without stopping!

9. Tétras : Motorway blue off the other side of Pelevos, useful to get you up to the bluer skiing and boarding around Marmottes lifts.

10. Chamois, Chapland : For those tired afternoon legs, particularly beginners and little people, the route back to town off Pelevos, if the cable car is too embarrassing.

11. Mouflons, Ecureuil, Coq : Same starting point. **Coq** is a wider piste than the others, but they all merge at the base of Marmotte.

12. Baisse Cabane : Relatively steep blue with amazing views off the Vallons chair. Links with the **Chamois/Chapland** pistes to give a very long last run in.

13. Blanchons : Another blue option at the top of Vallons.

14. Blanc : The quality of snow, tranquility and views through the trees make this a real gem. Take Cabane back up and go off the other side and it seems like another resort.

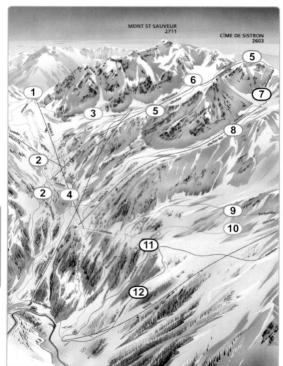

1. Verpes : The dubiously named Verpes is probably the first run you will do over this side of the mountain. Wonderful view of the St Saveurs range.

2. Calada, Myrtilles : Monster of a red that splits down the bottom into Myrtilles. Very long, winding with a couple of narrower and steeper pitches. Good contrast to the tree-lined slopes over the other side.

3. Pignals : Very long winding blue, relatively uncomplicated for most standards. Just pretty and motorway-like.

4. Vallon : Vallon is the follow-on piste of Verpes and Pignals taking you down..wait for it..through the valley to Génisserie station.

5. Sistron, Cloutas : Fabulous, long red from the highest point in the resort at 2603 metres, linking with Cloutas to give one of the best red runs around. This with fresh powder is the real deal. You need a rest at the end!

6. St Sauveur : Easier version of the Cloutas red piste, joinging Pignals. A must-do for all. Very boarder friendly too.

7. Boumphrey : One of only 3 black runs in Isola - this one is as high and as isolated as it gets. Check out the views off the back of the Cime de Mémé. Steep run down through a bowl with access to loads of off-piste. Do it properly and take a guide.

8. Merlier Bis, Merlier : What skiing and snowboarding were invented for! Long, long hidden valley-type run which in fresh powder is unbelievably good. Off-piste options too with the usual caveats.

9. Bartavelle : Another highlight run. If you can handle the length of time it takes to get there, you won't regret it. It has everything. Bowl skiing at the top, easy off-piste in the mid section and tree-lined descent at the bottom. Perfect.

10.Clairière : Blue version of Bartavelle - only longer! Make sure you don't turn off left onto Morisset unless you can seriously handle your skis/boards!

11. Morisset : Steep, fall-line black down through the trees to the Mene station. Narrow and steep at the top, but more open out of the trees at the bottom on the home run.

12. Mesclun : Stunning, long black run - this area is where the dawn powder-hounds head to if the snow has just fallen, know what I mean?